Edgar

Degas:

The Many

Dimensions

Of A Master

French

Impressionist

An exhibition organized by
the Center for the Fine Arts,
Miami, Florida and
The Dayton Art Institute,
Dayton, Ohio with
the collaboration of
Mississippi Museum of Art,
Jackson, Mississippi

Dominique H. Vasseur
Curator

Karen Wilkin
Guest Essayist

Edgar

Degas:

The Many

Dimensions

Of A Master

French

Edgar

Impressionist

Edgar Degas: The Many Dimensions of a Master French Impressionist

This exhibition is composed of a major loan of sculptures by Edgar Degas from the Museu de Arte de São Paulo Assis Chateaubriand, São Paulo, Brazil, with additional loans from U.S. collections.

In Miami, this exhibition was sponsored by Southern Bell, A BellSouth Company; Odebrecht Contractors of Florida; Varig Brazilian Airlines; Burdines; and with an indemnity from the Federal Council for the Arts and the Humanities.

In Jackson, this exhibition is the second in the Mississippi Museum of Art's Annie Laurie Swaim Hearin Memorial Exhibition Series and is sponsored in large part by the Robert M. Hearin Foundation, a grant from SkyTel, and funding provided by the Mississippi Department of Economic and Community Development.

In Dayton, this exhibition was sponsored in large part through a major grant from National City Bank, Dayton, Ohio, with additional funding from the Reynolds and Reynolds Company, Dayton, Ohio, The Iams Company, the Montgomery County Regional Arts and Cultural District, WDTN-Channel 2 Dayton, and the Dayton Daily News.

Exhibition Schedule

Center for the Fine Arts, Miami, Florida: April 2 – May 15, 1994

Mississippi Museum of Art, Jackson, Mississippi: May 30 – July 31, 1994

The Dayton Art Institute, Dayton, Ohio: August 13 – October 9, 1994

First Edition

Library of Congress Catalog Card Number 93-73669

Wilkin, Karen, and The Dayton Art Institute.

Edgar Degas: The Many Dimensions of a Master French Impressionist/The Dayton Art Institute; essay by Karen Wilkin. — 1st ed.

ISBN 0-937809-12-8

Designed by Graphica, Inc., Dayton, Ohio

Editing services by C.E.P., Inc., Cincinnati, Ohio

Typeset in Futura by Graphica, Inc., Dayton, Ohio

Printed on Mead Signature® Dull 100 lb. Text and Mead Mark I 10 point Cover
by The Nielsen Company/Queensgate Press Division

Bound by Cincinnati Bindery, Inc.

Printed in the United States of America

Contents

Acknowledgments: The Dayton Art Institute

It seems almost inconceivable now that the critic Max Liebermann would write in 1898:

"Degas never can or will be popular. He shuns the approval of the masses; he works for the few connoisseurs, hateful of the trivial taste of the crowd, proud and lonely, jealous not of success, but of his art."

Few artists in our day are as widely known or as genuinely popular as Edgar Degas. In organizing this exhibit, The Dayton Art Institute had three goals; first, to celebrate the Institute's 75th anniversary in 1994 in a grand style; second, to draw upon the strength of our impressive permanent collection for inspiration; and finally, to attempt to break all special exhibition attendance records with a memorable and meaningful aesthetic and educational experience.

In this exhibition we bring together, for the first time, Degas's collected bronze sculptural work and a large selection of his paintings, pastels, drawings, and lithographs in an effort to help clarify the relationship between these two dimensions. We hope the reader and the viewer find this challenge both interesting and enlightening. Although we can draw no decisive conclusions, this exhibition has added to our overall understanding of a very complex and fascinating artist.

This exhibition began several years ago during a meeting of the Association of Art Museum Directors. Mark Ormond, then director of the Center for Fine Arts, Miami, described in glowing details the wonderful collection of Degas bronzes which he was working to secure for exhibition. This conversation quickly led to the idea of adding the two-dimensional works, comparing and contrasting Degas's disparate yet strikingly connected work. This seemed a perfect cooperative effort. Mark and the staff of the Center for the Fine Arts have skillfully handled the bronze collection negotiations. The Mississippi Museum of Art in Jackson, which plays host to the International Ballet Competition in June, 1994, makes an ideal host. In Jackson, this exhibition is the second in a series dedicated to the memory of a very special patron of the arts, Annie Laurie Swaim Hearin, whom I had the great privilege of knowing and working with.

Finally, the Board of Trustees, staff and community of Dayton have been outstanding. Without the support of the exhibition's sponsors, this show would not have been possible. We owe our gratitude to Fred Schantz and Chuck Hoschouer of National City Bank, Jack Proud of Reynolds and Reynolds, Cate Laden of The Iams Company, Chuck Vella of The Dayton Daily News, Cheryl Craigie, Larry Ryan, and Kim Peters of WDTN-Channel 2 and Jon Verity and Judy Mott of the Montgomery County Regional Arts & Cultural District. We also sincerely thank the leadership of the Board of Trustees, including Brad Tillson, President, John Lombard, President-elect, Bev Shillito, Development Committee chair, and many others. They accepted and supported this massive endeavor. Last and certainly not least, Degas is the creative offspring of the staff which worked so diligently against odds which often seemed insurmountable: Marianne Lorenz, Chief Curator and Assistant Director for Collections and Programs; Pam Bruns, Assistant Director for Development; Dominique H. Vasseur, Curator of European Art; Eileen Carr, Curator of Education; Beverly Balger, Registrar; Sara Weber, Director of Public Relations; Pamela Koehler, Special Events Coordinator; Richard Boehner, Chief Preparator; and my assistant, Lynn Gathagan-Roberts.

Alexander Lee Nyerges
Director
The Dayton Art Institute

Acknowledgments: Center for the Fine Arts

It has been a great honor to have co-organized with the Dayton Art Institute and with the cooperation of the Mississippi Museum of Art this important exhibition of work by the prominent late 19th century French artist, Edgar Hilaire-Germain Degas. As the CFA celebrates its tenth anniversary, this exhibition is a continuation of our commitment to bring significant art exhibitions of the highest quality to Miami.

Edgar Degas: The Many Dimensions of a Master French Impressionist brings together important sculptures, paintings, drawings, and prints. The core of this exhibition features seventy-three cast bronze sculptures from the collection of the Museu de Arte de São Paulo, Brazil. The inclusion and integration of two-dimensional work in a variety of media offers the viewer a rich overview of Degas's important contribution during the late 19th century. Degas's work focused mainly on contemporary life. The subjects were usually horse racing scenes, ballet dancers, Parisian café life, the theater, the circus, and laundresses. From 1880, Degas began to model, primarily horses, women at their toilet, or nude dancers in characteristic postures. His elegant sculpture, much like his paintings and drawings, captured the essence of his subjects' gestures. It is a rare opportunity to provide the viewing public with the many dimensions of his oeuvre.

This exhibition has been made possible through the hard work and diligence of many individuals and by contributions from several sponsors and organizations. On behalf of the Board of Trustees, I would like to thank the Federal Council on the Arts and the Humanities for providing an indemnity and their commitment to the exhibition. In addition, the following sponsors have made significant contributions: Southern Bell, A BellSouth Company; Varig Brazilian Airlines; Odebrecht Contractors of Florida, Inc.; and Burdines. Additional support has been provided by the Hotel Inter-Continental, Air France and Marie Brizard Wine and Spirits.

Special mention must be made of the following individuals and institutions whose help ensured the success of this exhibition: Metropolitan Dade County Commissioner Javier Souto; State of Florida Secretary of Commerce, Charles Dusseau; Metropolitan Dade County/São Paulo Sister Cities Program, Dr. Aldo Raia, President, Sister City Delegation, São Paulo; Consul General of Brazil, Vera B. Machado; Vice-Consuls Cultural Department, Norah Aurelio and Geraldo Rivello of the Brazilian Consulate of Miami; Ambassador Rubens Ricupero in the consulate offices in Washington, D.C., for his support from the inception of the project.

The following individuals made invaluable contributions; David C. Peebles Jr., for his efforts on behalf of the exhibition; Chief Curator Fabio Magalhães, International Projects Person Eugênia Gorini Esmeraldo, and International Projects Assistant Leonarda Lascalla from the Museu de

Arte de São Paulo; and Dominique H. Vasseur, Curator of European Art at the Dayton Art Institute. From the staff of the CFA, I recognize Exhibitions Manager and Senior Registrar Arlene Dellis for her dedication and tireless professionalism in coordinating all logistical matters. In addition, I commend Jorge Gonzalez, Assistant Director for Administration, for his important efforts, and Regina Smith, my assistant, for her hard work. Finally, I thank Mark Ormond, former Director of the CFA, for his vision in initiating and developing this exhibition. His work is greatly appreciated.

Louis Grachos
Interim Director
Center for the Fine Arts

Acknowledgments: Mississippi Museum of Art

The Mississippi Museum of Art is pleased to present *Edgar Degas: The Many Dimensions of a Master French Impressionist,* the second exhibition in The Annie Laurie Swaim Hearin Memorial Exhibition Series of special presentations for the people of Mississippi and mid-South region in memory of one of our community's outstanding leaders and supporters of the arts.

We give very special thanks to the Robert M. Hearin Foundation for its continued vision and efforts in support of this exhibition series.

We are very grateful to SkyTel, particularly John N. Palmer, Chairman, for the leadership and support also making this exhibition possible for Mississippi and the mid-South region.

The Mississippi Museum of Art gratefully acknowledges our colleagues at the Center for the Fine Arts, Miami and The Dayton Art Institute for providing the curatorial and organizational development of this project.

We would be remiss in not recognizing and also thanking our own staff, particularly Rene Paul Barilleaux, Chief Curator, and Alisa Terry, Director of Development, for their efforts and those of their staffs in presenting this exhibition in Jackson, Mississippi.

Linda S. Sullivan
Executive Director
Mississippi Museum of Art

Curator's Statement

This exhibition has been not only exciting to organize but especially challenging to produce, given the extremely limited time between its inception and opening at the Center for the Fine Arts. Many people from the organizing and lending institutions, whose hard work and assistance made this exhibition possible, gratefully must be acknowledged for their contributions.

My thanks, first, to Alexander Lee Nyerges, Director of The Dayton Art Institute, to Louis Grachos, Acting Director of the Center for the Fine Arts, and to Linda S. Sullivan, Executive Director of the Mississippi Museum of Art, for their commitment to the concept of this exhibition and to seeing this important project through to its completion. Second, the exhibition would not have occurred without the willingness of the Museu de Arte de São Paulo Assis Chateaubriand to share their Degas bronze sculptures with the American public; to Mr. Fabio Magalhães, Chief Curator, and to his staff at the Museu de Arte de São Paulo goes my sincere gratitude for all their assistance. My appreciation goes to Ms. Karen Wilkin, who provided us with a highly comprehensive and most fascinating catalogue essay on the subject of our exhibition; it has been a pleasure to work with her.

In equal portion goes my deep appreciation to the many museums, corporations, and private collectors across the country who accepted our requests for loans of paintings, drawings, and prints with openness and generosity. I would like especially to mention Mr. James N. Woods, Director, and Ms. Suzanne Folds McCullagh, Curator of Prints and Drawings, The Art Institute of Chicago; Mr. Alain Joyaux, Director, Ball State University Museum of Art; Mr. James A. Bergquist; Mr. Peter C. Sutton, Mrs. Russell W. Baker Curator of European Paintings, and Ms. Sue Welsh Reed, Associate Curator of Prints, Drawings and Photographs, Museum of Fine Arts, Boston; Mr. David S. Brooke, Director, and Ms. Martha Asher, Registrar, The Sterling and Francine Clark Art Institute; Mr. Robert P. Bergman, Director, and Ms. Jane Glaubinger, Curator of Prints and Drawings, The Cleveland Museum of Art; Mr. Samuel Sachs II, Director, and Mr. Alan P. Darr, Curator of European Sculpture and Decorative Arts, The Detroit Institute of Arts; Mr. John Buchanan, Director, and Ms. Lisa Incardona, Registrar, The Dixon Gallery and Gardens; Mr. H. Peter Findlay; Ms. Donna Hassler, Curator and Acting Director of The Hyde Collection; Mr. Victor Carlson, Senior Curator of Prints and Drawings, Los Angeles County Museum of Art; Mr. William J. Chiego, Director, and Ms. Heather Hornbuckle, Acting Collections Manager, The Marion Koogler McNay Art Museum; Mr. Philippe de Montebello, Director, and Mr. Gary Tinterow, Englehard Associate Curator of European Painting, The Metropolitan Museum of Art; Mr. Hollister Sturges, Director, Museum of Fine Arts, Springfield, Massachusetts; Mr. Marc F. Wilson, Director, The Nelson-Atkins Museum of Art; Dr. Allen Rosenbaum, Director, The Art Museum, Princeton University; Mr. Harry S. Parker III, Director, and Mr. Steven A. Nash, Associate Director and Chief Curator, The Fine Arts Museums of San Francisco; Ms. Kathleen Ecklund, Supervisor of Administrative Services, The Sara Lee Corporation; Ms. Suzannah S. Fabing, Interim Director, Ms. Linda Muehlig, Associate Curator of Painting and Sculpture,

and Ms. Ann H. Sievers, Curator of Prints and Drawings, The Smith College Museum of Art; Mr. James D. Burke, Director, The Saint Louis Art Museum; Ms. Mary Gardner Neill, The Henry J. Heinz II Director, and Mr. Richard S. Field, Curator of Prints, Drawings and Photographs, Yale University Art Gallery; and, finally, a private collector who wishes to remain anonymous. To these people and to many others from the lending institutions' staffs goes our sincere appreciation.

I leave the pleasure of giving credit to the exhibition sponsors and to the staffs of the Center for the Fine Arts and the Mississippi Museum of Art to the directors of those institutions. Nevertheless, at The Dayton Art Institute, I would like to recognize Ms. Marianne Lorenz, Assistant Director for Programs and Collections, for her good counsel and unflagging support for this project; Ms. Beverly Balger, Registrar, and Ms. Patricia A. Huls, Assistant Registrar, for their highly professional handling of registrarial issues; Ms. Eileen Carr, Curator of Education, and Ms. Robin Crum, Public Programs Coordinator, for their assistance with numerous matters and for their handling of the educational components of this exhibition; and, finally, Mr. Richard Boehner, Chief Preparator, for his tireless and flawless installation preparations, and Mr. Rick Allison, Building Superintendent, for much behind-the-scenes preparation and assistance. I also wish to thank Ms. Judy O'Neill and Ms. Mary Lou Motl, of Custom Editorial Productions, Inc., Cincinnati, for excellent editorial services in the preparation of this catalogue.

I trust that the efforts of all these and the many others too numerous to mention here will be rewarded by the success of this exhibition and by a shared and deepening appreciation for the art of a most complex and fascinating artist — Edgar Degas.

Dominique H. Vasseur
Curator of European Art
The Dayton Art Institute

Introduction

It is interesting to speculate whether Edgar Degas, during his visit to his mother's family in New Orleans in 1872–73, ever thought that his work would be so enthusiastically collected, exhibited, and appreciated in this foreign land far from his home in Paris. Degas's sojourn to the United States doubtlessly had little effect on him personally or artistically; nevertheless, the enduring power of his art on generations of American collectors and museum visitors can be underscored by the passionate response it has received ever since Degas's death in 1917. Furthermore, his popularity shows little signs of waning; recent years have seen numerous important exhibitions of Degas's work both in this country and abroad, and many highly interesting and important articles have appeared in a variety of scholarly reviews.[1] Degas seems very much a man of our own time.

This continued interest in Degas is quite understandable; his work pleases the layman and scholar alike, and the subjects of his art, like the landscapes and city scenes of most of the Impressionist artists, are readily understandable and accessible to modern audiences. Nevertheless, under the easy exterior of such seemingly mundane subjects as bathers, ballet dancers, and horses lies a highly personal world filled with complexities, difficulties, and paradoxes that reflect Degas the man and that mirror, perhaps, the complexities and dilemmas we ourselves find in our late twentieth-century world.

Anonymous French,
19th century
Edgar Degas, c. 1855–60
Courtesy Bibliothèque
Nationale, Paris

This exhibition, although by no means a retrospective, recognizes the paradoxical and problematic nature of this important artist's life's work. Through the generosity of the Museu de Arte de São Paulo Assis Chateaubriand, we have a wonderful opportunity to share with our audience seventy-four Degas sculptures, a rare treat by any standard. Wishing, however, to capitalize on this chance to present Degas in a more comprehensive manner, we set about the task of supplementing the exhibition's core of bronzes with two-dimensional works, securing additional loans from American collections.

Obtaining supplementary loans for an exhibition of this scope was accomplished in near record time. The works were selected for their correlation to the three essential themes of Degas's sculptures: the racetrack, the female nude, and the ballet. In no instance can we make the claim that a two-dimensional work exhibited here served as a direct study for one of Degas's wax models (or vice-versa, for that matter). Perhaps the only exception to this fact is, as Theodore Reff[2] has pointed out, The Schoolgirl (exh. no. 31), which appears to be directly related to the etching The Actress Ellen Andrée (exh. no. 30); both works obviously share a close tie with pencil studies for The Schoolgirl found in Degas's notebooks, now in the Bibliothèque Nationale in Paris.

In many instances the mere juxtaposition of, for example, a charcoal drawing and a sculpture of a ballet dancer, posed as in Grande Arabesque, Second Time (exh. nos. 76 and 78), allows the viewer to, as it were, participate in Degas's own experience of seeing and creating, an experience formed from years of observation and manipulating pencil, charcoal,

oil paint, pastel, wax, and clay. As John Rewald has put the issue, "there is an enormous difference between seeing something and seeing it *while modeling it*,"[3] and Degas undoubtedly learned much about his subjects and about his own response to them through his experiences using different techniques and media. To put the matter succinctly, the better Degas understood the subjects of his lifelong interests through such multimedia and dimensional explorations, the better *we*, the viewers, too can understand them.

The great paradox of any Degas exhibition that places sculpture at its center is the issue that the majority of Degas's sculpture was, by the artist's own admission, not intended for public viewing and was rarely seen except by his friends and studio visitors. Apart from the famous *Little Dancer of Fourteen Years* (exh. no. 59), Degas appears to have modeled most of his wax-and-clay sculptures as personal exercises meant to help him better understand the attitude, form, and volume of his subjects.

Unlike the wax models that the seventeenth-century French artist Nicolas Poussin created and posed in stage settings to help him better construct his painted compositions, Degas's sculptures seem, for the most part, to be intentionally unrelated to other finished products. And whereas Poussin's models were part of a specific progressive, evolutionary process that culminated in an oil painting, Degas's sculptures of horses, bathers, and dancers appear to have been a private or, at the very least, a highly personal aspect of his work, perhaps sometimes directly related to specific two-dimensional works but at other times completely unrelated. Whatever the case, Poussin would never have thought of himself as a sculptor, yet the essential instincts of a sculptor *were* present in Degas, who, as a young man, is quoted as having said, "I often wonder whether I will be a painter or a sculptor. I will not conceal from you that I am very uncertain [about this]."[4] It is obvious that although Degas was (and perhaps still is) better known as a painter, his sculpture was as important to him personally as his two-dimensional work.

Excepting, of course, the *Little Dancer* — the one work he did intentionally exhibit to the public's great surprise — all of Degas's sculptures have the appearance of being quickly made. Untrained as he was in sculpting, Degas created and reworked his malleable wax-and-clay figures, adjusting and readjusting them perhaps over periods of days, months, or years, consciously destroying some and merely allowing others to disintegrate through time or as a result of inherent technical instability. Surviving wax-and-clay sculptures collected studio dust until they were transformed by A. A. Hébrard et Compagnie into the durable bronzes exhibited here.

We acknowledge in this exhibition, too, the questions that arise about Degas's place in French Impressionism. Although popularly he is thought of as an Impressionist, one could argue that Degas was far more concerned with the art of the past — a point emphasized by his own preferences in art collecting;[5] a further argument might be made that Degas's art stands as a

bridge between the great art of the nineteenth century and the art of the twentieth century. Degas's art (e.g., exh. no. 32) demonstrates a synthesis of the fine draftsmanship of J.-A.-D. Ingres — essentially a *trompe-l'oeil* form of art in two dimensions — and an exquisite use of color as form — a lesson Degas learned from Eugène Delacroix. This synthesis of two opposing "schools" of art, line versus color, served as the basis for his explorations in three-dimensional form, which Degas accomplished literally with wax and clay. To depict form in space, indeed, form in movement, was the central issue in his art and a challenge that Degas met throughout his long career.

At times the visual links among works in two and three dimensions are strong, demonstrating how deeply involved Degas was with examining and evaluating a given human or animal movement. Take, for example, the unusual *Standing Female Nude (Bather)* from the Princeton University Art Museum collection (exh. no. 19), which is a two-dimensional analogue to the bronze *Woman Taken Unawares* (exh. no. 20). Though no doubt both were created around 1896, it is nearly impossible to determine which work sprang first from Degas's mind. Indeed, exact dating of Degas's works, especially the privately created sculptures, has been a difficult task.[6]

Degas's persistent involvement with certain themes and subjects over the span of years, exploring them in a variety of media and in two and three dimensions, is an interesting aspect of the artist's psychology. The bold and energetic 1866 charcoal study of a bolting horse in The Sterling and Francine Clark Art Institute's *Study for "Steeplechase: The Bolting Horse"* (exh. no. 54) shows surprising affinities with the somewhat abstracted bronze *Horse and Jockey: Horse Galloping on Right Hoof* (exh. no. 55), which is thought to have been made some twenty years later, circa 1888–90. In the charcoal study, Degas enhances the sense of movement by accentuating and enforcing certain contours of the horse while weakening others by his thoughtful pentimenti of the horse's head and rear legs. His use of parallel lines introduces the suggestion of background against which the horse stands in relief, as it were, moving from left to right as it leaves the fallen jockey. The bronze horse, hurtling through space at great speed, likewise skillfully conveys the suggestion of movement, especially in the horse's highly abstracted head and lithe neck, which seem almost streamlined. The body and rear quarters of the horse show greater bulk and strength, features joined elegantly in the other Degas horses. The bronze demonstrates a further aspect of Degas's creative evolution, that is, his acknowledgment of the photographic evidence of human and animal movement as presented by Eadweard Muybridge (e.g., exh. nos. 50 and 53). Here, Degas accurately presents the sculptural horse with one hoof touching the ground.[7]

Degas's own interest in photography during the mid-1890s is a fascinating subject in and of itself.[8] His work with photography, similar to his sculpture, seems to have been intended for his personal understanding and appreciation, adding yet another medium to his vast repertory of visual expression. Not unlike his famous photograph of a nude woman, *After the Bath* of

1896 (illus. p. 16), Degas addressed time and again the subject of a woman bathing: in pastel (e.g., exh. nos. 8, 14, and 16), in printed medium (exh. nos. 3, 6, and 9), and in bronze (exh. nos. 2, 11, 12, and 13). Although each example is of a different medium, is seen from different angles, and is often from different dates, one still senses an overarching set of concerns evident in these explorations, each carrying the first-hand experience of his subjects through both physical space and time.

What, then, can be learned from yet another exhibition of Degas, albeit one that cannot present large numbers of two-dimensional work related to his sculptures. Perhaps the answer lies implicit in the experience of just such an exhibition. Foremost, Degas's sculptures, now widely acknowledged among the most important created in the nineteenth century, are works that herald the twentieth century and point to the art of our own time. Certainly no reproduction or poster, however artfully photographed or color corrected, can accurately capture the experience of viewing an artwork, especially a sculpture. Therefore, any chance to view all seventy-four sculptures is an important one, an enriching one, especially for audiences hungry to know more about this interesting and complex painter-sculptor-printmaker.

Just as viewers in 1881 were shocked, amazed, and spellbound by the *Little Dancer,* viewers today may find her charming or unsettling, but they will be, no doubt, richer for the experience of having encountered her. The ability to show Degas in a variety of media allows the viewer to better understand him, just as Degas's own use of oil paint, pastel and chalk, printmaking, and sculpture helped him to better express his creativity, allowing him to transcend, as it were, the imposed limitations of technique and the restrictions of dimension.

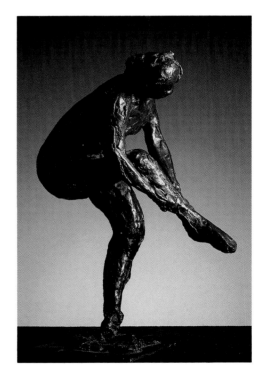

Dancer Putting on Her Stocking,
c. 1900-1905
Courtesy Museu de Arte de
São Paulo Assis Chateaubriand,
São Paulo, Brazil

The question of the relationship between Degas's sculpture and his two-dimensional work may ultimately be an open-ended one; the two seem to be intertwined, an integral part of the artist's own experience, yet they have distinct properties and characteristics. By placing the sculpture on equal footing with his other works, one stands to gain a more intimate sense of Degas's complexity, of his working methods, and of his creative spirit.

The exhibition greatly benefits from the participation of Ms. Karen Wilkin, whose catalogue essay addresses the many paradoxes and multidimensional aspects of Edgar Degas, the man and the artist. As Ms. Wilkin skillfully demonstrates, Degas's personality and technical explorations, while at times disconcerting and difficult to categorize, in contrast with the easily understood subject matter of his art, provide just the richness and complexity to ensure his enduring popularity. She and I are pleased and grateful for this opportunity to present to our audience, Edgar Degas, an undisputed master Impressionist, in many dimensions.

Dominique H. Vasseur
Curator of European Art

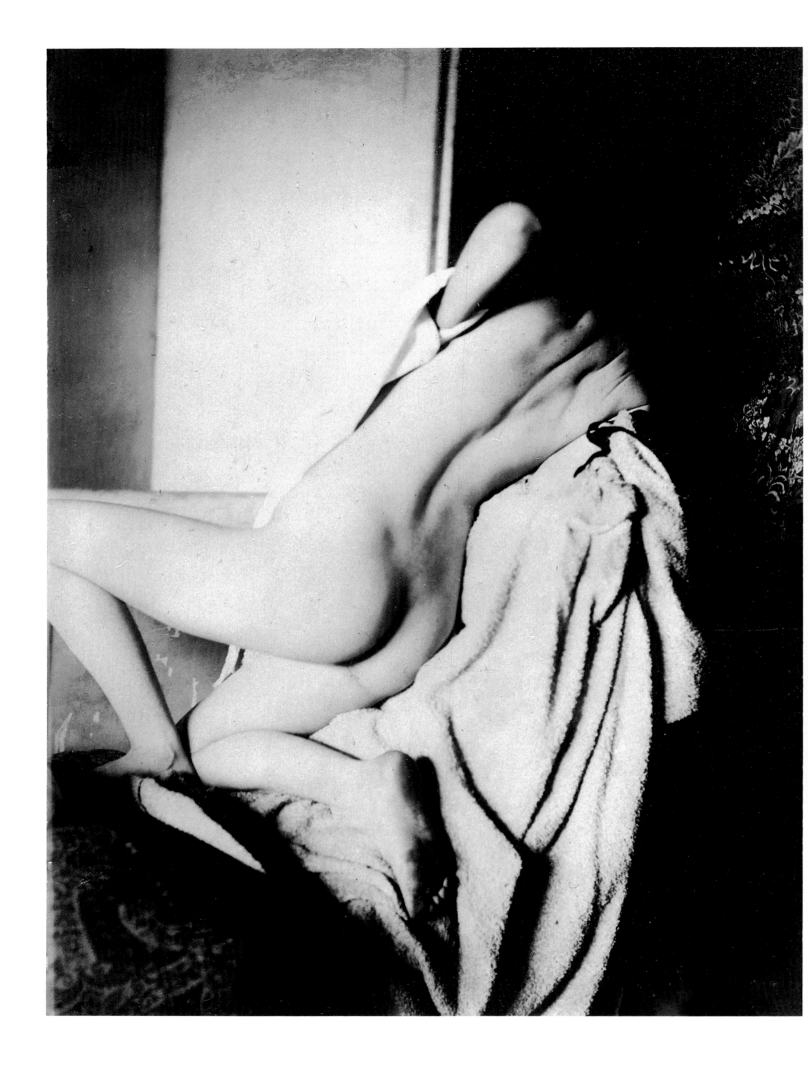

1 No doubt the most important monographic exhibition of Degas in recent years (1988–89) was that organized by Jean Sutherland Boggs et al., which was shown at the Grand Palais, Paris (February 9–May 16, 1988), the National Gallery of Canada, Ottawa (June 16–August 28, 1988), and at The Metropolitan Museum of Art, New York (September 27, 1988–January 8, 1989). Degas's work has also been examined in *Degas in The Art Institute of Chicago* (July 19–September 23, 1984), organized by Richard R. Brettell and Suzanne Folds McCullagh, and in *Edgar Degas: The Painter as Printmaker* (Museum of Fine Arts, Boston, November 14, 1984–January 13, 1985; Philadelphia Museum of Art, February 17–April 14, 1985; Arts Council of Great Britain, May 15–July 7, 1985), organized by Sue Welsh Reed and Barbara Stern Shapiro of the Museum of Fine Arts, Boston. Other exhibitions to specifically include the São Paulo set of bronzes have taken place in Tokyo at the Isetan Museum of Art (October 27–November 15, 1988), with travel to four other Japanese museums, and most recently at the Fondation Pierre Gianadda in Martigny, Switzerland (June 19–November 21, 1993), organized by Ronald Pickvance.

2 See, e.g., Theodore Reff, *Degas, The Artist's Mind* (Cambridge, Mass., and London: Belknap Press of Harvard University Press, 1987).

3 John Rewald, *Degas: Sculpture* (New York: Harry N. Abrams, Inc., 1956), 11.

4 This often-referenced remark is said to have been made in an unrecorded letter from Degas to Pierre Cornu, quoted by Borel; see, e.g., Charles W. Millard, *The Sculpture of Edgar Degas* (Princeton, N.J.: Princeton University Press, 1976), 3.

5 Reff, *Degas,* 37.

6 See Millard, *The Sculpture of Edgar Degas,* chapter 1.

7 See, e.g., Jean Sutherland Boggs, ed., *Degas,* exhibition catalogue (New York: Metropolitan Museum of Art; Ottawa: National Gallery of Canada, 1988), 459–63.

8 See, e.g., "Degas Photograph," *L'Oeil,* no. 65 (May 1960): 36–43; Ronald Pickvance, "Degas as a Photographer," *Lithopinion* 5, no. 1 (Spring 1970): 73–79; or Eugenia Parry Janis, "Edgar Degas's Photographic Theater," in *Degas: Form and Space,* ed. Maurice Guillaud (Paris: Centre Culturel du Marais, 1984), 451–86.

Edgar Degas
After the Bath (Après le bain,
femme s' essuyant le dos),
1896
Gelatin silver print
Collection of the J. Paul Getty
Museum, Malibu, California

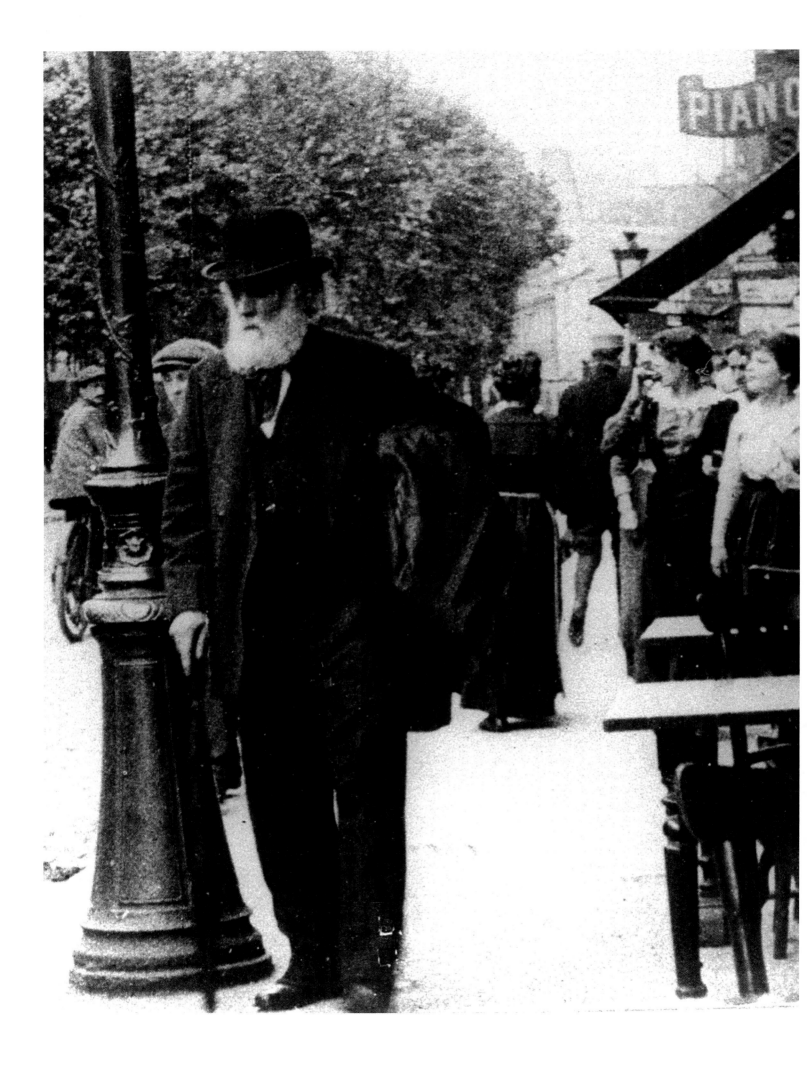

Considering Edgar Degas

by Karen Wilkin

Hilaire-Germain-Edgar Degas (1834–1917) has been called "the most misunderstood of the famous modern artists."[1] His dancers are almost as readily recognized as Vincent van Gogh's sunflowers; yet, while much of van Gogh's art, along with his turbulent life story, has entered the public consciousness, Degas's full achievement remains vague to nearly all but specialists and his most passionate admirers. Popularly labeled "the Impressionist who painted ballet dancers" and perceived as a maker of charming images of graceful young women, Degas is, in fact, a tough, complex, unpredictable artist. Not just a painter of the ballet, he surveyed the whole spectrum of nineteenth-century Parisian life with a curious mixture of detachment and feeling and translated it into some of the most inventive and innovative images in the history of modern art.

Yet Degas remains difficult to know. His personal history belies the reputation of the Impressionists as convivial hedonists fond of communal outings and of painting one another and their families. Reclusive, prickly, seemingly misanthropic, and commonly held to be deeply misogynistic, he never married, had few friends, rarely went out, and tolerated few visitors in the studio. The brief memoir by his dealer, Ambroise Vollard, depicts a slightly warmer man, but one intensely private and cranky in a manner that recalls the neurasthenic Marcel Proust.[2] Other contemporaries, such as the critic Michel Georges-Michel, remember Degas's "biting *mots* and devastating quips, which were the talk of Paris."[3]

Deeper probing reveals more problematic and, at times, even distasteful elements. Any effort to discuss Degas's evolution involves thorny problems of interpretation and questions of dating exacerbated by the artist's habit of recycling images and returning to works begun decades earlier. Feminist critics are disturbed by his presumed attitudes towards women, interpreting his pictures of dancers as images of availability and his nudes as embodiments of the voyeur's clandestine observation. Social historians note that the women who populate Degas's boulevards are not an "innocent" sampling of *parisiennes* seen out of doors but *grisettes* and prostitutes plying their trade. Others point out that, unlike the great majority of artists, particularly modern artists, Degas came from an affluent *haute bourgeoise* family with aristocratic connections and shared their entrenched, essentially reactionary, point of view. There is, however, evidence of an early flirtation with more progressive ideas, and the painter was the first to write his aristocratic family name, "de Gas," in a more democratic fashion. Most troubling is Degas's well documented anti-Semitism and his deplorable behavior towards colleagues and friends who supported Dreyfus.[4] And someone will mention his failing eyesight, his blindness in old age.

If knowing more about Degas's life does little to illuminate his art, knowing more about his art reveals inconsistencies that make it both fascinating and challenging. The closer one looks, the more elusive this apparently familiar artist becomes and the more contradictory the dominant characteristics of his work seem. Rather than clarifying Degas's achievement, closer scrutiny reveals increasing complexity and provokes new questions.

If we focus, for example, on the best known of Degas's images, the ballet dancers, we realize quickly that they are not what they seem at first acquaintance. Far from being visions of effortlessness, of ethereal grace, they are tributes to hard work. Dancers in class and rehearsal, Degas's principal subjects, are often captured in moments of randomness and unguardedness, of exhaustion or repose, before or after the coherence of the lesson or the performance. What is made clear is the inherent artifice of the ballet. Similarly, if we concentrate on Degas's most "traditional" images, the portraits, the female nudes, and the genre scenes, we realize that they are no more straightforward than the ballet dancers. Degas treats these staple subjects of Western painting neither as opportunities to comment on the past nor, as we might expect from a forward-looking painter of his generation, as occasions to document *fin de siècle* Paris. Rather, they allow him to make revelations about private, interior, life that seem strikingly contemporary in mood to late twentieth-century eyes. The bad-tempered eternal bachelor who is supposed to have disliked most female company produced astonishingly sympathetic images of women: portraits remarkable for their psychological penetration and modern-day genre scenes remarkable for their figurative nakedness — studies of women in unguarded moments, bathing, dressing, working, going about the everyday business of their lives apparently unaware of being observed.

Degas was no more predictable in terms of technique than of approach. The celebrated painter produced an extraordinary body of work on paper: drawing, pastels, and monotypes as ambitious and innovative as anything he did on canvas, if not more so. More surprising is the fact that this master of two dimensions, acclaimed as a colorist and draftsman, produced some of the most provocative sculpture in the history of modernist art. Although Degas often insisted that modeling in wax was only a means of achieving greater vitality in his paintings, the practice increasingly absorbed his energy and time over the years. Studio visitors commented frequently on how much effort Degas expended on his sculptures and commented, too, on how little he troubled to preserve them or to show them. The making, rather than the product, was of primary importance to him. Vollard tells of returning to Degas's studio to see a work earlier described by the artist as almost ready to be cast and finding that "all that remained of the little dancing girl was the original lump of wax from which she had sprung. Seeing my disappointment, Degas said: 'All you think of, Vollard, is what it was worth. But I wouldn't take a bucket of gold for the pleasure I had in destroying it and beginning over again.'"[5]

Sculptures were not only destroyed and reworked, but those brought to some state of completion were often set aside for long periods, with distressing results. The critic George Moore noted seeing "much decaying sculpture" in Degas's studio; another visitor commented on "maquettes falling to pieces in their glass cases."[6] What survived of a large body of work produced over more than twenty years remained almost unknown during Degas's lifetime, uncast, and with one exception, unexhibited. It was only after Degas's death that efforts were made to restore and preserve the deteriorating waxes stored in his studio and have them cast in bronze. And it was only after Degas's death that the public was introduced to Edgar Degas, sculptor, or more accurately, to Degas, sculptor of anything other than *Little Dancer of*

Fourteen Years (c. 1878–81), the sole work exhibited in his lifetime and one that earned him more notoriety as a radical than reputation as an artist in three dimensions.[7]

Not only was Degas far more than "the Impressionist who painted ballet dancers" but it is even arguable whether in any of his guises — as painter, draftsman, printmaker, or sculptor — he was an Impressionist at all. It is true that in 1873 he was a founder, along with Monet, Pissaro, Sisley, Morisot, Cézanne, and others, of the Society of Painters, Sculptors, and Engravers, an organization formed to hold free nonjuried shows as alternatives to the official salons. Degas participated in the society's early exhibitions, publicly associating himself with artists later known as the Impressionists, but he is reported to have raged against being described as one of the "school."

From the first, vast differences between his work and that of his colleagues were apparent. The persistent emphasis on drawing, clear contour, and solid composition in Degas's work set him apart from most of his "fellow Impressionists," who preferred to structure their images with color rather than with line. Such crispness of construction could be explained by the influence of Japanese prints, which Degas, like many of his colleagues, knew and admired. His boldly cropped, spatially compressed compositions owe an obvious debt to the abrupt scale shifts and flattenings of the prints known to Europeans of his generation, yet an underlying classicism overwhelms Degas's *japonisme*. Degas's classicism is most evident in his early works, with their subtle modeling and incisive drawing, but it is still palpable in the most radical of his late pastels, in which a pervasive sense of latent geometry and order serves to hold in check blazing color and fiercely stroked surfaces.

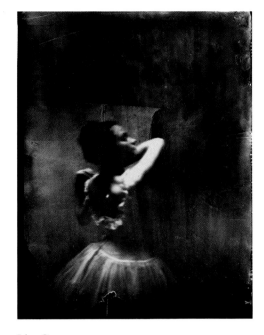

Edgar Degas
Dancer of the Corps de Ballet,
c. 1896
Modern print from the
original collodian plates.
Courtesy Bibliothèque
Nationale, Paris

It is worth noting that the pianist Richard Goode has compared Degas to Brahms, describing both the painter and the composer as innovators whose efforts to achieve excellence drove them back to classical forms.[8] Degas was, in fact, a neoclassicist by inclination and early training. His first hero was Jean-Auguste-Dominique Ingres; his first teacher, Ingres's pupil; his first efforts, copies and tracings of celebrated Neoclassical works. As a mature, formed artist, Degas collected works by Ingres, amassing over the years some twenty paintings and ninety drawings.[9] But just as Degas's work declares a wider set of influences than strict neoclassicism, even of Ingres's perfervid, exotic sort, his collection offers proof of his broader taste. Degas, the neoclassicist, was equally enthusiastic about romanticism and realism: witness his thirteen paintings and one-hundred-ninety drawings by Eugène Delacroix; his six paintings and drawings and eighteen-hundred lithographs by Honoré Daumier.[10] If Degas prized the lucidity, firmness, and elegance of Ingres, he seems to have valued no less the inventive color, suggestive rendering, and sensual touch of Delacroix and the scrupulous observation, virtuoso line, and expressive tonality of Daumier. His own possibly unclassifiable style was compounded of such apparently diverse elements as the suppressed intensity of Ingres, the lush color of Delacroix, and the pitiless accuracy of Daumier.

That the result of this combination can be construed as Impressionism is open to debate. Degas is plainly not an Impressionist if Impressionism is defined chiefly in terms of method, with

its typical picture a landscape or cityscape painted *en plein air* in broken strokes and divided color. By such a definition, only Monet, of all the artists who exhibited with the Society of Painters, Sculptors, and Engravers, could be properly dubbed an Impressionist. (Similarly, the textbook definition of New York abstraction of the 1950s — the picture conceived as the record of a state of mind, executed with "wet into wet" paint, emphasizing gesture and preserving the accidental — would allow only Willem de Kooning to be called an Abstract Expressionist.) The Impressionist enterprise was wider than its stereotypical devices. It had its origins in a quest for fidelity to the actual that began earlier in the nineteenth century, in a search for truth that opposed the idealism of the official art schools and salons. The directly observed landscapes of J.-B.-Camille Corot and the Barbizon school, like the uningratiating nudes and peasants of Gustave Courbet, defied the codified rules of the academy, substituting in their place a realism based on experience. For Courbet, this could be termed a realism of the body, an effort to depict what he knew through corporeal experience, to evoke not only how things looked but how they felt. For a generation of radical young artists in the 1860s, this realism of the body was supplanted by a realism of the eye, an effort to paint what was understood through visual experience, to capture how things appeared without taking into account what was known by other means.[11] They deemed the act of seeing sufficient motivation for making art and deliberately made their ways of putting pictures together and of applying paint seem as "artless" as their motivation. Impressionism's aim, for the most part, was to be faithful to largely unedited visual experience; the broken stroke and divided color that became hallmarks of a debased "international-style" Impressionism sprang originally from an effort to suggest transient vision.

Like the Impressionists, Degas was fascinated by the ephemeral; but where Monet, for example, strove to evoke unstable effects of nature (never mind that he seems to have reworked his canvases indoors), Degas concentrated on the human figure, except for a few landscapes and a great many images of horses and the racetrack. What his ballet dancers, nudes, and boulevard and racetrack scenes have in common is a sense of the momentary. Only in Degas's portraits do figures seem, of necessity, at rest (there are exceptions to this, as well); but they are no less about something transient and difficult to perceive the emotions. Paradoxically, the painter famous for his misanthropy seems to have been deeply engaged by his sitters' states of mind and by the relationship between sitter and portraitist.

With the exception of the portraits, Degas's most consistent themes are taken from public and private spectacles of nineteenth-century Paris: the theater, the opera house, the *café concert*, the racetrack, the boulevard, the rehearsal, the workplace, the boudoir. The assumption that anything seen is worthy subject matter for art, an assumption that substitutes the random events of modern life for traditional themes of history, mythology, and religion and for nineteenth-century motifs of the exotic — the remote in time or place — ultimately separates Degas from the Classicists and Romantics he admired and links him with the Impressionists. Yet Degas's declared aim was not the purely visual accuracy that the Impressionists often claimed as

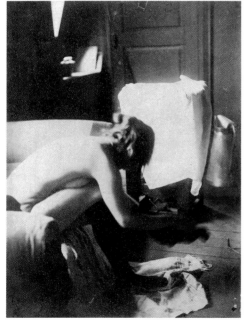

Edgar Degas
Seated Nude, 1895
Gelatin silver print
Collection of the J. Paul Getty
Museum, Malibu, California

justification for their blurred, loosely rendered evocations of natural phenomena. Degas sought not the most recognizable, telling, or even suggestive image, but the most accurate. This is not to discount his powerful sense of abstract structure, placement, and interval; the issue was truth, not verisimilitude. Degas's passion for truthfulness accounts for his interest in Eadweard Muybridge's photographic studies of human and animal motion, images that startled nineteenth-century audiences by revealing previously unseen and unimagined positions of bodies progressing through space. Muybridge's sequence of a galloping horse (exh. no. 53), for example, proved that art's conventional rendition of a horse at full speed, with all four legs outstretched, was pure invention. Degas seems to have been fascinated by this unexpected information. Just as he had looked to classical antiquity and to Renaissance prototypes when he began to model horses, he looked to Muybridge's photographs when he began to render them in motion; several sculptures are based directly on Muybridge's images.[12]

This desire for truth, even when unverifiable by normal vision, helps to explain why a painter interested in transience, in movement, in things barely glimpsed or seen out of the corner of the eye should devote so much energy to making sculpture, which is, after all, unequivocally present and static. Degas's deteriorating eyesight is often used to account for his increasing devotion to modeling, but once again, there are no clear answers. Charles W. Millard, in his definitive study of Degas's sculpture, describes the question of Degas's failing eyesight as "a perplexing one since it seems to have been in part a neurotic affliction of which he took advantage to shield himself from the world."[13] The evidence of friends and relations suggests that his vision, although impaired, never prevented him from drawing or working in pastel; and although dating of Degas's sculptures is always problematic, it is clear that his beginning to work in three dimensions predated any serious deterioration in his sight and that modeling was an adjunct to painting and drawing, not a substitute. François Thiébault-Sisson, who published his recollections of Degas and his work in 1921, describes the painter as saying:

> I modeled animals and people in wax for my own satisfaction, not to take a
> rest from painting or drawing, but to give more expression, more spirit, and
> more life to my paintings and drawings. They are exercises to get me started.[14]

Although Degas spoke fairly often about having his sculpture cast, which implies that he intended it to be permanent and most probably exhibited, ample evidence exists that he regarded modeling in wax as a private activity, something that he did, as he claimed, for "his own satisfaction." His indifference to technical requirements supports the assumption that he was more engaged by process than by result as does Thiébault-Sisson's memoir. He quotes Degas as telling him:

> My sculptures will never give that impression of completion that is the ultimate
> goal of the statue-maker's trade, and since, after all, no one will ever see these
> efforts, no one should think of speaking about them, not even you. After my
> death, all that will fall apart by itself, and that will be better for my reputation.[15]

There is no doubt that Degas's *ad hoc* studio practice — using cork and paper to extend forms, mixing wax and clay, employing flexible armatures that sagged under the weight of the wax — and his (perhaps cultivated) ignorance of basic sculpture technique contributed to the deterioration of his work, even during his lifetime; but it also afforded him enormous freedom.[16] Thinking of himself as a painter, hence unconstrained by sculptural conventions, was also liberating. Henri Matisse offers a parallel. Like Degas, he saw himself primarily as a painter and was similarly unschooled as a sculptor; his sculpture, too, was at least partly inspired by an effort to intensify his painting and drawing, but the result is a rethinking of the possibilities of figuration in three dimensions. Like Degas's sculpture, Matisse's is at once authoritative and maladroit, fiercely intelligent and awkward, and among the most challenging, and original, of the twentieth century.

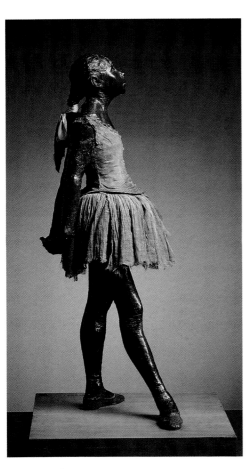

Little Dancer of Fourteen Years,
1878-81
Courtesy Museu de Arte de
São Paulo Assis Chateaubriand,
São Paulo, Brazil

Degas's sculptures, at first, seem eminently tactile. Their worked surfaces retain the memory of both the artist's hand and the malleable stuff from which they were fashioned. They are sturdy, physically insistent, yet longer acquaintance suggests that they are not so much about form as about implied movement. Degas seems to have worked from the center of the sculpture outward, coaxing limbs and head into space from a centralized mass, indifferent to practical necessities of support or conventional notions of the harmonious transfer of weight.[17] The figures seem unstable, especially the dancers (e.g., exh. no. 79), who, poised for the most part in Muybridge-like attitudes of transition, are neither in the alert stance of preparation nor the triumphant achievement of a fully extended *arabesque* or *développé*; rather, they exist in casual "in-between" movements that distill into a single body the disorder of the classroom or the rehearsal, which Degas explored so thoroughly on canvas and paper. The bathers, too, are caught in moments of no importance, chosen apparently at random from an infinity of gestures and motions. They reach behind, arch forward, lean to the side, raise a leg to sponge it or wipe it dry. Yet these "incomplete" postures contain both the memory of the activity's beginning and the promise of its completion.[18]

This sense of imminence is part of what makes Degas's sculpture modern and original. It separates him from "the statue-makers" whom he held in contempt and also from his contemporary, Auguste Rodin, despite their shared distaste for academic conventions. Degas's sculpture is essentially realist in intent — although not naturalistic — with none of the overarticulation or dramatic heightening of the relationship of part to part so characteristic of Rodin's work. Degas's "sculptural realism" manifests itself most extremely in a work that at once sums up his concerns and is largely atypical: *Little Dancer of Fourteen Years* (exh. no. 59). When it was first exhibited as a wax, in 1881, it created a scandal; its fleshy tones, beribboned wig, and fabric costume prompted critics to see the sculpture as a monstrous doll and to deplore the "vicious" expression of the model.[19] The sculpture remains startling, even transgressive, today because of its astonishing tensions between its unusual literalness and its distinctly unliteral smaller-than-life size, between the "artfulness" of the bronze and the fact of the tarlatan skirt and silk hair ribbon, tensions that are echoed in its taut, restless pose. The model's broad, sharp-nosed face is the least of it.

The "real" inclusions that still demand attention in *Little Dancer* are by no means unique. Degas "dressed" some of his sculpted jockeys, turned an inkwell into a tub in *Woman Washing Her Left Leg* (exh. no. 11), and rendered towels, chairs, and even a *chaise longue* as props for his agile bathers. The seated nudes, emerging, like Michelangelo's bound slaves, from their massive, blocky armchairs, undoubtedly influenced Gaston Lachaise's 1924 *Woman in a Chair;* but the most provocative of Degas's "realist" sculptures is his study of a woman bathing, *The Tub* (exh. no. 2). At once weighty, inert, and lively, the sculpture is compellingly horizontal, spreading in a fashion that prefigures twentieth-century works that sprawl across the viewer's space instead of remaining confined to a pedestal. Seen from above, the nude subsides into the flat plane of the water; but from the side, the compressed figure, with its folded legs, reads as anything but relaxed, straining against the shallow horizontals of the tub and cloth-draped base. The idea of rendering water in sculpture is arresting enough, but like *Little Dancer, The Tub* originally depended on contrasting materials for heightened effect — reddish wax for the figure, white plaster for the water, and a real sponge in the bather's hand; even homogenized by casting, the sculpture retains its powerful originality.

The subject matter of Degas's sculptures is identical to that of his paintings, pastels, drawings, and monotypes, but a first impression is of radical difference. On paper and canvas Degas emphasized contour and interval; the placement of elements — figures, horses, furniture — is crucial and clearly responsive to the two-dimensional givens of the support. The pull of the vertical-horizontal axes of canvas and paper, like the implied pressure of its flat surface, seems to thrust forms towards us. In the late pastels, especially, Degas's audacious cropping reduces fleshy bodies to nearly abstract masses. The physicality of their surfaces, their repetitive stroking, and their dry, crumbly texture further emphasize the flat expanse of the paper and all but dissolve the bulky forms of the nude bodies. Only Degas's monotypes, constructed of bold swipes of black and white, seem to spring from the same impulse as the modeled figures and horses. The women in the monotypes (e.g., exh. no. 22) are more massive than their sisters in pastel; flattened into the shallow space of the paper, they are monumental, weighty, like miniature relief sculptures. Perhaps this likeness between monotype and sculpture has to do with the technique of monotype itself, a process of wiping away to pull lights out of surrounding darkness that be seen as an equivalent for modeling.[20]

The rough surfaces of Degas's waxes, faithfully recorded in the bronzes, can be read as equivalents for the disjunctive touch of "typical" Impressionist painting, the increasingly visual instability most notable in Monet's late work. In his *Nymphéas,* for example, in which the nominal subject is that most elusive of phenomena, the reflection, the surface of the canvas is made congruent with the reflective, insubstantial surface of the water, while the wholly intangible subject is translated into streaks and stutters of discontinuous color. To some extent, the insistent stroking of Degas's pastels simply creates tension between the fiction of depicting a robust body and the fact of depositing a crumbly material on a flat surface. The surfaces of his sculptures have a different effect. Bearing witness to the presence of the artist's hand, they

remind us of how wax was pinched, pulled, and added onto. Rather than disembodying form, these inflections affirm the material presentness of the sculptures, unlike, for example, the blurred surfaces and softened contours of Medardo Rosso's heads and busts, works regarded as paradigms of Impressionist sculpture, which nevertheless remain essentially nonsculptural. For all their inventiveness, Rosso's elusive images depend on the transposition of painting practice into three dimensions; they remain pictorial, insubstantial rather than volumetric. Degas's figures, tracing their unstable trajectories through space, are aggressively sculptural, conceived as masses laboriously coaxed into being.

The daring cropping of the late pastels, which fragments the figure in a way that seems antithetical to the sculptural "wholeness" of the modeled nudes, proves, paradoxically, to assert their kinship. The cropped images suggest that the figure extends beyond the confines of the support, even beyond the field of vision of the viewer, so that the bathers in the late pastels seem rapidly glimpsed, caught unawares, like the mobile modeled dancers, galloping horses, and unselfconscious nudes, who are also caught in their transitional, pregnant poses, in their "in-between" postures. The unexpectedness of Degas's viewpoint, like the incompleteness of the sculpted poses, dislocates the viewer, including, perhaps, the artist himself, as, in Michael Fried's phrase, the "first beholder" of his work,[21] a dislocation that enforces both the accuracy of Degas's vision and the distance travelled from literalness.

The unposed quality and startling intimacy of the nudes have led critics to describe them as "seen through a keyhole,"[22] but the suggestion contained within this phrase — of the artist as voyeur — is a distortion. Degas's gaze is dispassionate, albeit deeply engaged, with none of the (often disguised) prurience of the neoclassical and romantic painters he admired, certainly with none of the deliberate effort to titillate of Gustave Courbet. The ballet girls and models who posed for Degas may have belonged to a class of available women (at that time), but they are not displayed for delectation. Formal considerations of edge, interval, color relationships, surface, and all the rest of it, subsume issues of specific content. The undeniable intensity of these works has to do with aesthetic, not bodily, issues. If anything, the seen-through-a-keyhole conceit suggests Degas's legendary shyness. It implies an effort to be invisible, to see, while making art, but not to be seen.

For Degas, as for his Impressionist colleagues, seeing was not merely passive observation but an active assertion of will, a distinction drawn by Robert L. Herbert in his insightful discussion of the role of the *flâneur* in Degas's Paris.[23] Not simply an idler on the boulevards, the *flâneur* bore witness to the public spectacle of daily life in the city, the spectacle that formed such a large part of the Impressionists' — and certainly Degas's — subject matter. Public spectacle — the theater, the dance, the life of the streets, the cafés, and the racetrack — implies that being seen, like seeing, is an active state based on reciprocity with the viewer. Degas's portraits are ambiguous: the apparent introspection of the sitter suggests unawareness of the artist's presence even though we know that the portraits were posed, that the subject made himself available to

the artist's gaze and was carefully studied. Degas's images of private spectacles — the workplace, the rehearsal, the boudoir — are doubly ambiguous because they imply the presence of an unobserved observer who has assured himself of the complicity of his models.

The transparency of means in Degas's work (particularly in his later work) can be seen as an equivalent of the explicit act of seeing on which his paintings and sculptures depend. At the same time, the dry texture of the pastels, the fraying line of the drawings, the tactile surfaces and pulled-out forms of the sculptures bear vivid witness to the action of the artist's hand driven by the processes of intellect and intuition, by calling the viewer's attention to "how" as much as to "what." Pigment, chalk, and bronze remain pigment, chalk, and bronze, never transubstantiating themselves into illusionistic textures. (This is part of why the real hair ribbon and tarlatan tutu of *Little Dancer of Fourteen Years* are so shocking.)

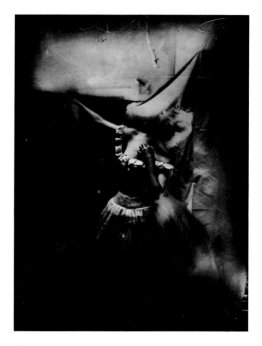

Edgar Degas
Dancer of the Corps de Ballet,
c. 1896
Modern print from the
original collodian plates.
Courtesy Bibliothèque
Nationale, Paris

None of this seeming contradictoriness is unique to Degas, of course, but rather, it distinguishes modernism itself; such paradoxical manifestations in the most inventive art of the nineteenth century help to define it as modernist. In Degas's work, however, the forthrightness of his technique and the materiality of, especially, his later work, create a further contradiction in our perception of his art. A fundamental assumption about painting, as Michael Fried has stated, is that it is made to be beheld. The painter becomes the painting's first beholder, seeing the work as it is made, as it reveals itself to the eye. The presence of visible traces of the artist's role as maker could be interpreted as offering later viewers an intimate sense of the painting's evolution, one that allows them to participate mentally in both the act of seeing and of reinventing what has been seen. Yet the modernist emphasis on the "how" of painting substitutes autonomy for depiction, rendering the modernist picture materially very present but, at the same time, to a greater or lesser degree, disembodied and distanced from whatever provoked it — in other words, more or less abstract. Sculpture, especially modeled sculpture, reveals itself to touch as well as to the eye, although it is not usually intended to be touched by anyone other than its maker (and first beholder). The tactile is translated into the visual, but no matter how insubstantial sculpture is, how much it addresses the eye instead of the hand, it is by its very nature unequivocally *there,* factually real.

Degas's sculpture, almost without exception, was made wholly for the sculptor himself, for the artist as "toucher-beholder." The great majority of Degas's works in three dimensions were never revealed to the eye of a nonmaker, a "pure" viewer, during his lifetime. They existed principally as unseen objects dependent on the hand as much as the eye, embodiments of the artist's thought and touch. Could we say, then, that Degas's modeled figures are at once among the most abstract and the most physical sculptures in the history of modernism?

New York, N.Y., October 1993

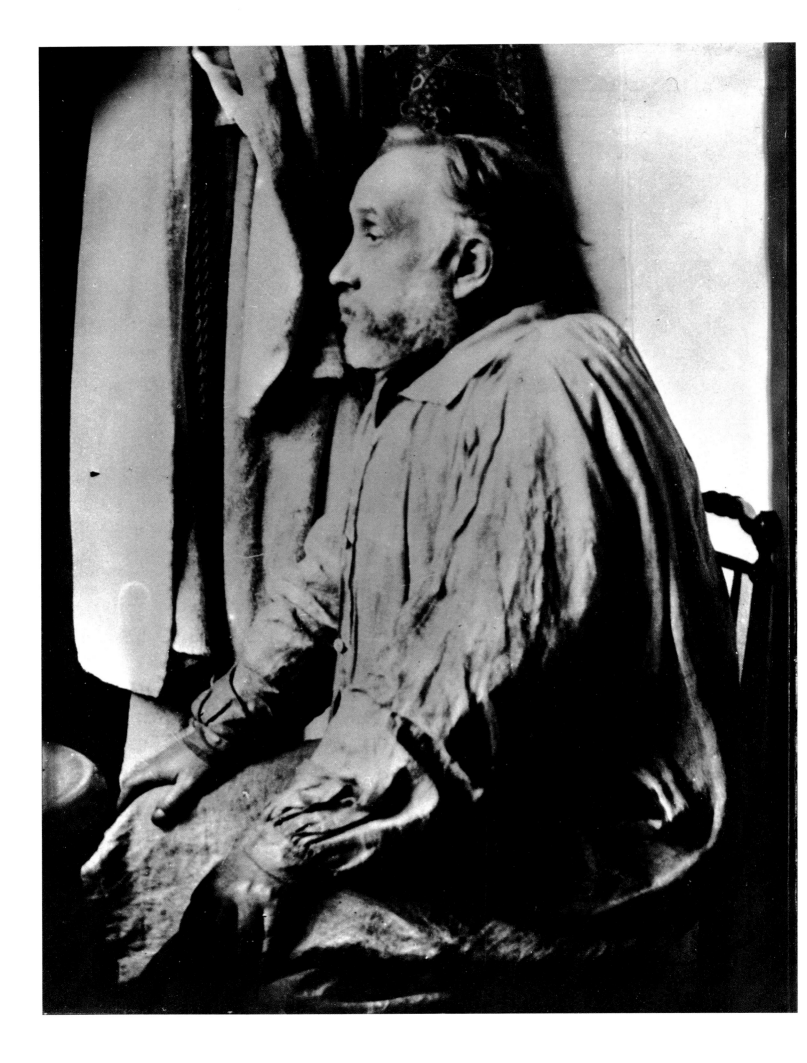

1 Charles F. Stuckey, "Degas, artiste: sans cesse corriger et jamais achever," in *Degas: le modelé et l'espace,* exhibition catalogue (Paris: Marais-Guillard Editions, 1984), 13.

2 Ambroise Vollard, *Degas, An Intimate Portrait,* trans. Randolph T. Weaver (New York: Dover Publications, 1986), passim.

3 Michel Georges-Michel, *From Renoir to Picasso, Artists in Action,* trans. Dorothy and Randolph Weaver (Boston: Houghton Mifflin Co., 1957), 11.

4 For a full discussion of Degas and the Dreyfus affair, see Linda Nochlin, "Degas and the Dreyfus Affair: A Portrait of the Artist as an Anti-Semite," in *The Dreyfus Affair: Art, Truth and Justice,* ed. Norman L. Kleeblatt, exhibition catalogue (Berkeley, Los Angeles, and London: University of California Press and the Jewish Museum, New York, 1987).

5 Vollard, *Degas,* 89.

6 Charles W. Millard, *The Sculpture of Edgar Degas* (Princeton, N.J.: Princeton University Press, 1976), 36.

7 For a detailed discussion of Degas's technique and a history of the exhibition and casting of Degas's sculpture, see Millard, "Exhibition, Casting, and Technique" in *The Sculpture of Edgar Degas.* Millard provides the most reliable general chronology of Degas's sculpture, based on the assumption of "development from less to more movemented poses" (p. 23). See also Gary Tinterow, "A Note on Degas's Bronzes," in Jean Sutherland Boggs, ed., *Degas,* exhibition catalogue (New York: Metropolitan Museum of Art; Ottawa: National Gallery of Canada, 1988), which amends Millard's dating slightly. Both Millard and Tinterow supersede the chronology of John Rewald, *Degas: Sculpture* (New York: Harry N. Abrams, Inc., 1956).

8 Richard Goode, *Stagebill* program notes for Carnegie Hall concerts, New York, July 14 and 15, 1993.

9 Theodore Reff, *Degas, The Artist's Mind* (Cambridge, Mass., and London: Belknap Press of Harvard University Press, 1987), 39.

10 Reff, *Degas,* 39.

11 I am indebted to conversations with Michael Fried for the phrases "realism of the body" and "realism of the eye," concepts that he develops fully in his forthcoming book on Edouard Manet.

12 For a detailed discussion of Degas's interest in photographic motion experiments, see Millard, *The Sculpture of Edgar Degas,* 20–23.

13 Millard, *The Sculpture of Edgar Degas,* 69 n. 19.

14 François Thiébault-Sisson, "Degas sculpteur, raconté par lui-même," in *Degas: le modelé et l'espace,* 179.

15 Thiébault-Sisson, "Degas sculpteur," 179.

16 See Millard, "Exhibition, Casting, and Technique," passim.

17 See William Tucker, "Gravity," in *The Language of Sculpture* (London: Thames and Hudson, Ltd., 1974).

18 I am indebted to William Edward O'Reilly for the development of ideas about the effect of "incompleteness" in Degas's sculptures.

19 See Millard, "Appendix: Critical Reaction to the Exhibition of the Little Dancer in 1881," and entries 222–27 (pp. 342–52) in Boggs, ed., *Degas.*

20 The British sculptor Tim Scott has written perceptively about the sculptural quality of Degas's monotypes in an unpublished article of November 1988.

21 The concept of the "painter-beholder," fundamental to Fried's criticism, is most fully developed in his writings on Courbet, notably in *Courbet's Realism* (Chicago and London: University of Chicago Press, 1990).

22 Stuckey, "Degas, artiste," 13.

23 Robert L. Herbert, "Impressionism and Naturalism," in *Impressionism: Art, Leisure, and Parisian Society* (New Haven: Yale University Press, 1988), passim.

Attributed to Bartholomé
Edgar Degas in His Studio,
Rue Victor-Massé, c. 1898
Courtesy Bibliothèque
Nationale, Paris

Explanatory Notes

After Degas's death in 1917, a large number of wax and clay sculptures, many in extremely fragile condition, were found in the artist's studio. Of this number, only 72 (excluding the *Little Dancer of Fourteen Years*) were felt to be in a condition suitable for casting in bronze. Degas's heirs entrusted the job to A.A. Hébrard et Compagnie. Foreman Albino Palazzolo headed the project which probably began soon after his return from Italy to Paris in 1918. Palazzolo first strengthened the wax and clay originals from which he produced meticulous duplicates; using these intermediary figures, the bronzes were cast by the lost wax (*cire perdue*) method. Production of the bronzes may have begun in 1919 and the entire project was probably not completed until 1932. A complete set of 73 bronzes was first exhibited in 1921 at Hébrard's gallery in Paris.

According to Hébrard, a set of 22 casts was made from each of the 72 wax and clay original sculptures. Each piece was stamped "Cire perdue A.A. Hébrard", incised with "Degas" and numbered from 1 to 72. Each of 20 sets was assigned a letter from A through T and were intended for sale on the open market. Of the final two complete sets, one was kept by Hébrard and the other went to Degas's heirs. The inscriptions HER (*héritier*, heir) and HERD (*héritier Degas*, Degas's heir) used on pieces intended for the foundry and the Degas family are confused.

The 73rd work to be cast was *The Little Dancer of Fourteen Years*, the only sculpture which Degas ever publically exhibited. There is some confusion about the number of casts made of this work; numbers range from 22 to 25. Each casting was dressed similar to the original Degas plaster and wax sculpture.

The 74th sculpture, *The Schoolgirl* was originally produced out-of-series for the Degas family in a small edition of about 5. After the original wax sculpture was purchased by Knoedler & Co. in New York in 1956, an edition of 20 bronzes was produced by Hébrard at Knoedler's request, 2 of which were unnumbered and the rest numbered "3 - 20" to correspond with the earlier Hébrard series.

Selected Bibliography

Boggs, Jean Sutherland, editor. *Degas*, exhibition catalogue. New York and Ottawa: Metropolitan Museum of Art and National Gallery of Canada, 1988.

Kleeblatt, Norman L., editor. *The Dreyfus Affair: Art, Truth and Justice*, exhibition catalogue. Berkeley, Los Angeles and London: University of California Press and the Jewish Museum, N.Y., 1987.

Georges-Michel, Michel. *From Renoir to Picasso, Artists and Action*, translated by Dorothy and Randolph Weaver. Boston: Houghton Mifflin Co., 1957.

Herbert, Robert L. *Impressionism: Art, Leisure, and Parisian Society*, New Haven: Yale University Press, 1988.

Millard, Charles W. *The Sculpture of Edgar Degas*. Princeton, N.J.: Princeton University Press, 1976.

Reff, Theodore. *Degas, the Artist's Mind*. Cambridge, Mass. and London: The Belknap Press of Harvard University Press, 1987.

Stuckey, Charles F., et al., *Degas: le modelé et l'espace*, exhibition catalogue. Paris: Marais-Guillard Editions, 1984.

Tucker, William. *The Language of Sculpture*. London: Thames and Hudson Ltd., 1974.

Vollard, Ambroise. *Degas, An Intimate Portrait*, translated by Randolph T. Weaver. New York: Dover Publications, 1986.

Catalogues Raisonnés

referenced in the exhibition checklist:

Adhémar Jean Adhémar and Françoise Cachin, *Edgar Degas: The Complete Etchings, Lithographs and Monotypes*, (translated by Jane Brenton, foreward by John Rewald), New York: Viking Press, 1974.

Delteil Loys Delteil, *Le Peintre-graveur illustré*, vol. 9, Paris: printed privately, 1919.

Janis Eugenia Parry Janis, *Degas Monotypes*, Cambridge, Mass.: Fogg Art Museum, 1968.

R & S Sue Welsh Reed and Barbara Stern Shapiro, *Edgar Degas: The Painter as Printmaker*, Boston: Museum of Fine Arts, 1984.

Rewald John Rewald, *Degas: Sculpture*, New York: Abrams, 1956.

Edgar Degas
Zoe Reading the Newspaper
to Degas, 1895
Gelatin silver print
Collection of the J. Paul Getty
Museum, Malibu, California

Lenders to the Exhibition

The Art Institute of Chicago, Illinois

Ball State University Museum of Art, Muncie, Indiana

Mr. James A. Bergquist, Boston, Massachusetts

The Sterling and Francine Clark Art Institute, Williamstown, Massachusetts

The Cleveland Museum of Art, Ohio

The Dayton Art Institute, Ohio

The Detroit Institute of Arts, Michigan

The Dixon Gallery and Gardens, Memphis, Tennessee

The Fine Arts Museums of San Francisco, California

Mr. H. Peter Findlay, New York, New York

The Hyde Collection, Glens Falls, New York

Los Angeles County Museum of Art, California

Marion Koogler McNay Art Museum, San Antonio, Texas

The Metropolitan Museum of Art, New York, New York

Museum of Fine Arts, Boston, Massachusetts

Museum of Fine Arts, Springfield, Massachusetts

The Nelson-Atkins Museum of Art, Kansas City, Missouri

Princeton University, The Art Museum, Princeton, New Jersey

Private Collector, Buffalo, New York

The Saint Louis Art Museum, Missouri

The Sara Lee Corporation, Chicago, Illinois

Smith College Museum of Art, Northampton, Massachusetts

Yale University Art Gallery, New Haven, Connecticut

Exhibition Key

a Museu de Arte de São Paulo Assis Chateaubriand inventory number
b Shown only at The Dayton Art Institute
c Shown only at the Center for the Fine Arts, Miami
d Shown only at the Center for the Fine Arts, Miami, and the Mississippi Museum of Art, Jackson
e Shown only at the Mississippi Museum of Art, Jackson
f Shown only at The Dayton Art Institute and the Center for the Fine Arts, Miami

33

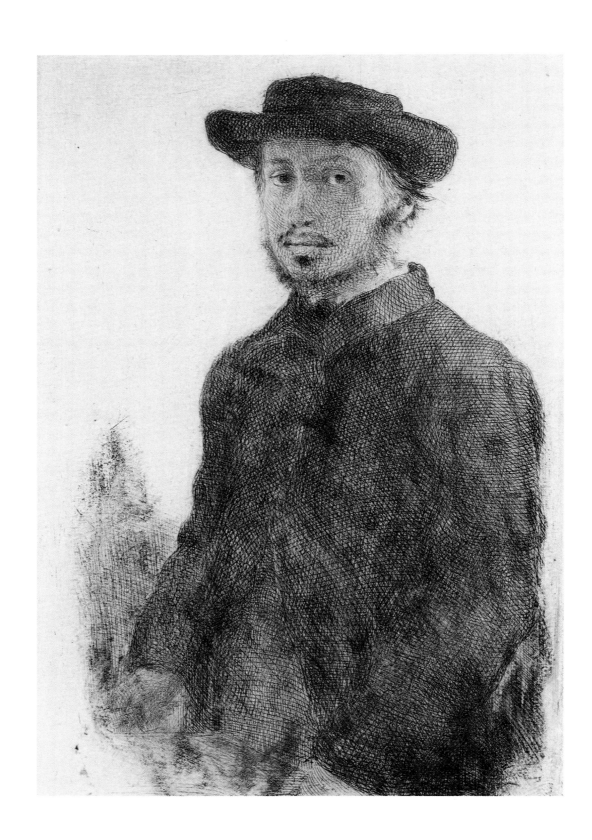

1

Self-Portrait, 1857

Etching, state iv/iv, 9⅟₁₆ x 5¹¹⁄₁₆ in. (plate)

(Delteil 1; Adhémar 13; R & S 8)

Los Angeles County Museum of Art, California

Purchased with funds provided by the Garrett Corporation,

1981, acc. no. M.81.54

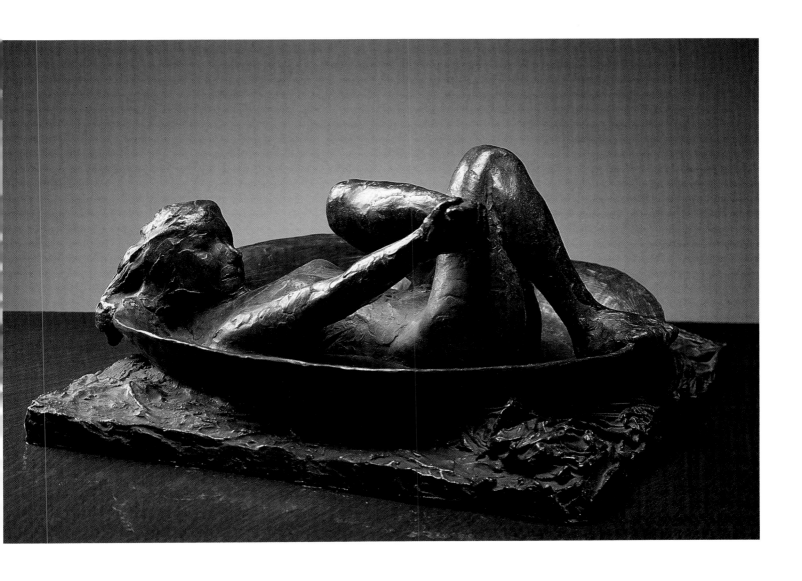

2

The Tub, c. 1886–88

Bronze 18 x 17¼ in.

(Rewald 27; BR.ᵃ S-26)

Museu de Arte de São Paulo Assis Chateaubriand,

São Paulo, Brazil

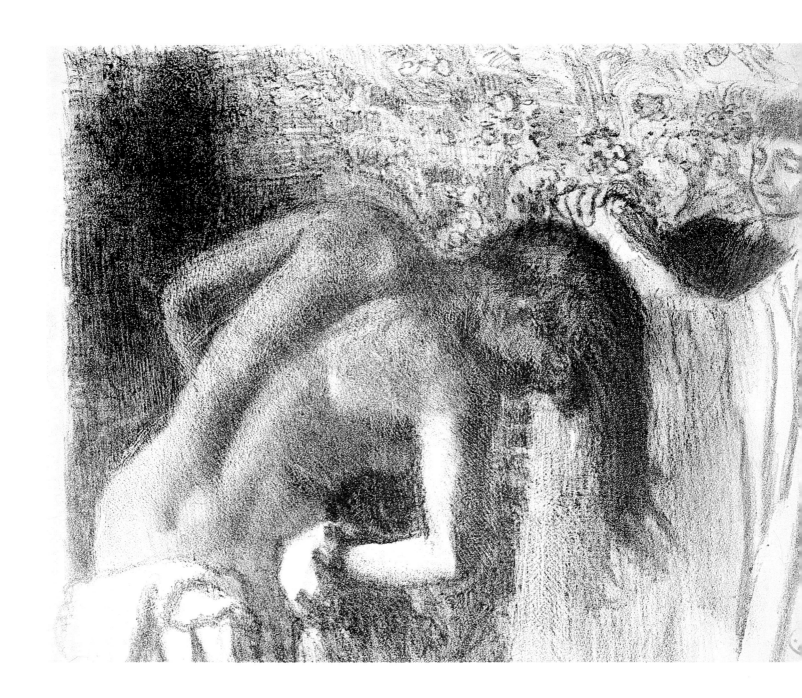

3

After the Bath, 1891–92

Lithograph, transfer, and crayon, on paper; state iv/v;

10¹³⁄₁₆ x 12⅝⁄₁₆ in. (image)

(Delteil 64; Adhémar 68; R & S 66)

Museum of Fine Arts, Boston, Massachusetts

Katherine E. Bullard Fund in memory of Francis Bullard and

proceeds from sale of duplicate prints, acc. no. 1983.312

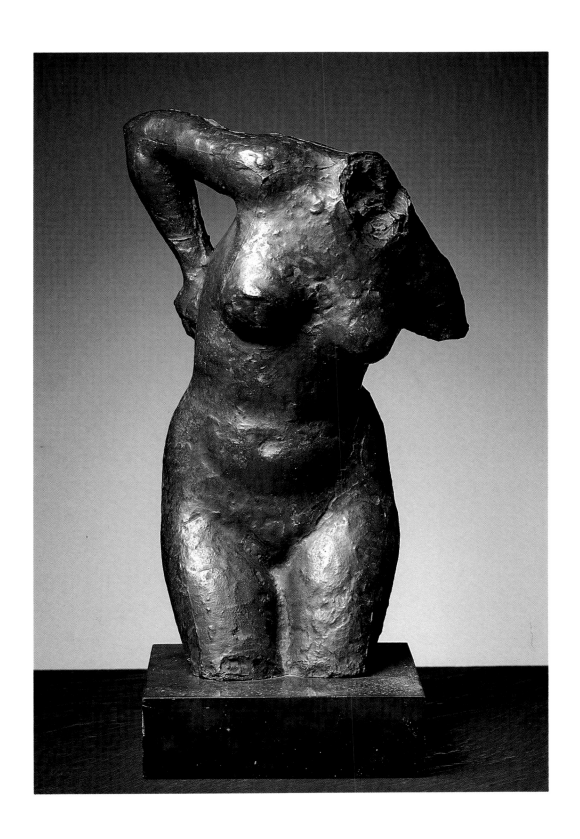

4

Woman Rubbing Her Back with a Sponge,
Torso, c. 1888
Bronze, 19⅛ in. high
(Rewald 51; BR. C-28)
Museu de Arte de São Paulo Assis Chateaubriand,
São Paulo, Brazil

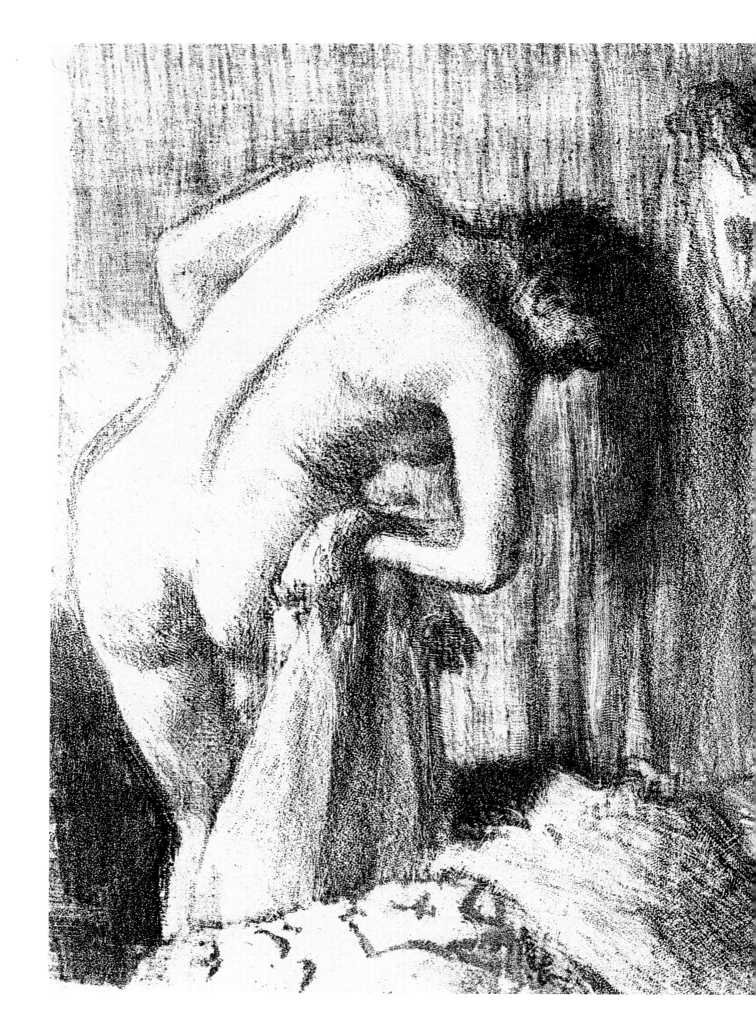

5

After the Bath _(La Sortie du bain)_,[b] 1891–92

Lithograph, state i/ii, 9⅞ x 9⅟₁₆ in. (image)

(Delteil 63; Adhémar 67; R & S 65)

The Marion Koogler McNay Art Museum, San Antonio, Texas

Gift of the Friends of the McNay, acc. no. 1961.11

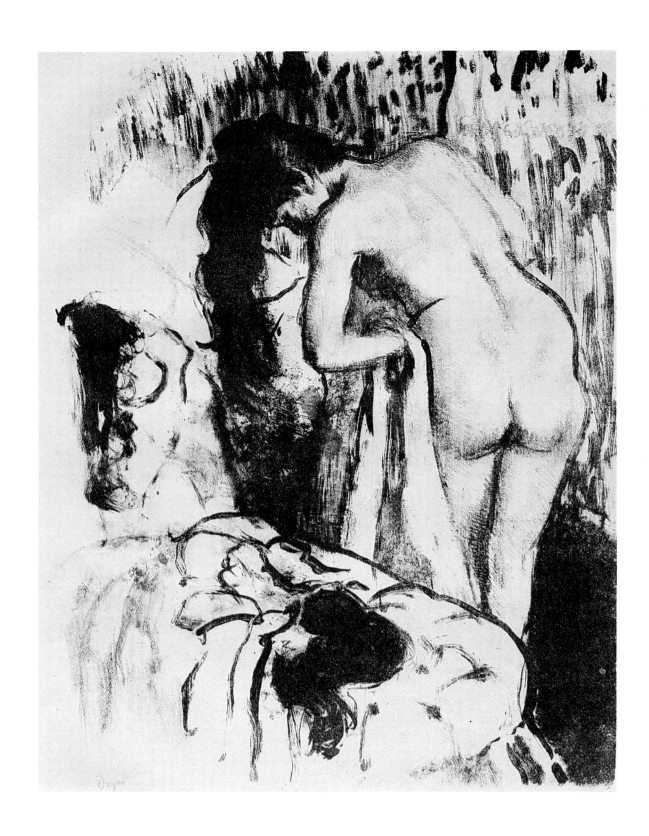

6

Nude Woman Standing, Drying Herself, 1891–92

Lithograph, state iv/vi, 13 x 9¾ in.

(Delteil 65; Adhémar 63; R & S 61)

The Sterling and Francine Clark Art Institute,

Williamstown, Massachusetts, acc. no. 62.032,

acc. no. 1962.38

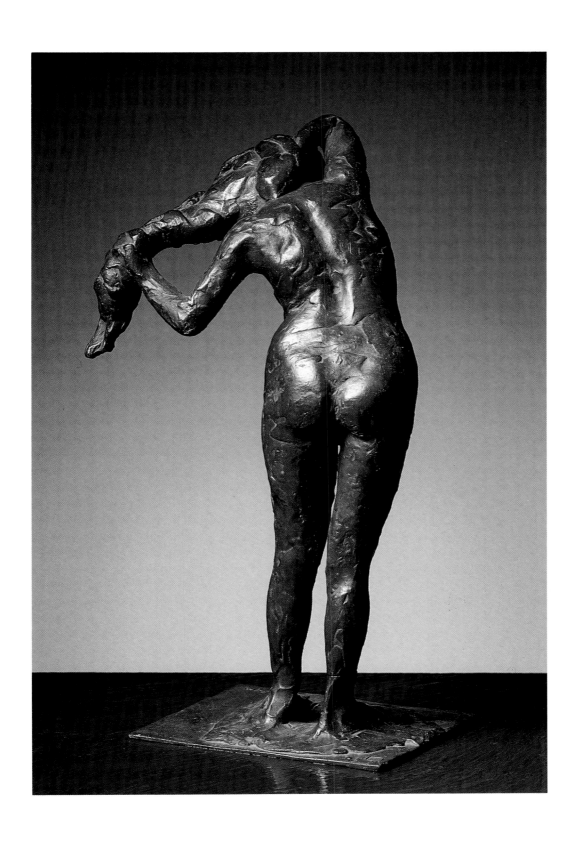

7

Woman Arranging Her Hair, c. 1900–05

Bronze, 18½ in. high

(Rewald 50; BR. S-50)

Museu de Arte de São Paulo Assis Chateaubriand,

São Paulo, Brazil

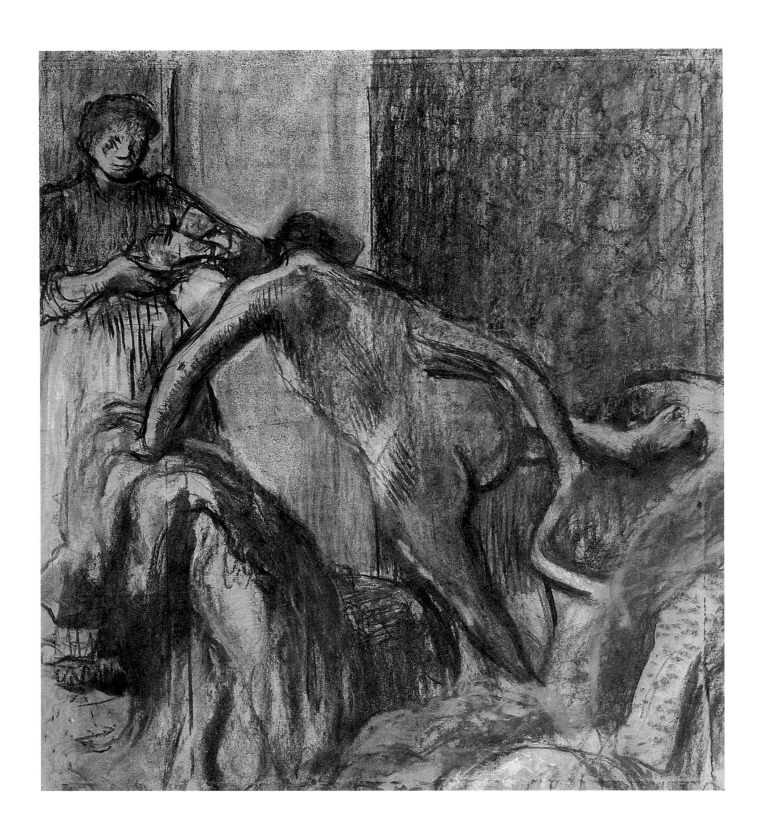

8

After the Bath, c. 1895–98

Pastel on paper, 37 x 33 in.

The Sara Lee Corporation, Chicago, Illinois

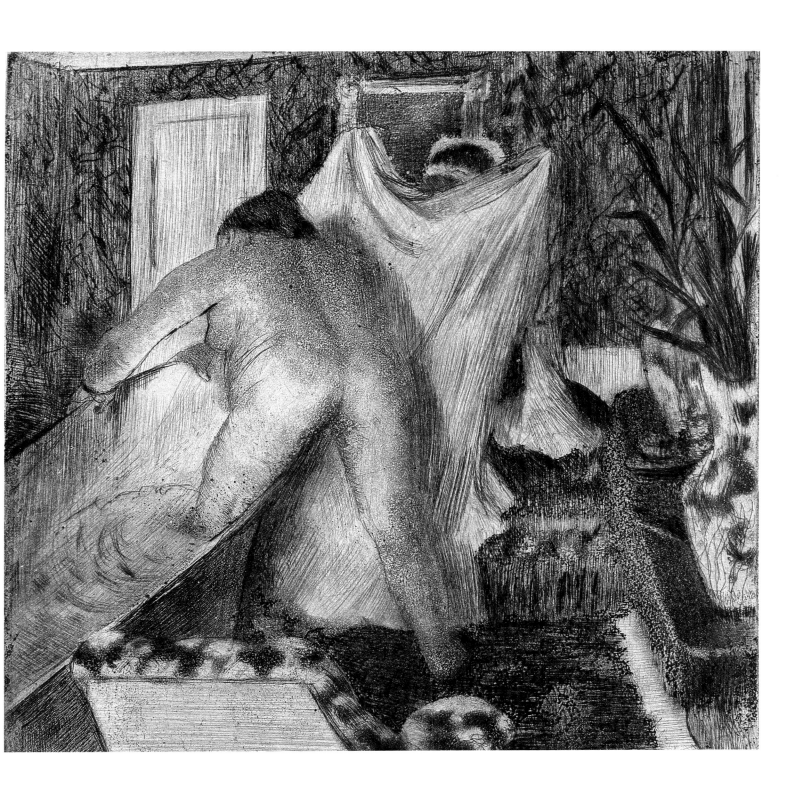

9

Leaving the Bath (*La Sortie du bain*), c. 1879–80

Drypoint and aquatint, printed in black ink on tan wove

paper; state xviii/xxii; 5 x 5 in. (plate)

(Delteil 39; Adhémar 49; R & S 42)

Mr. James A. Bergquist, Boston, Massachusetts

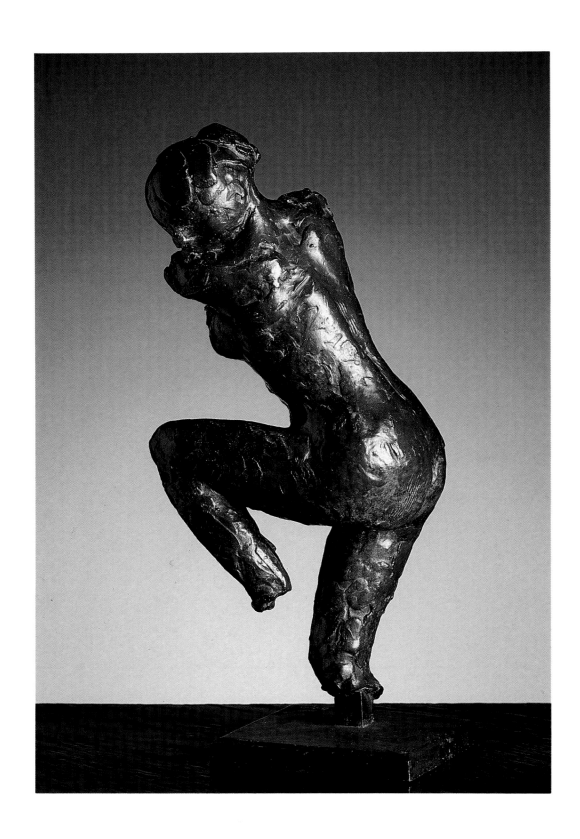

10

Woman Getting out of the Bath (Fragment),

c. 1895–1900

Bronze, 16⅚ in. high

(Rewald 59; BR. S-71)

Museu de Arte de São Paulo Assis Chateaubriand,

São Paulo, Brazil

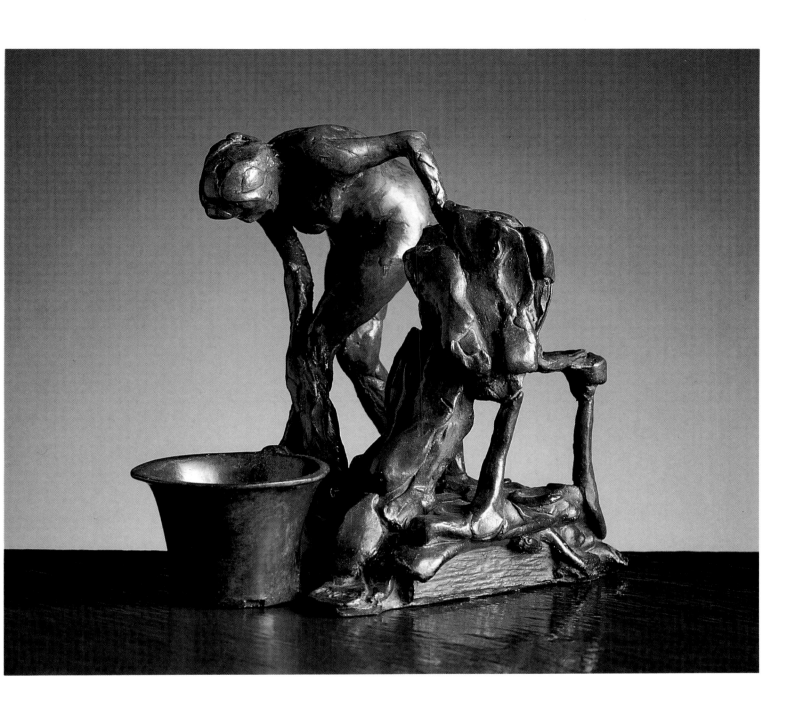

11

Woman Washing Her Left Leg, c. 1900–03

Bronze, 7⅞ in. high

(Rewald 68; BR. S-61)

Museu de Arte de São Paulo Assis Chateaubriand,

São Paulo, Brazil

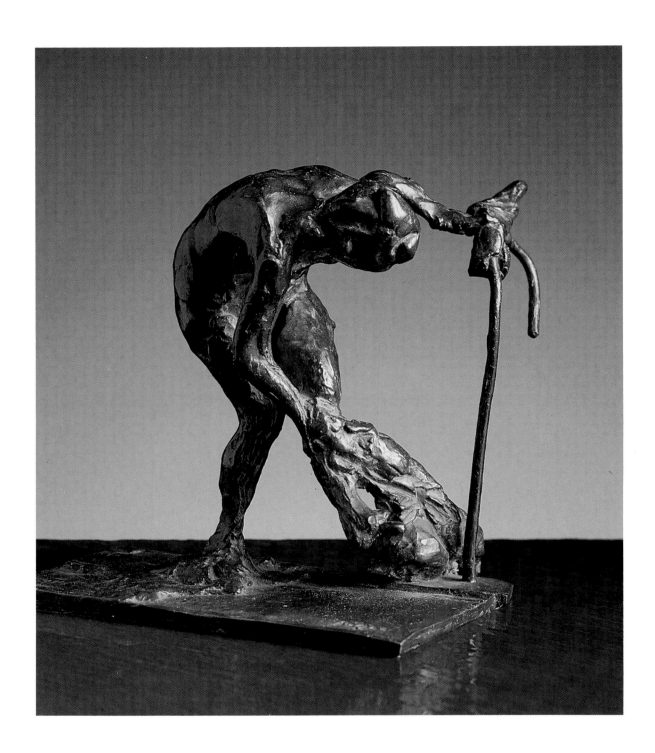

12

Woman Washing Her Left Leg, c. 1900–03

Bronze, 5¹⁵⁄₁₆ in. high

(Rewald 67; BR. S-17)

Museu de Arte de São Paulo Assis Chateaubriand,

São Paulo, Brazil

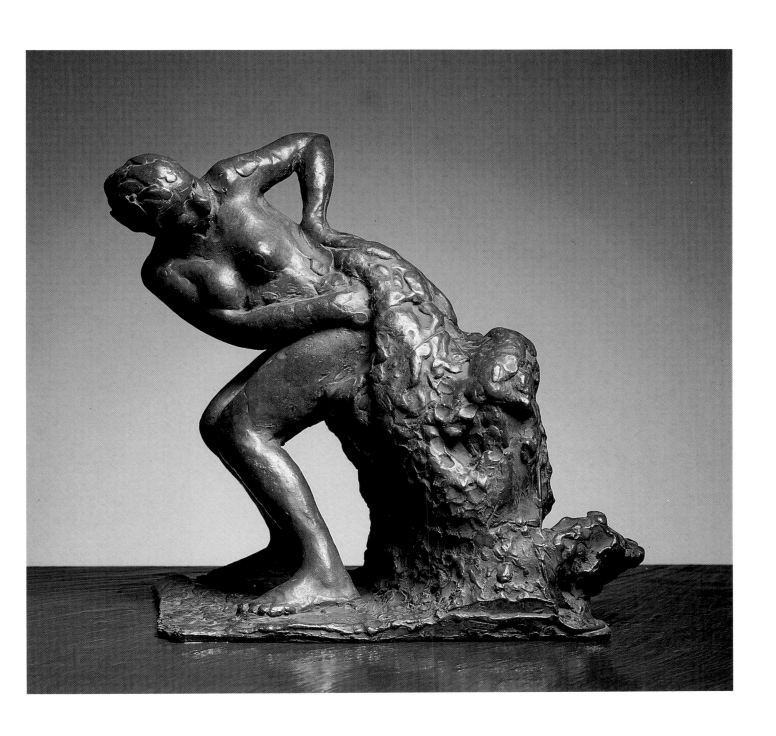

13

Seated Woman Wiping Her Left Side, c. 1900–03

Bronze, 13⅜ in. high

(Rewald 69; BR. S-46)

Museu de Arte de São Paulo Assis Chateaubriand,

São Paulo, Brazil

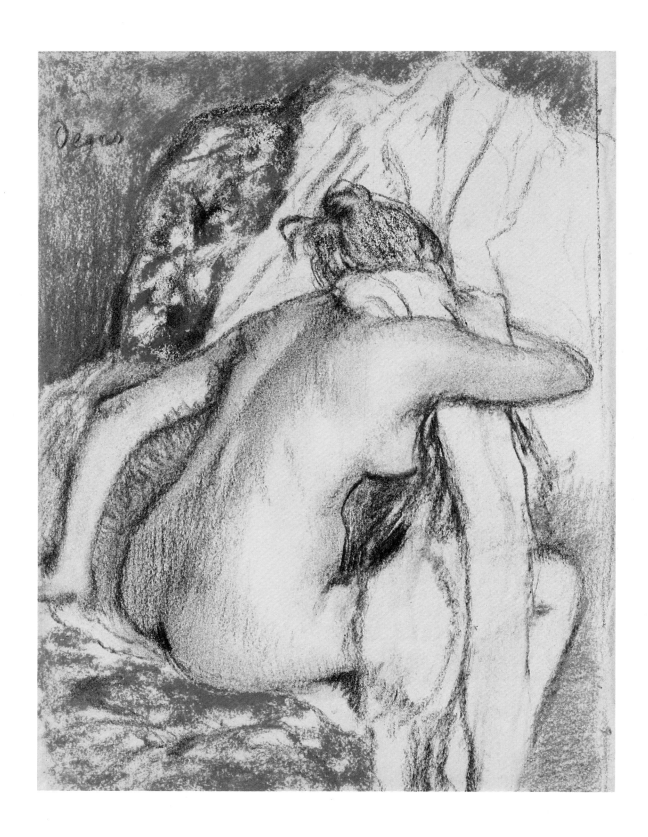

14

After the Bath, Seated Woman Drying Herself,[b]

c. 1885

Charcoal and pastel on paper, 13⅜ x 9¾ in.

The Nelson-Atkins Museum of Art, Kansas City, Missouri

Gift of Mrs. David M. Lighton, acc. no. 35-39/1

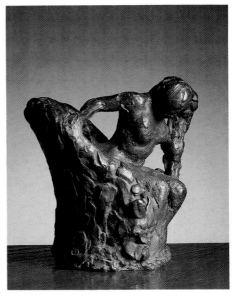

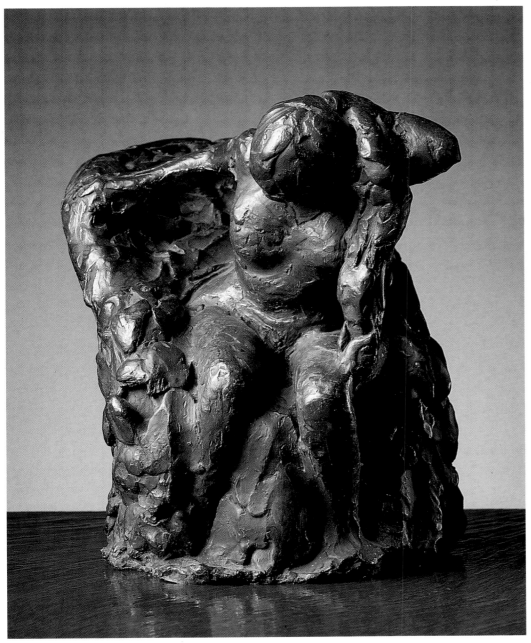

15

**Woman Seated in an Arm-Chair Wiping
Her Neck**, c. 1900–03

Bronze, 12¹³⁄₁₆ in. high

(Rewald 70; BR. S-44)

Museu de Arte de São Paulo Assis Chateaubriand,

São Paulo, Brazil

16

After the Bath, c. 1886

Charcoal and pastel on cream laid paper

with PL BAS watermark, 18 x 23¼ in.

The Dayton Art Institute, Ohio

Gift of Mr. and Mrs. Anthony Haswell, acc. no. 52.33

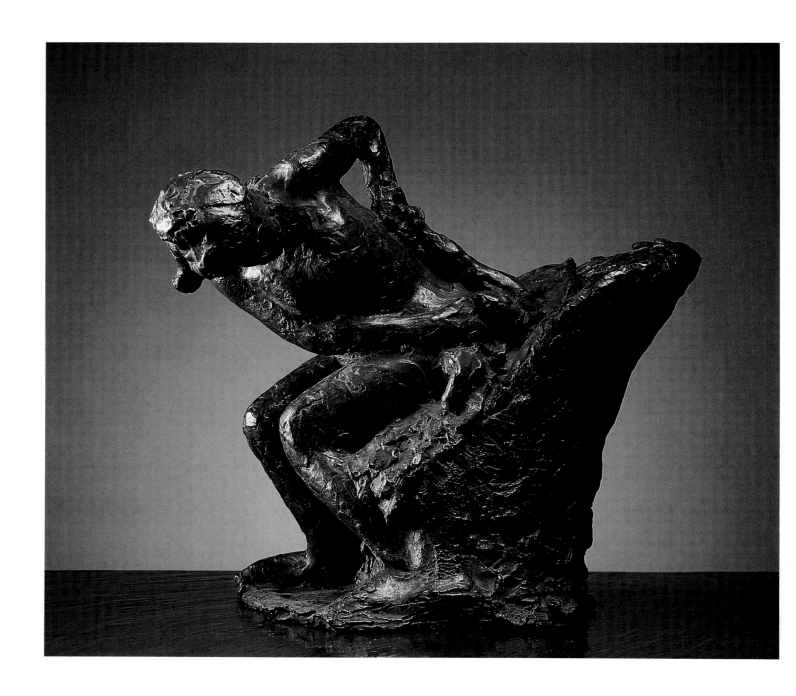

17

Seated Woman Wiping Her Left Hip, c. 1900–03

Bronze, 17⅞ in. high

(Rewald 71; BR. S-54)

Museu de Arte de São Paulo Assis Chateaubriand,

São Paulo, Brazil

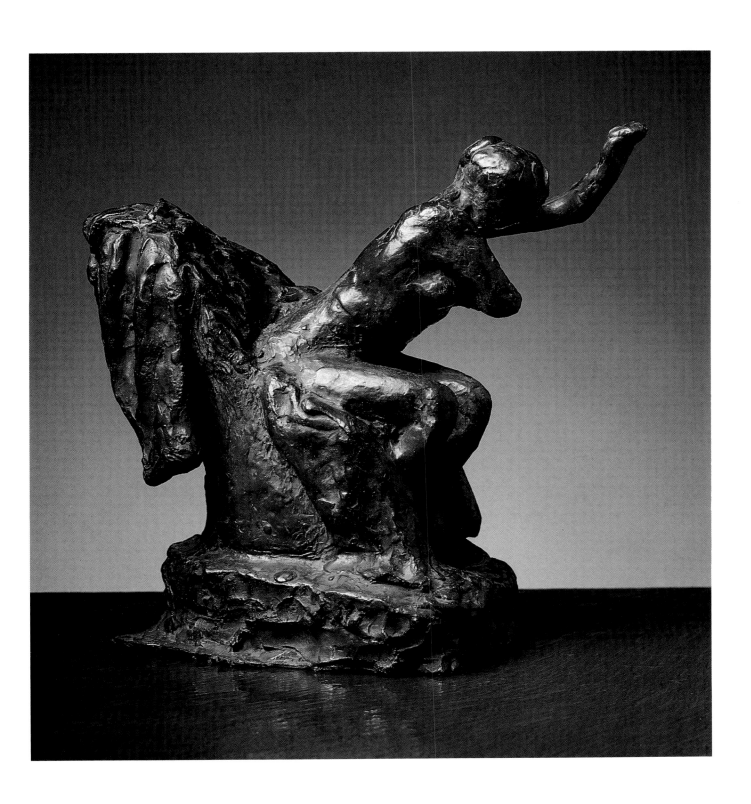

18

Woman Seated in an Arm-Chair Wiping Her Left Armpit, c. 1900–05

Bronze, 12⅜ in. high

(Rewald 72; BR. S-43)

Museu de Arte de São Paulo Assis Chateaubriand,

São Paulo, Brazil

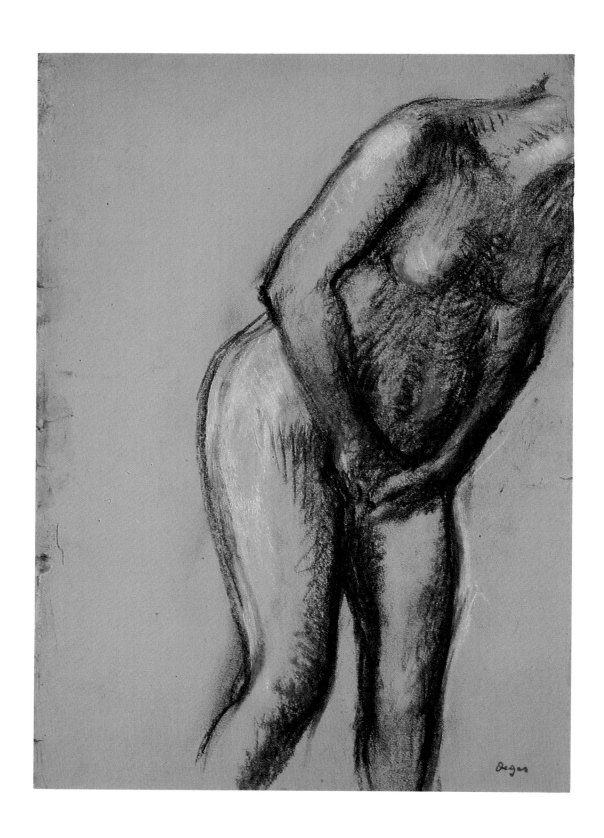

19

Standing Female Nude (Bather), c. 1896

Charcoal and pastel on light blue paper, 18½ x 12⅝ in.

The Art Museum, Princeton University, Princeton, New Jersey

Gift of Frank Jewett Mather, Jr., acc. no. 43-136

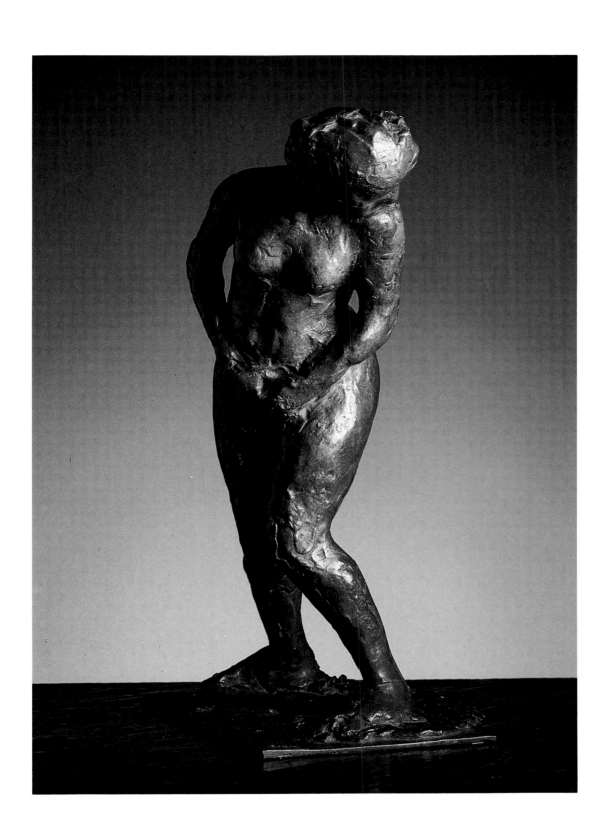

20

Woman Taken Unawares, c. 1896-1899

Bronze, 16⅛ in. high

(Rewald 54; BR. S-42)

Museu de Arte de São Paulo Assis Chateaubriand,

São Paulo, Brazil

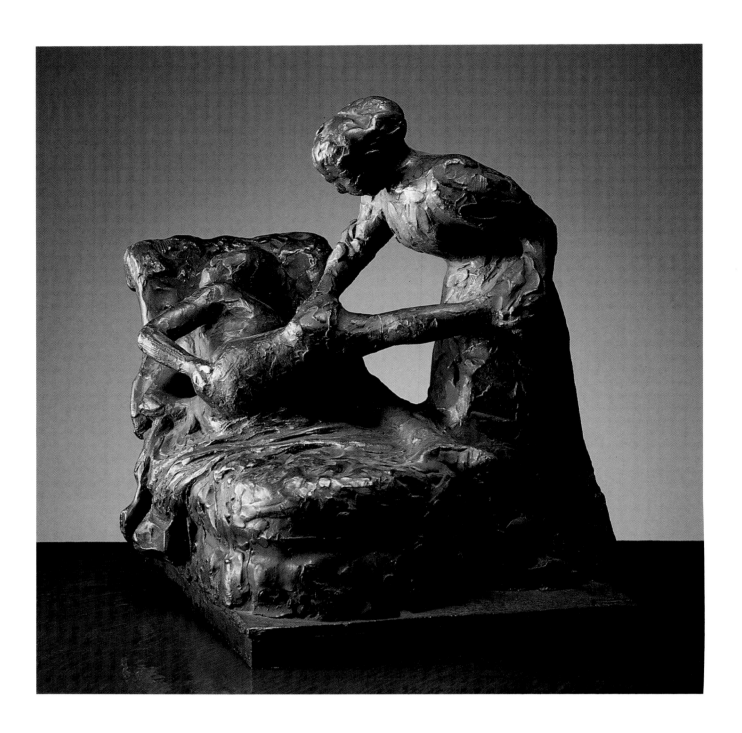

21

The Masseuse, c. 1900–03

Bronze, 16¹⁵⁄₁₆ in. high

(Rewald 73; BR. S-55)

Museu de Arte de São Paulo Assis Chateaubriand,

São Paulo, Brazil

22

Bathers (Les Baigneuses), c. 1875–80

Monotype in black ink on tan laid paper with

partial DAMBRICOURT FRERES watermark, 4¾ x 6¼ in.

(Adhémar 169; Janis 262)

Mr. James A. Bergquist, Boston, Massachusetts

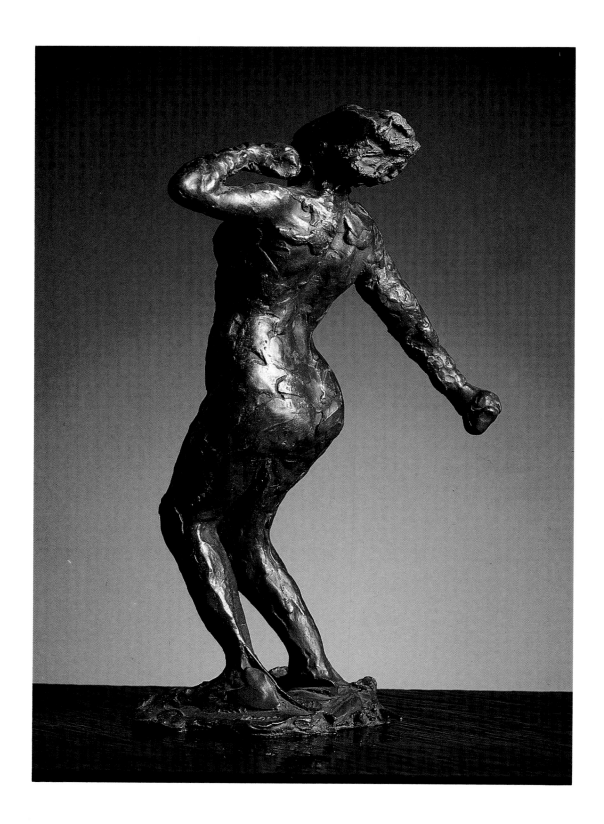

23

Woman Stretching, c. 1895–1900

Bronze, 14⅜ in. high

(Rewald 64; BR. S-53)

Museu de Arte de São Paulo Assis Chateaubriand,

São Paulo, Brazil

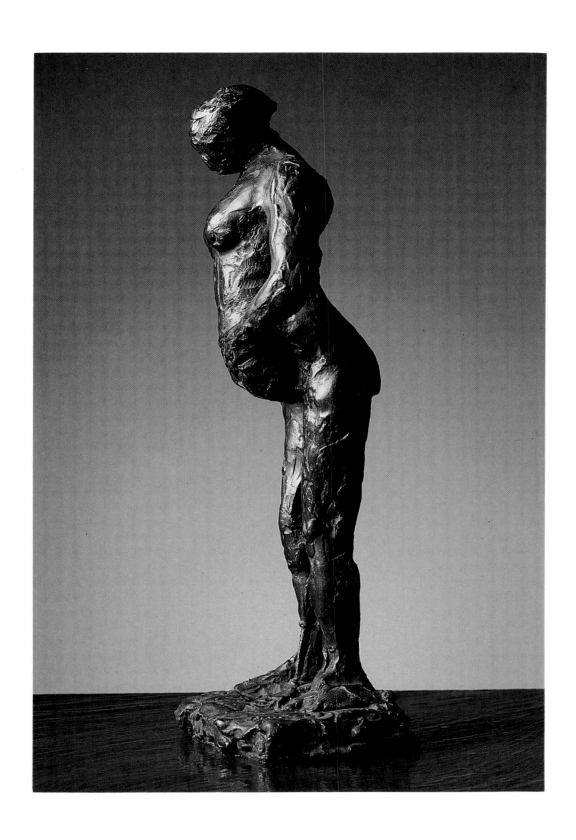

24

Pregnant Woman, c. 1895–1900

Bronze, 17⅜ in. high

(Rewald 63; BR. S-24)

Museu de Arte de São Paulo Assis Chateaubriand,

São Paulo, Brazil

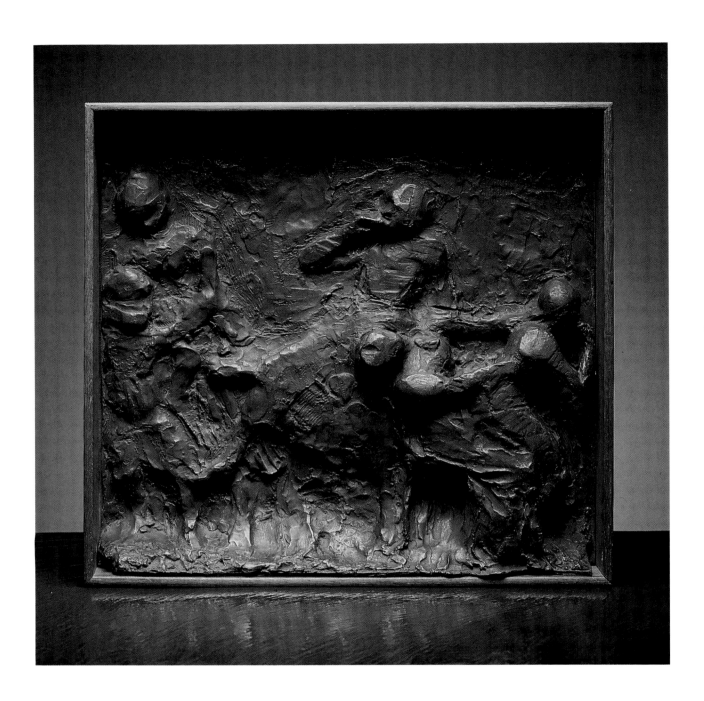

25

Picking Apples, before 1870

Bronze, 19⅛ x 18 in.

(Rewald 1; BR. S-37)

Museu de Arte de São Paulo Assis Chateaubriand,

São Paulo, Brazil

26

Woman Arranging Her Hair,[b] c. 1885

Charcoal and pastel on paper, 23 x 16¹⁵⁄₁₆ in.

The Fine Arts Museums of San Francisco, California

Achenbach Foundation for Graphic Arts

Memorial Gift from Dr. T. Edward and Tullah Hanley,

Bradford, Pennsylvania, acc. no. 69.30.42

27

Head Resting on One Hand, Bust, c. 1879–81

Bronze, 4⅜ in. high

(Rewald 29; BR. S-62)

Museu de Arte de São Paulo Assis Chateaubriand,

São Paulo, Brazil

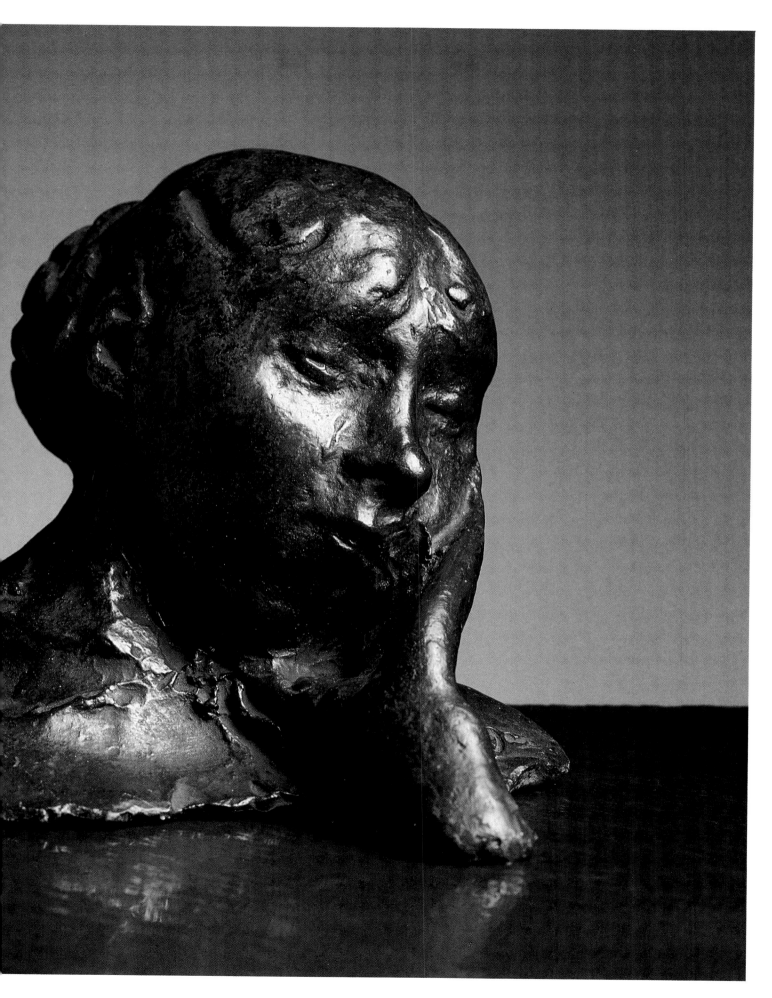

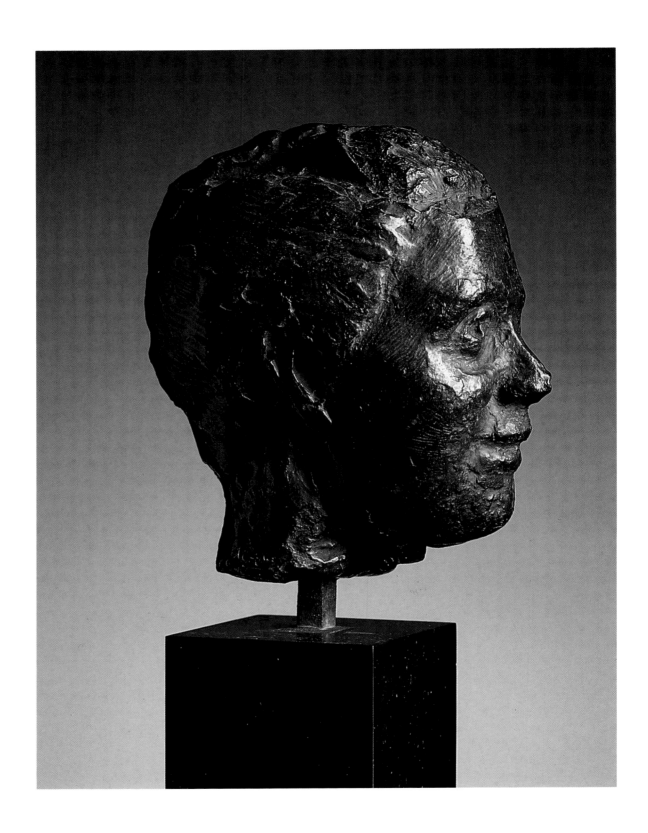

28

Head, Study for the Portrait of Madame S.,

c. 1892

Bronze, 10⅜ in. high (16⅜ in. high with base)

(Rewald 31; BR. S-27)

Museu de Arte de São Paulo Assis Chateaubriand,

São Paulo, Brazil

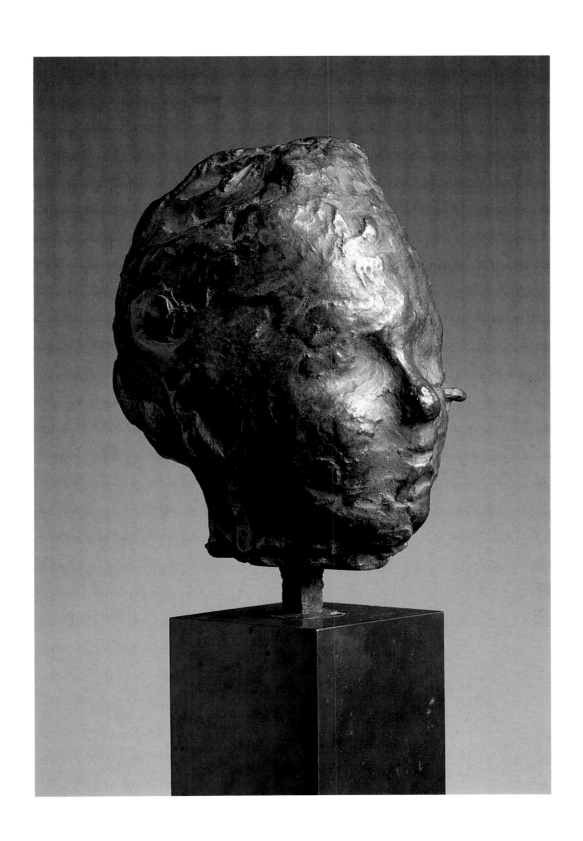

29

Head, Study for the Portrait of Madame S., c. 1892

Bronze, 6⅜ in. high

(Rewald 30; BR. S-7)

Museu de Arte de São Paulo Assis Chateaubriand,

São Paulo, Brazil

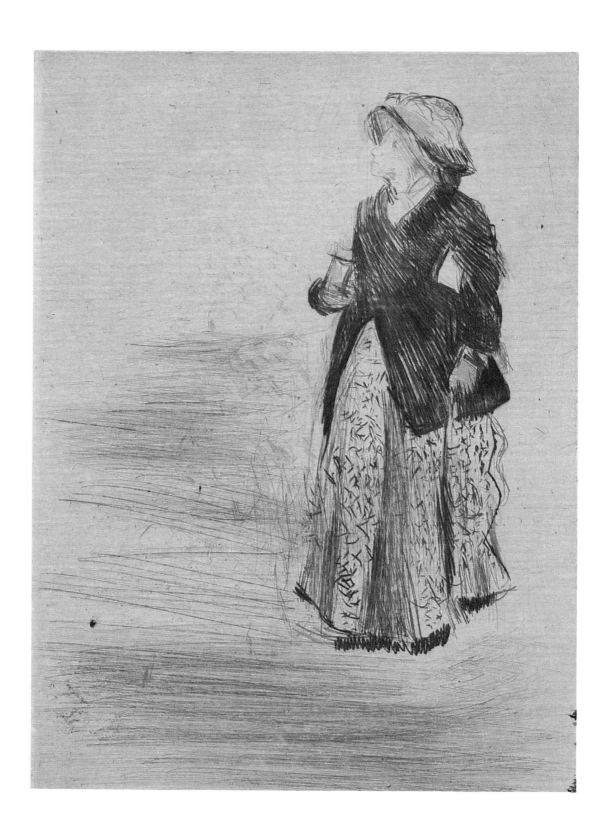

30

The Actress Ellen Andrée, 1879

Drypoint, state iii/iii, 4⁷⁄₁₆ x 3⅛ in. (plate)

(Delteil 20; Adhémar 52; R & S 40)

Museum of Fine Arts, Boston, Massachusetts

Katherine E. Bullard Fund in memory of Francis Bullard and

proceeds from sale of duplicate prints, acc. no. 1983.317

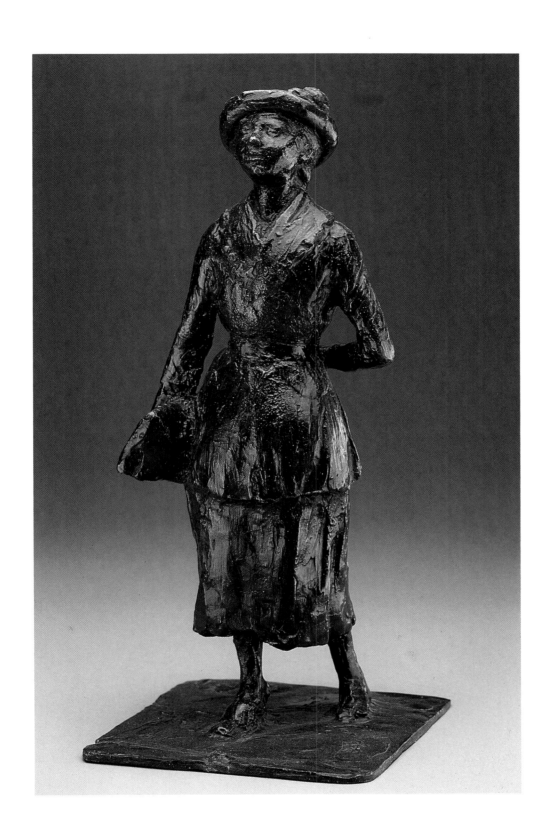

31

The Schoolgirl, c. 1880–81

Bronze, 10¾ in. high

(Rewald 74)

Lent by The Detroit Institute of Arts, Michigan

Gift of Dr. and Mrs. George Kamperman, acc. no. 56.173

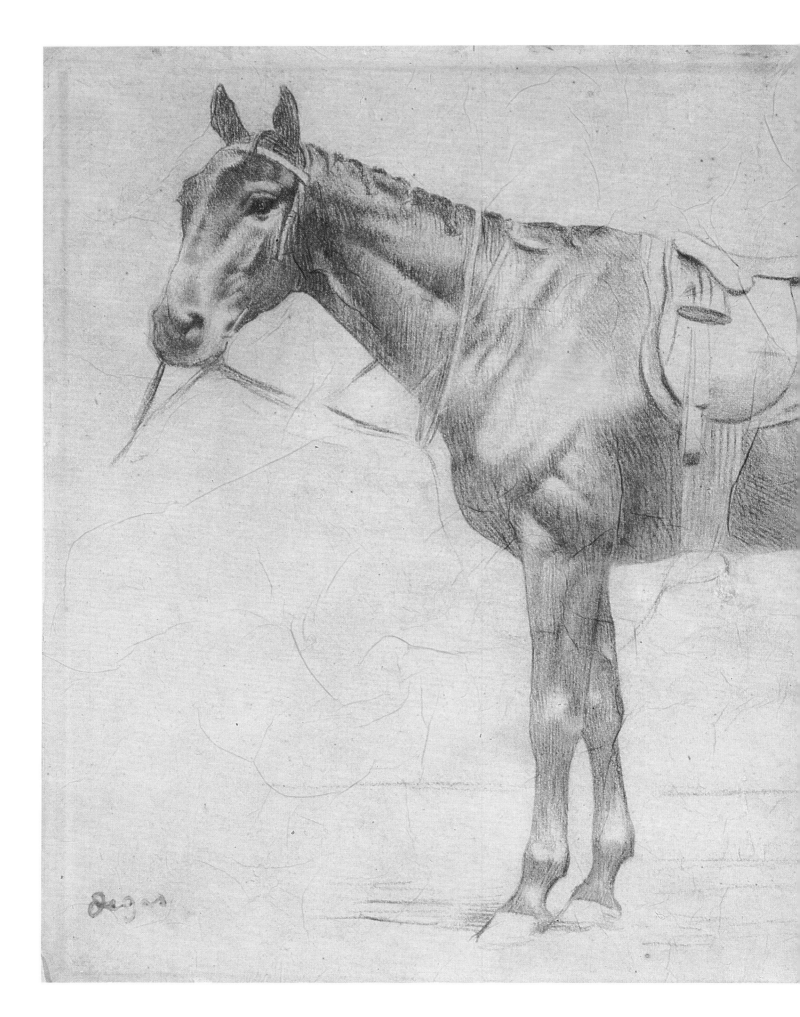

32

Study of a Saddled Horse, c. 1873

Pencil on paper, 9 x 11¾ in.

Private Collector, Buffalo, New York

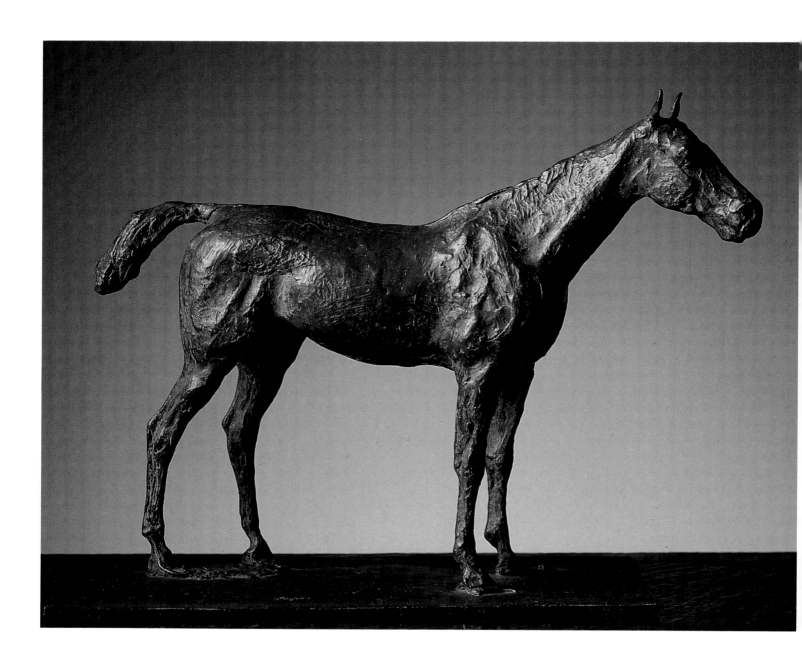

33

Horse Standing, c. 1866–68

Bronze, 11⅜ in. high

(Rewald 3; BR. S-38)

Museu de Arte de São Paulo Assis Chateaubriand,

São Paulo, Brazil

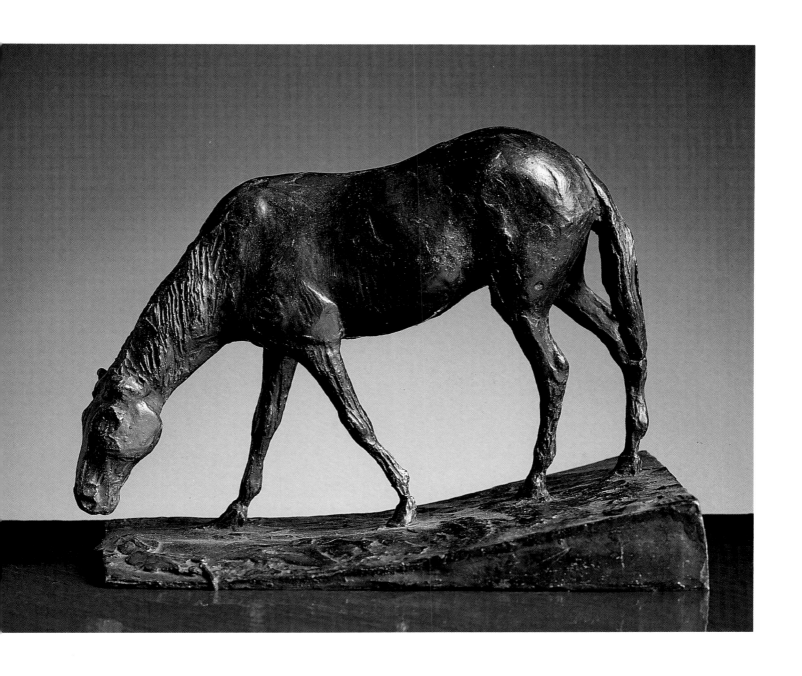

34

Horse at Trough, c. 1866–68

Bronze, 6½ in. high

(Rewald 2; BR. S-13)

Museu de Arte de São Paulo Assis Chateaubriand,

São Paulo, Brazil

35

Horses in the Meadow, c. 1891–92

Softground etching, aquatint, and drypoint; intermediate unrecorded state between
ii and iii/iii; as published in Georges Lecomte, *L'Art impressioniste d'après la collection
privée de Monsieur Durand-Ruel* (Paris, 1892); 5⅛ x 5¹³⁄₁₆ in. (plate)
(Delteil 66; Adhémar 57; R & S 56)
Mr. James A. Bergquist, Boston, Massachusetts

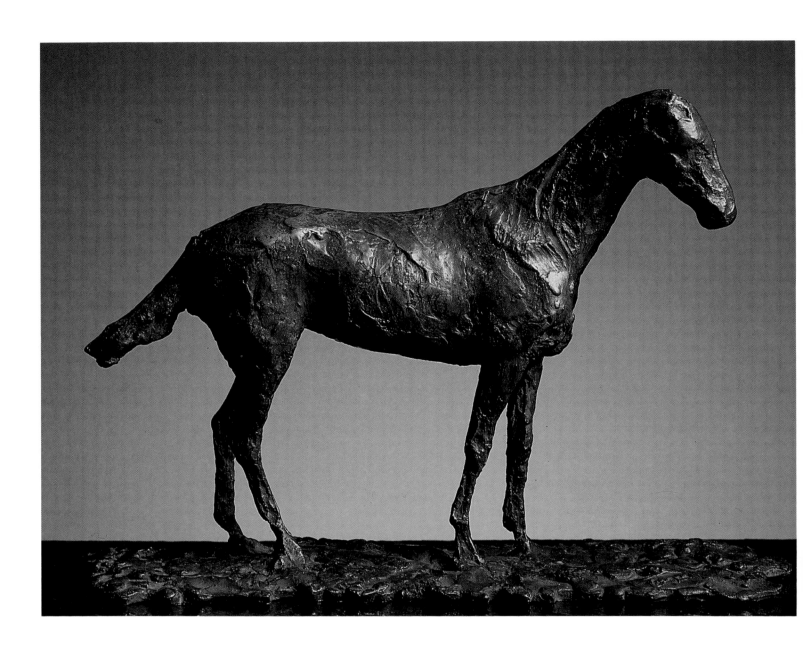

36

Study of a Mustang, c. 1882–85

Bronze, 8⅝ in. high

(Rewald 8; BR. S-21)

Museu de Arte de São Paulo Assis Chateaubriand,

São Paulo, Brazil

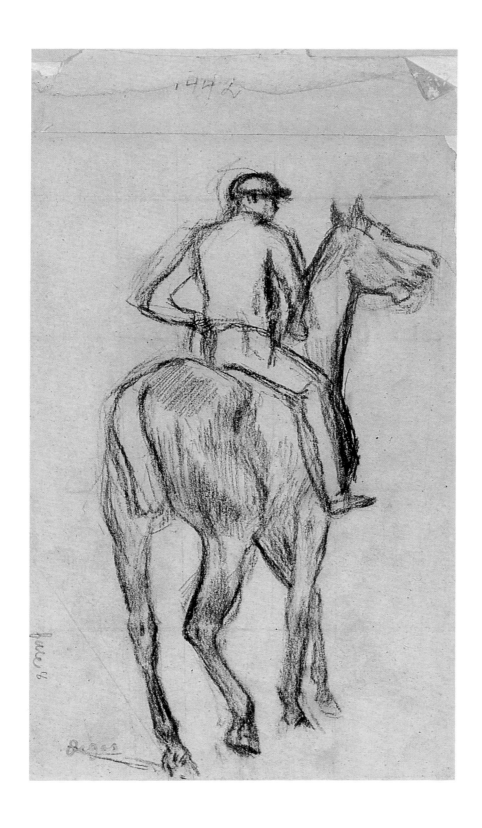

37

The Jockey, 1881–85

Charcoal on paper, 13¾ x 8½ in.

Private Collector, Buffalo, New York

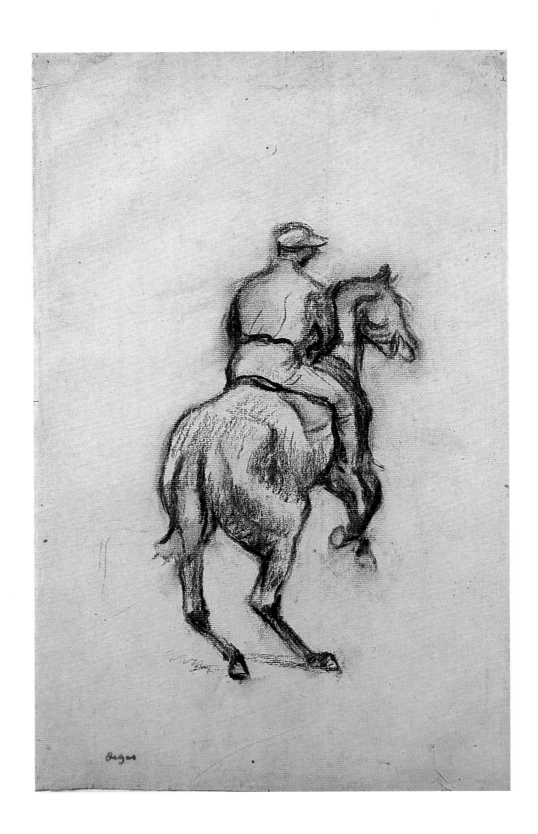

38

The Jockey,[b] c. 1881–85

Charcoal on paper, 19⅛ x 12⁹⁄₁₆ in.

The Cleveland Museum of Art, Ohio

Gift of the Print Club of the Cleveland Museum of Art,

acc. no. 27.301

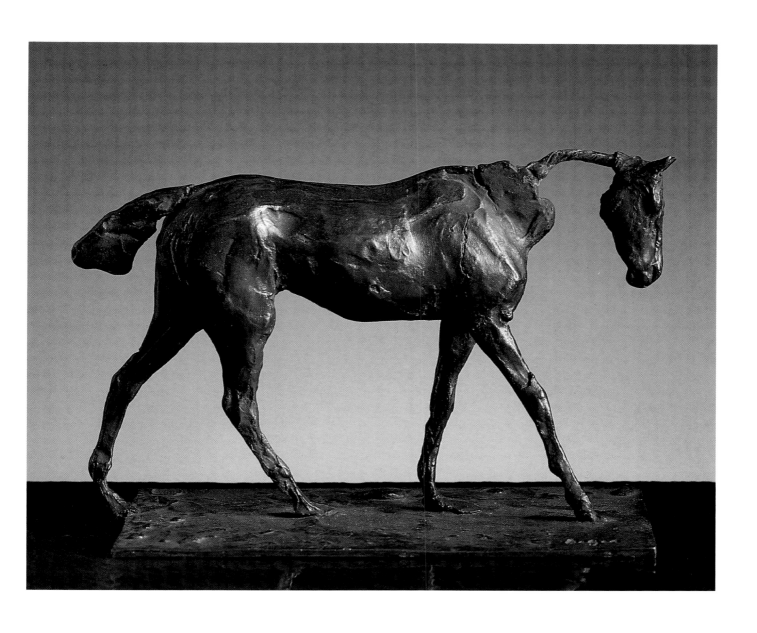

39

Thoroughbred Horse Walking, c. 1882–85

Bronze, 5¼ in. high

(Rewald 5; BR. S-66)

Museu de Arte de São Paulo Assis Chateaubriand,

São Paulo, Brazil

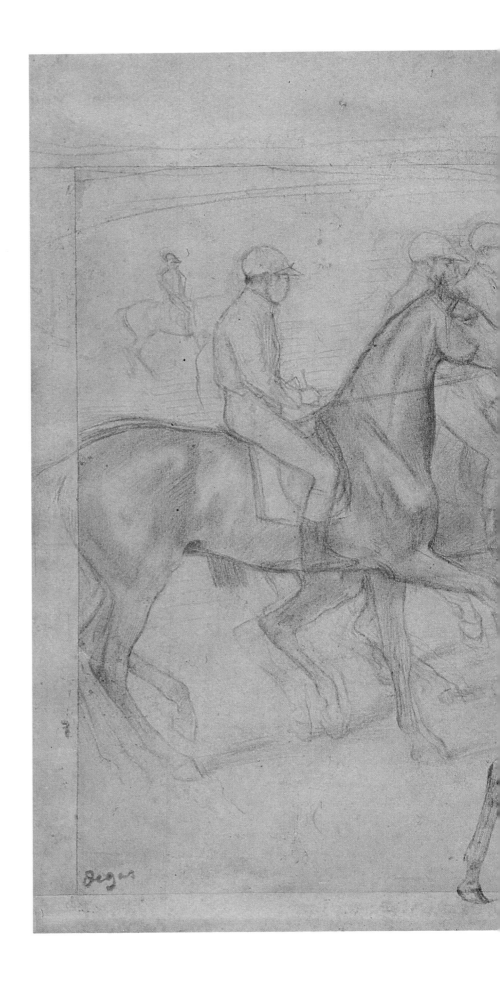

40

At the Races, 1862

Pencil on paper, 13¾ x 19 in.

The Sterling and Francine Clark Art Institute,

Williamstown, Massachusetts, acc. no. 1401

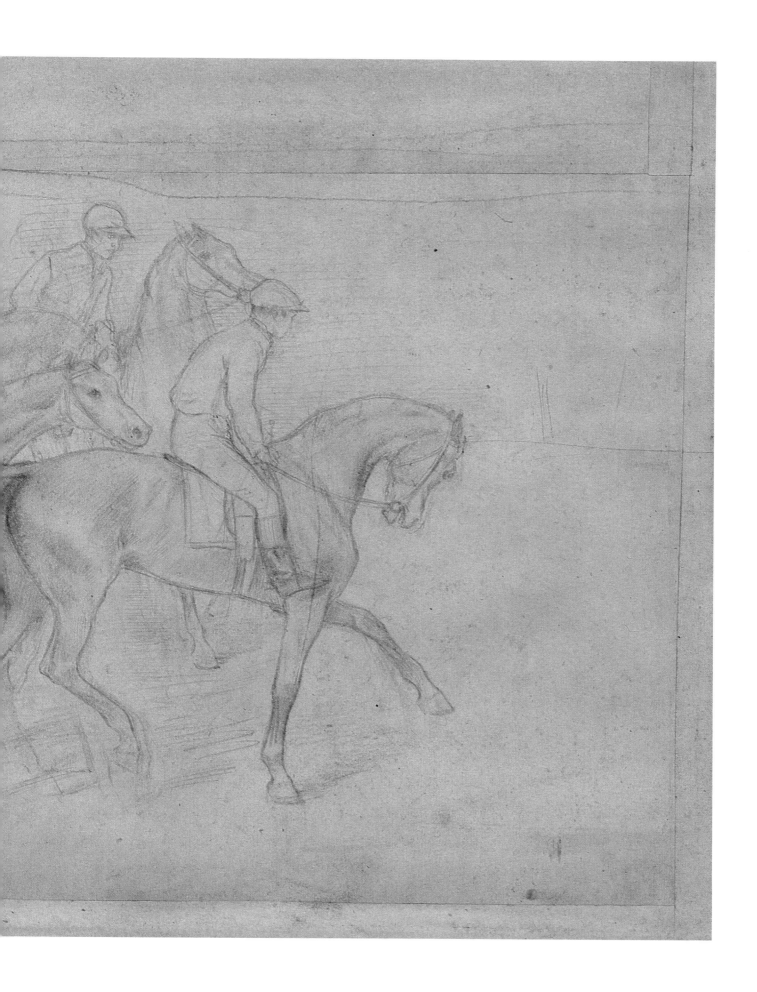

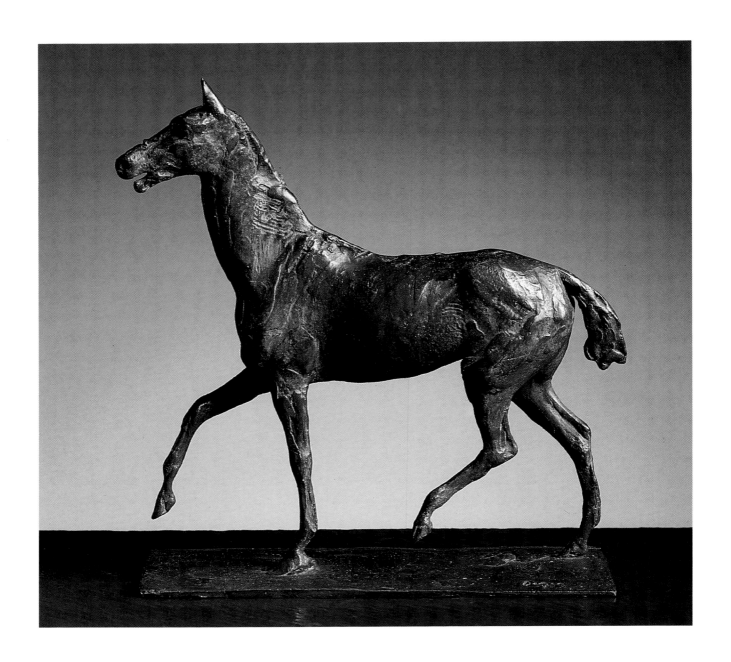

41

Horse Walking, c. 1882–85

Bronze, 9¹⁄₁₆ in. high

(Rewald 4; BR. S-11)

Museu de Arte de São Paulo Assis Chateaubriand,

São Paulo, Brazil

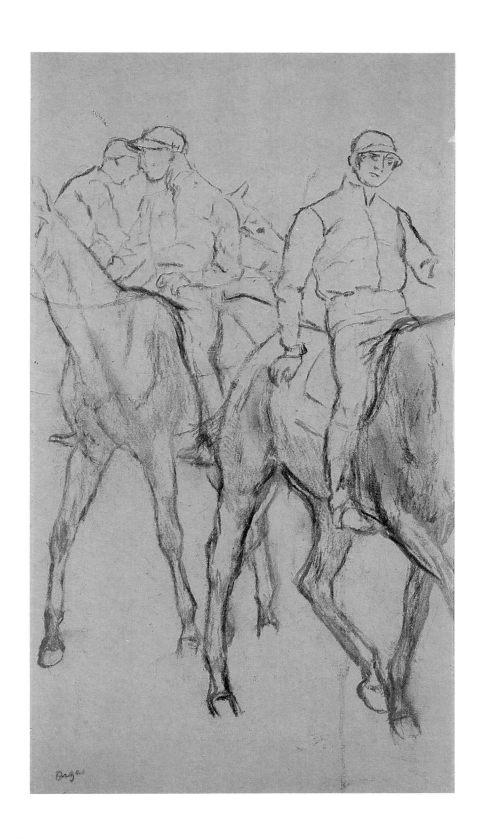

42

Jockeys on Horses, c. 1885

Charcoal on tan paper, 24⅜ x 12⅜ in.

The Art Museum, Princeton University, Princeton, New Jersey

Gift of Albert E. McVitty, acc. no. 43-218

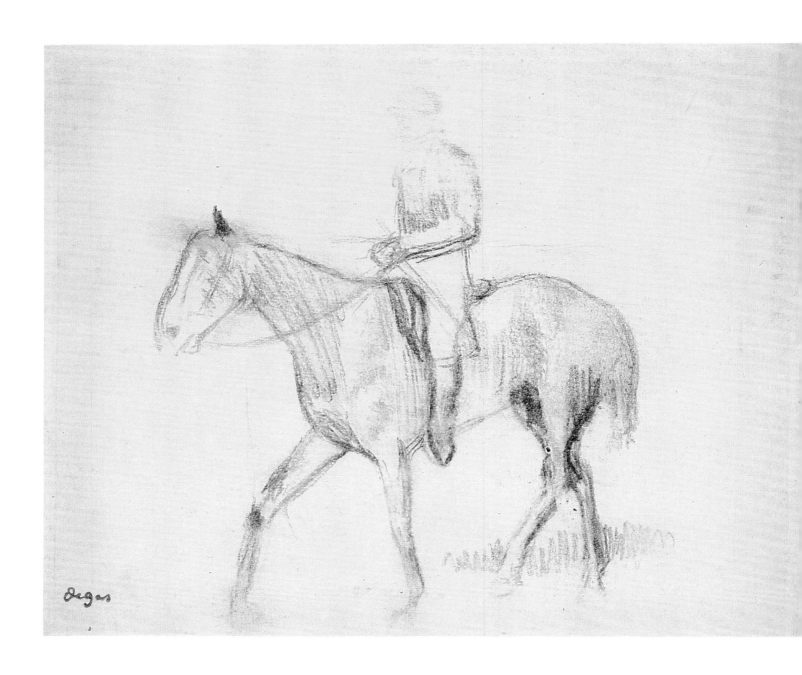

43

Horse and Rider,[c] c. 1887–90

Charcoal on buff tracing paper, 10 x 11⅞ in.

The Art Institute of Chicago, Illinois

Bequest of Joseph Winterbotham, acc. no. 1954.329

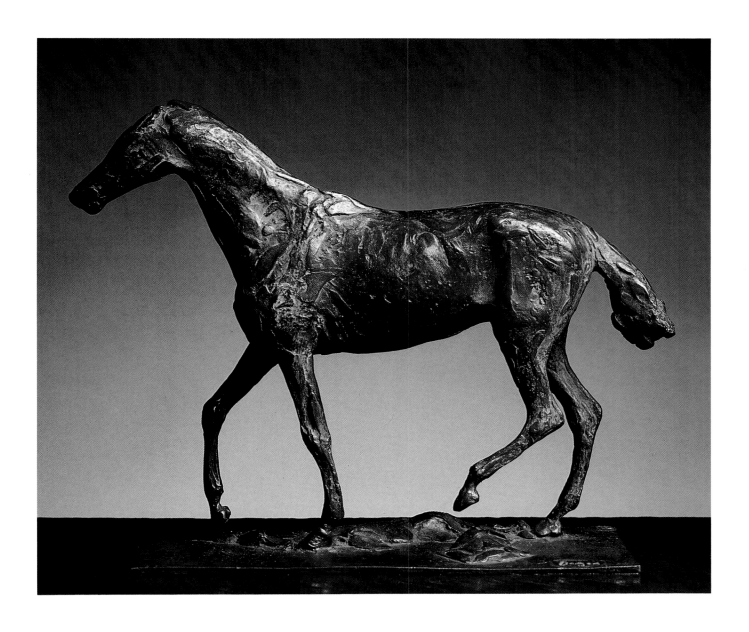

44

Horse Walking, c. 1882–85

Bronze, 8⅜ in. high

(Rewald 10; BR. S-10)

Museu de Arte de São Paulo Assis Chateaubriand,

São Paulo, Brazil

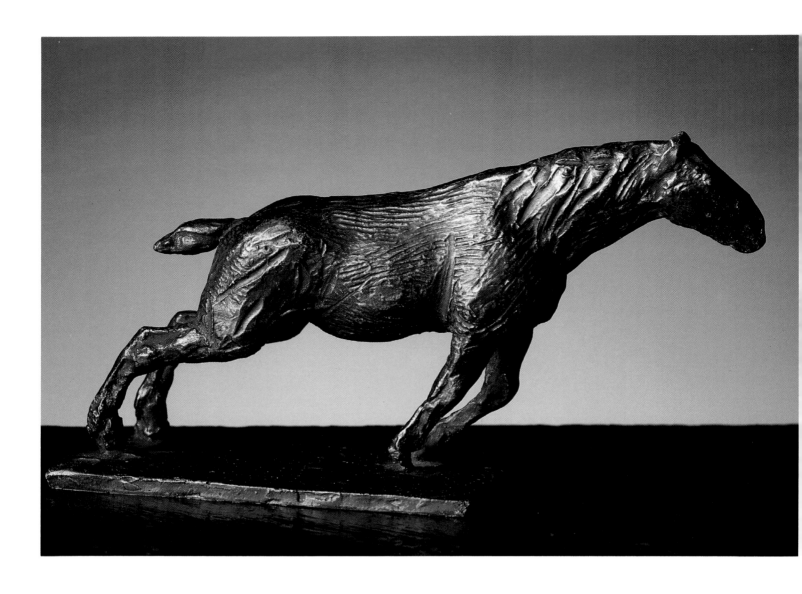

45

Draft Horse, c. 1882

Bronze, 3¹³⁄₁₆ in. high

(Rewald 7; BR. S-30)

Museu de Arte de São Paulo Assis Chateaubriand,

São Paulo, Brazil

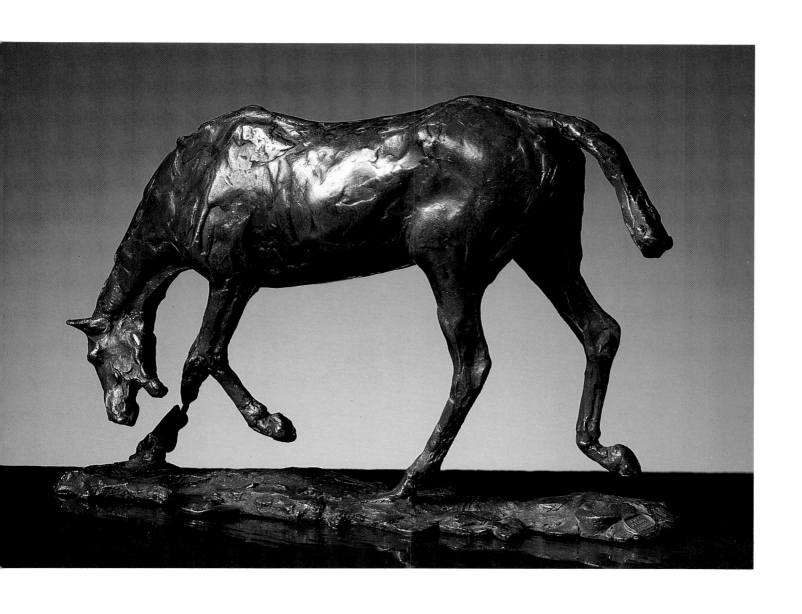

46

Horse with Head Lowered, c. 1882–85

Bronze, 7⅜ in. high

(Rewald 12; BR. S-22)

Museu de Arte de São Paulo Assis Chateaubriand,

São Paulo, Brazil

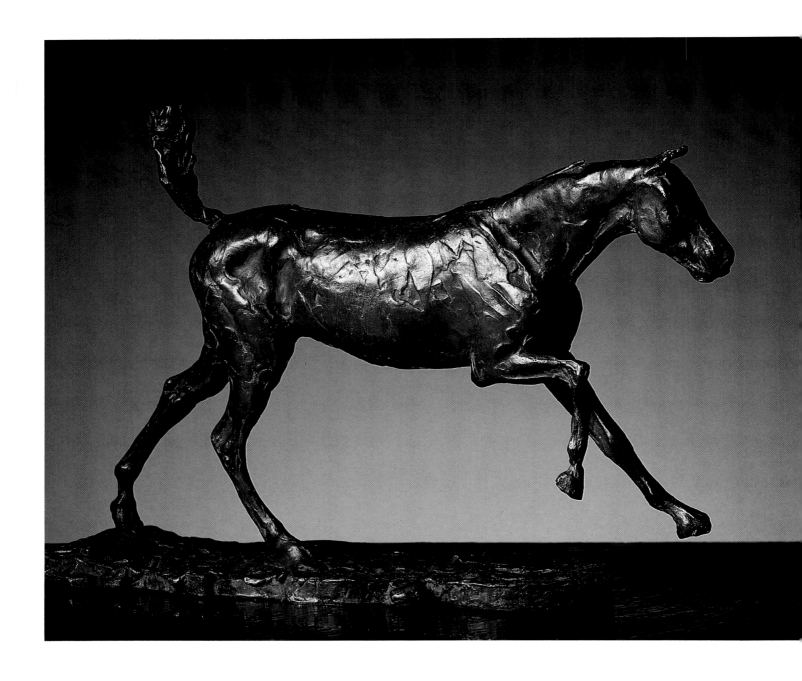

47

Horse Galloping on the Right Hoof, c. 1888–90

Bronze, 12½ in. high

(Rewald 6; BR. S-47)

Museu de Arte de São Paulo Assis Chateaubriand,

São Paulo, Brazil

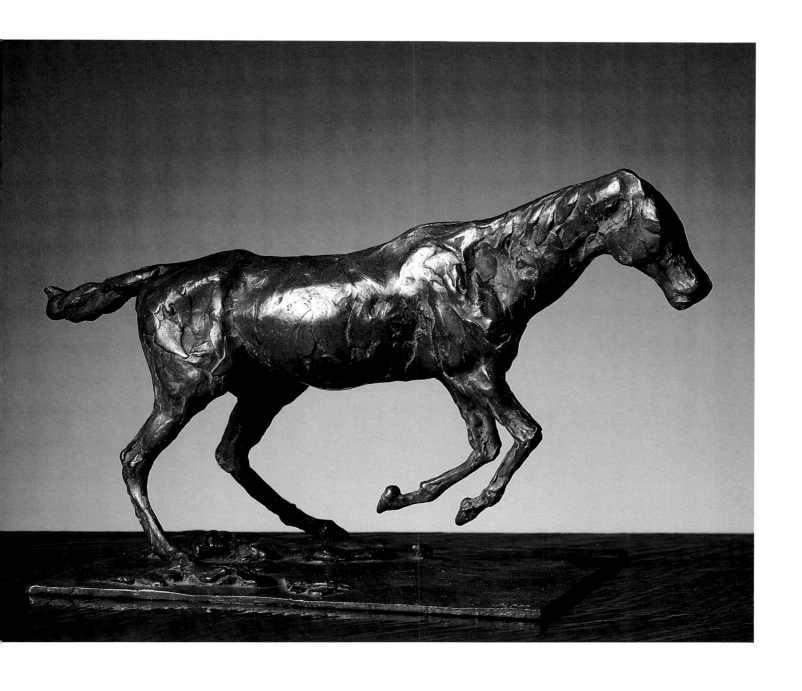

48

Horse Clearing an Obstacle (or Horse Standing)

c. 1888–90

Bronze, 11 in. high

(Rewald 9; BR. S-48)

Museu de Arte de São Paulo Assis Chateaubriand,

São Paulo, Brazil

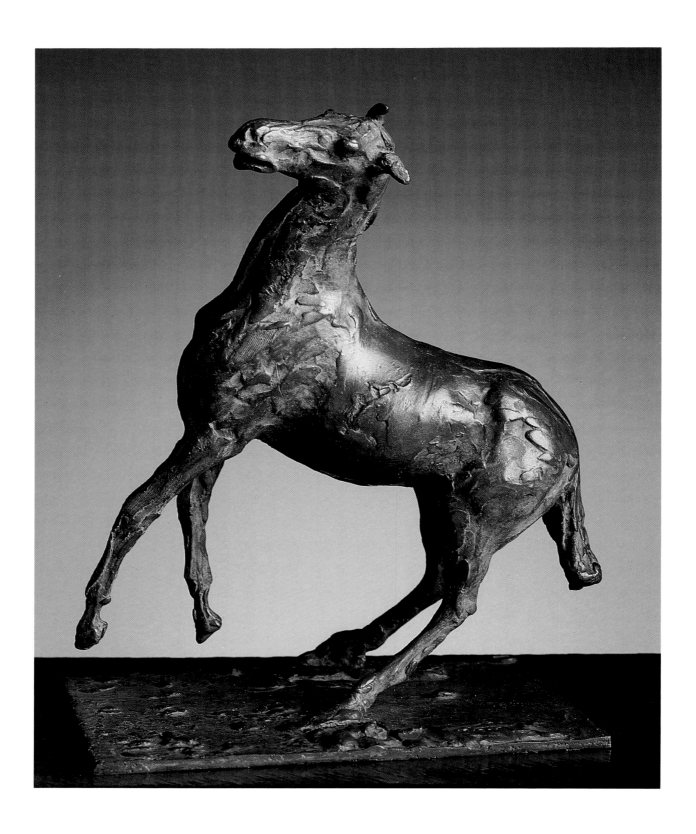

49

Rearing Horse, c. 1888–90

Bronze, 12¼ in. high

(Rewald 13; BR. E-4)

Museu de Arte de São Paulo Assis Chateaubriand,

São Paulo, Brazil

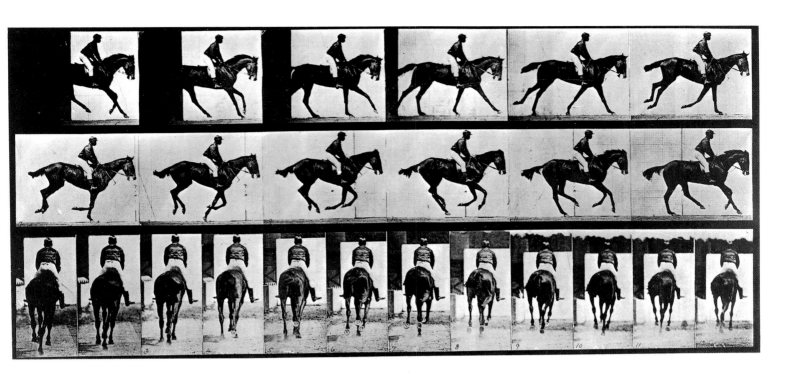

50

Horse Cantering

Photogravure; plate 620 from *Animal Locomotion*, 1887;
7½ x 16⅛ in. (image); 19½ x 24¼ in. (sheet)
The Smith College Museum of Art, Northampton, Massachusetts
Gift of the Philadelphia Commercial Museum, 1950,
acc. no. 1950:53-620

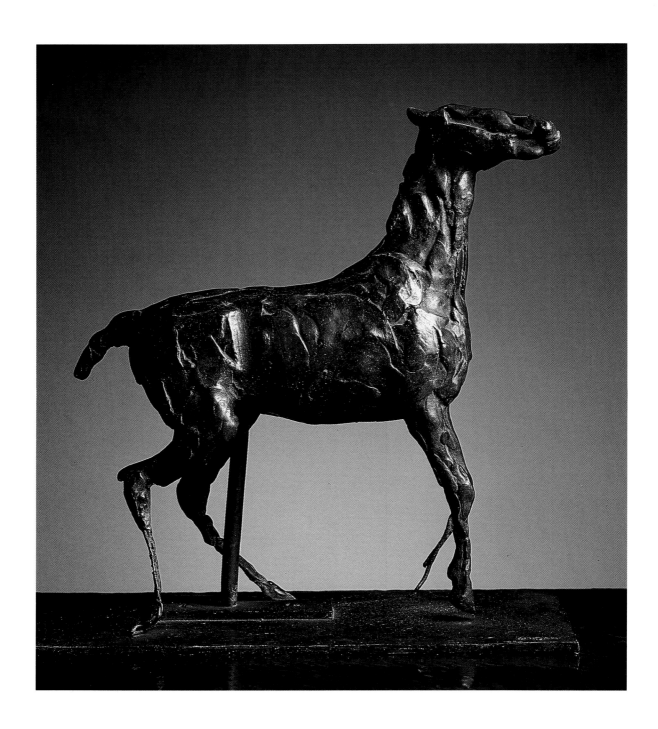

51

Prancing Horse, c. 1888–90

Bronze, 10⅝ in. high

(Rewald 16; BR. S-65)

Museu de Arte de São Paulo Assis Chateaubriand,

São Paulo, Brazil

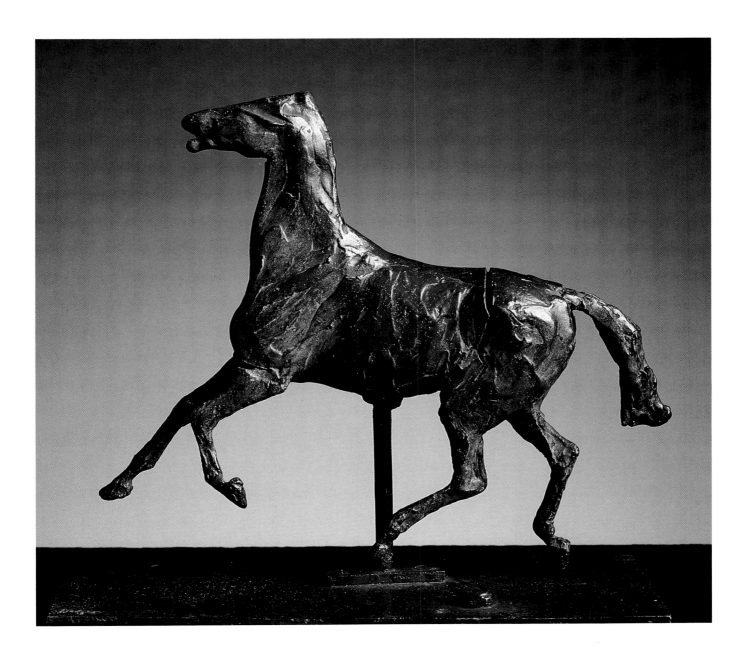

52

Horse Trotting, the Feet Not Touching the Ground, c. 1888–90

Bronze, 9¼ in. high

(Rewald 11; BR. S-49)

Museu de Arte de São Paulo Assis Chateaubriand, São Paulo, Brazil

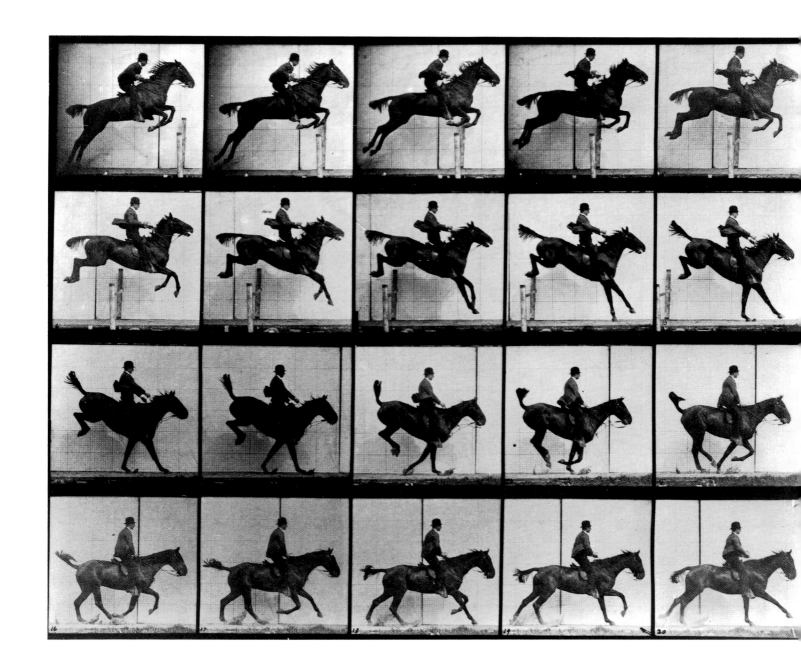

53

Horse Jumping a Hurdle

Photogravure; plate 637 from *Animal Locomotion*, 1887,

10⅛ x 12⅜ in. (image); 19¼ x 24⅜ in. (sheet)

The Smith College Museum of Art, Northampton, Massachusetts

Gift of the Philadelphia Commercial Museum, 1950,

acc. no. 1950:53-637

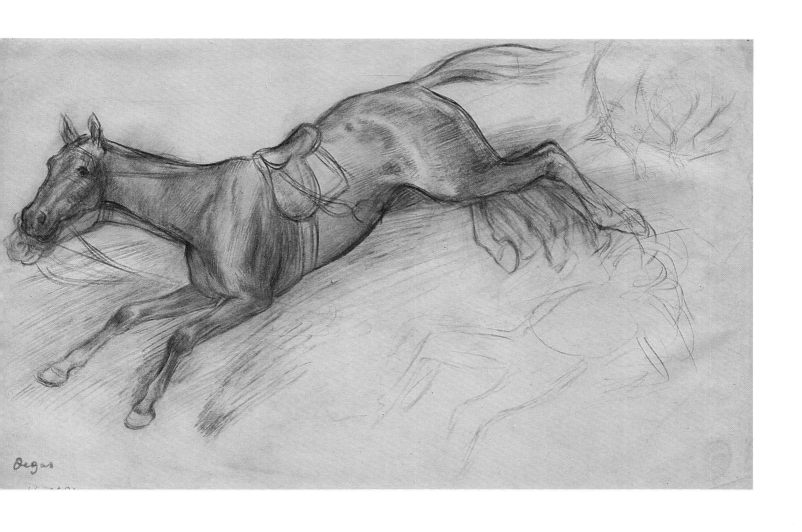

54

Study for "Steeplechase: The Bolting Horse,"

c. 1866

Charcoal on paper, 9⅛ x 14⅛ in.

The Sterling and Francine Clark Art Institute,

Williamstown, Massachusetts, acc. no. 1397

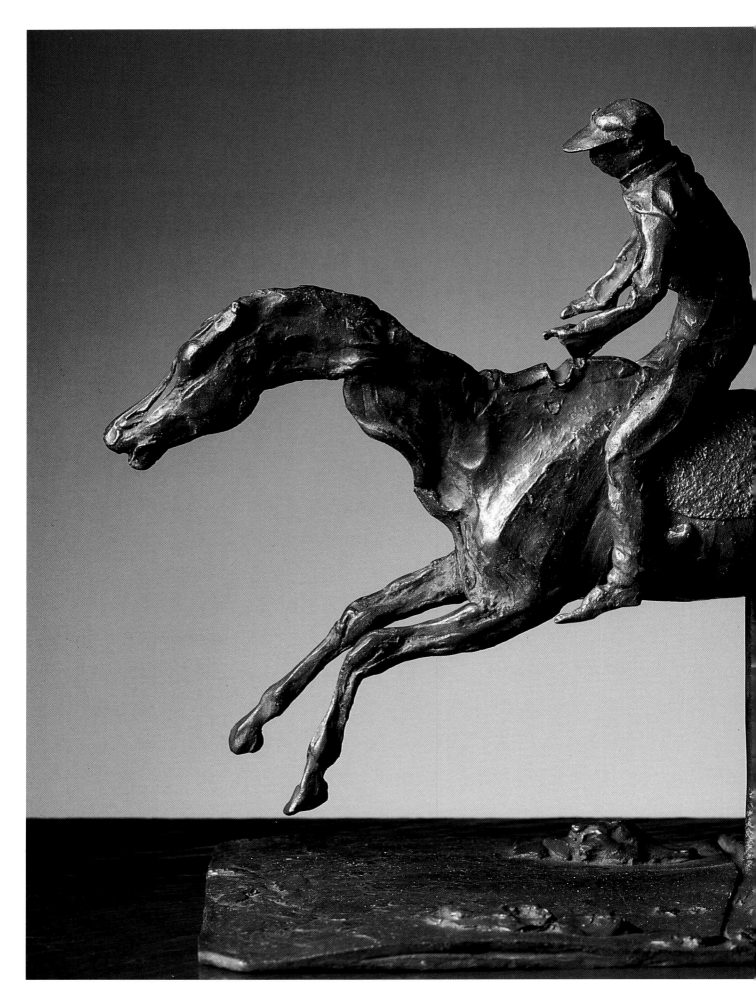

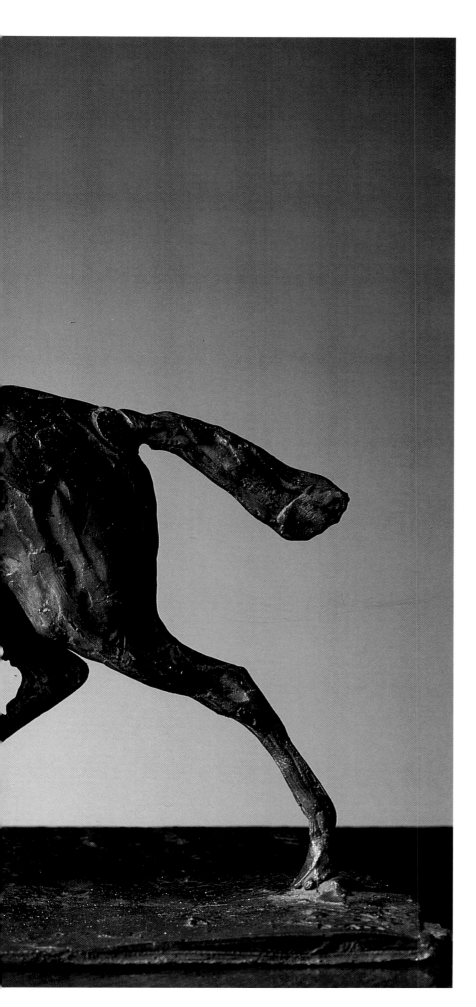

55

**Horse and Jockey: Horse Galloping on Right Hoof,
the Back Left Only Touching the Ground**, c. 1888–90

Bronze, 11 in. high

(Rewald 14 and 15; BR. S-25 and S-35)

Museu de Arte de São Paulo Assis Chateaubriand,

São Paulo, Brazil

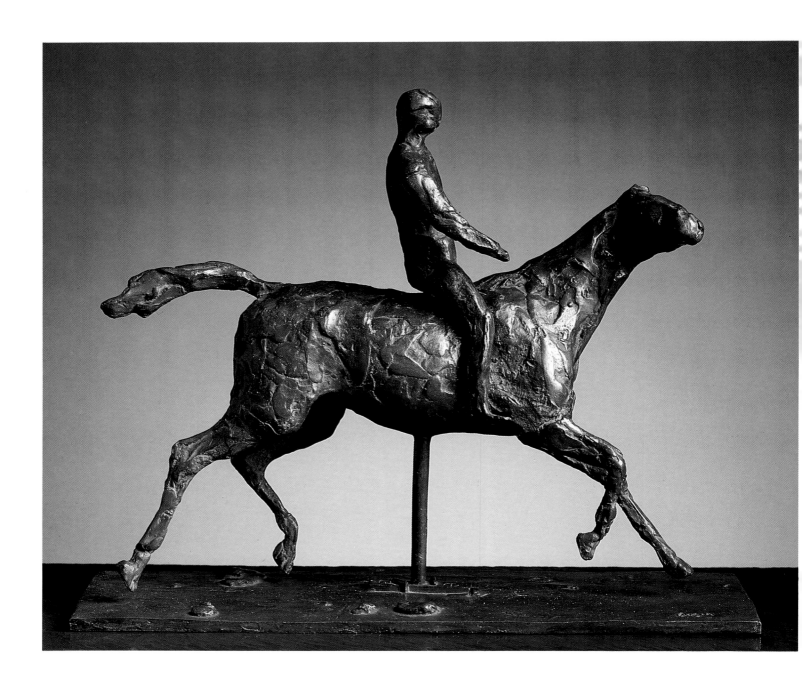

58

Horse and Jockey: Horse Galloping, Turning the Head to the Right, the Hooves Not Touching the Ground, c. 1888–90

Bronze, 11⅜ in. high

(Rewald 17 and 18; BR. S-32 and S-36)

Museu de Arte de São Paulo Assis Chateaubriand,

São Paulo, Brazil

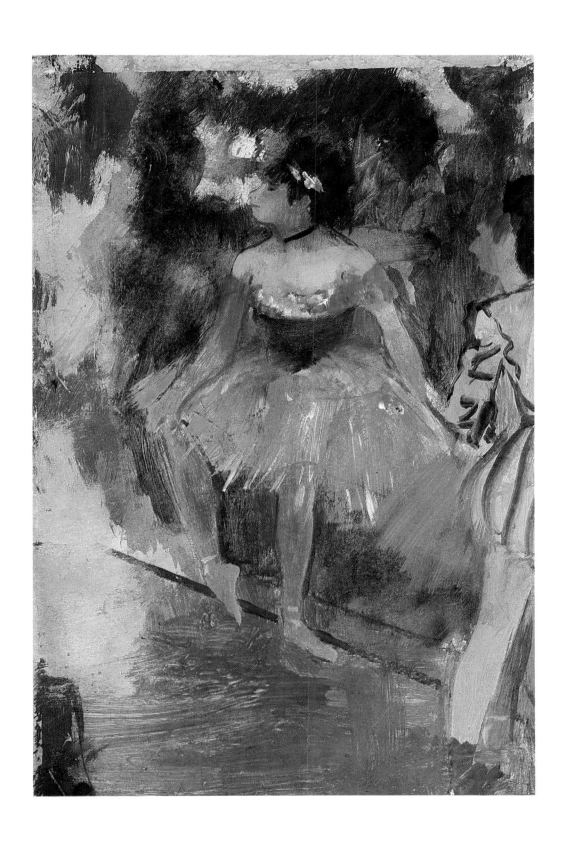

57

Dancers,[b] c. 1878

Oil over graphite on paper, 6⅞ x 4½ in.

Yale University Art Gallery, New Haven, Connecticut

The Collection of Frances and Ward Cheney, B.A. 1922,

acc. no. 1970.113.2

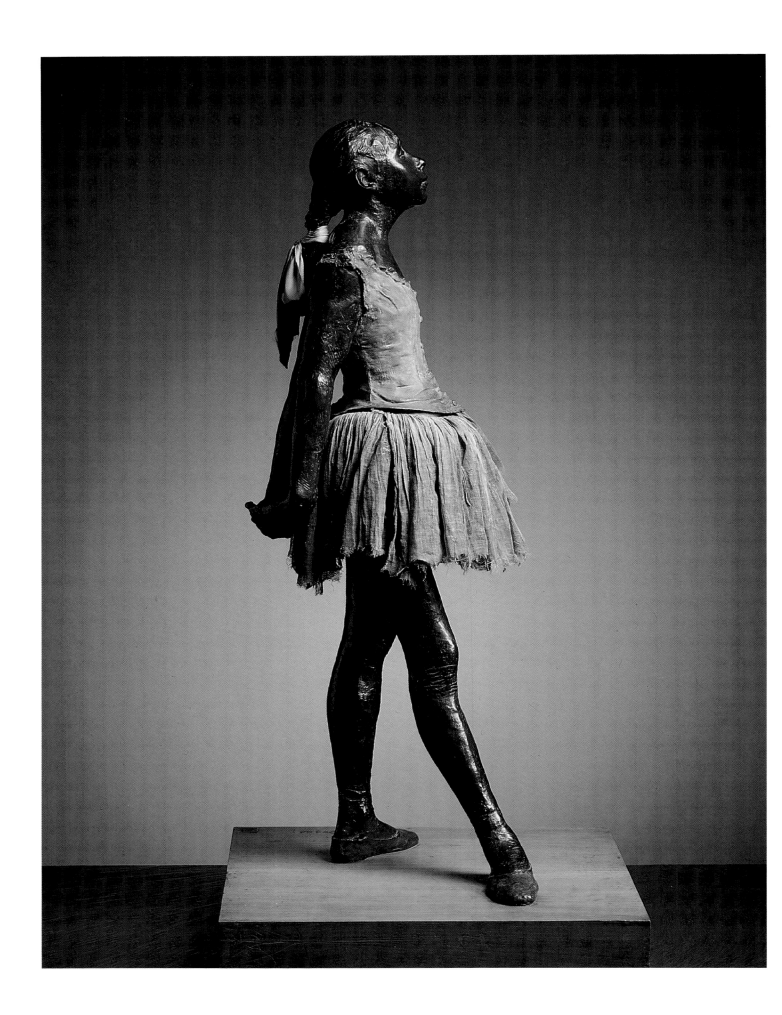

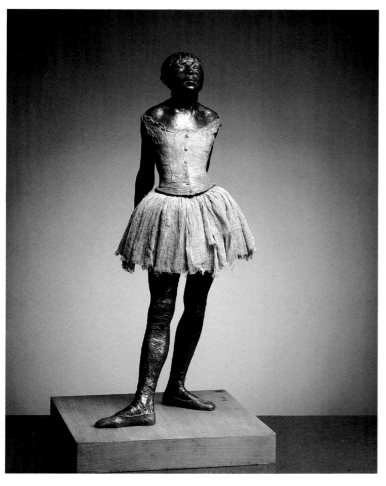 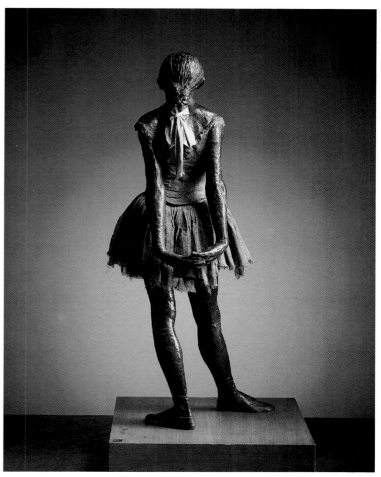

58

Ballet Dancer, Dressed

(or Little Dancer of Fourteen Years), 1878–81

Bronze, tinted in part, skirt of cotton, with satin ribbon and

wooden base; 39 in. high

(Rewald 20; BR. S-73)

Museu de Arte de São Paulo Assis Chateaubriand,

São Paulo, Brazil

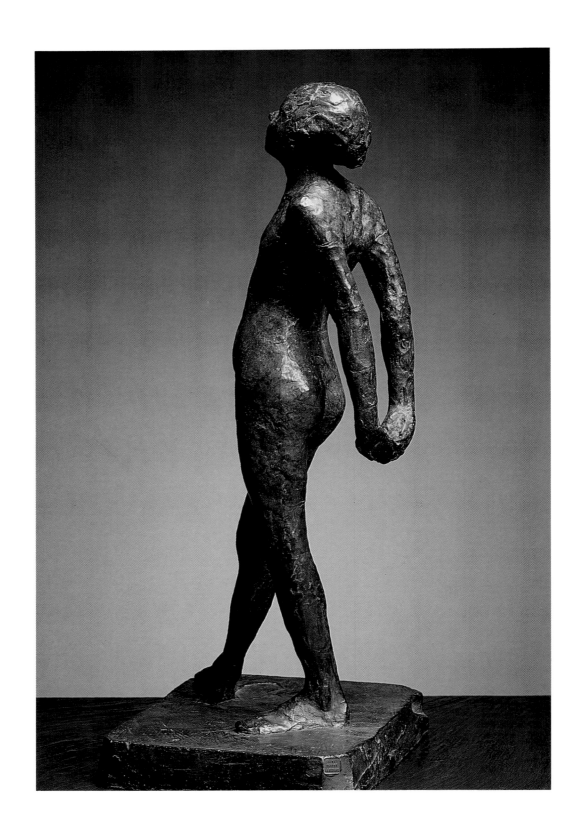

59

Study in the Nude for the Dressed Ballet Dancer, c. 1878–79

Bronze, 28¹⁵⁄₁₆ in. high

(Rewald 19; BR. S-56)

Museu de Arte de São Paulo Assis Chateaubriand,

São Paulo, Brazil

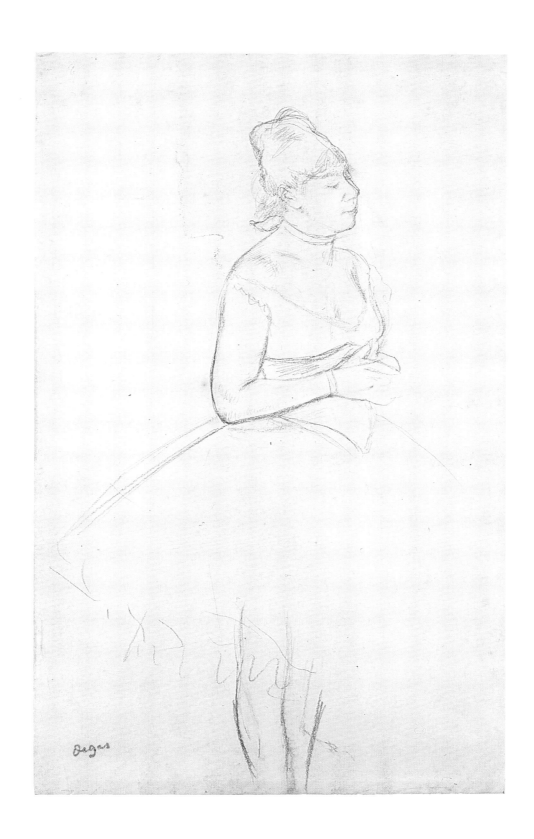

60

Dancer Taking a Bow,[d] c. 1878

Graphite on paper, 14⅛₆ x 9⅜ in.

The Art Institute of Chicago, Illinois

Bequest of Mrs. Gordon Palmer, acc. no. 1985.470

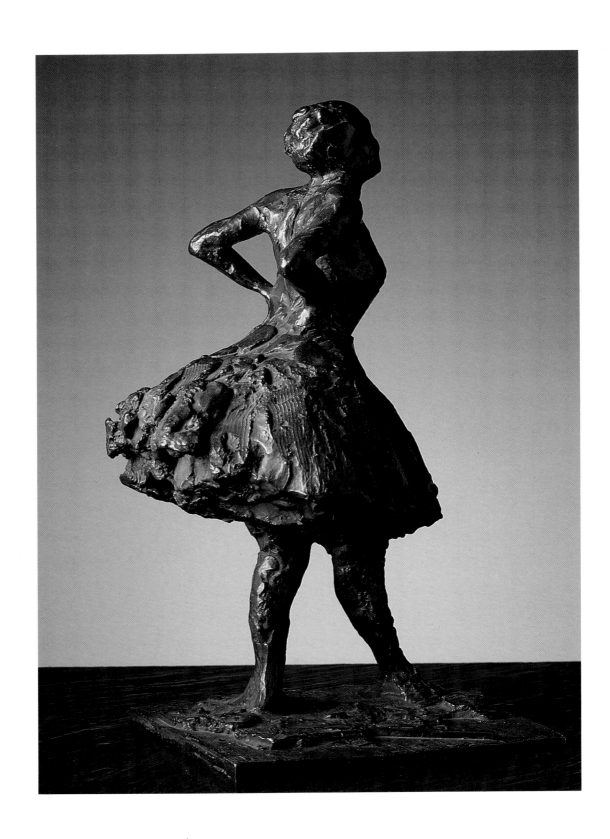

61

Dressed Dancer at Rest, Hands Behind Her Back,

Right Leg Forward, c. 1895–99

Bronze, 17⅛ in. high

(Rewald 52; BR. S-51)

Museu de Arte de São Paulo Assis Chateaubriand,

São Paulo, Brazil

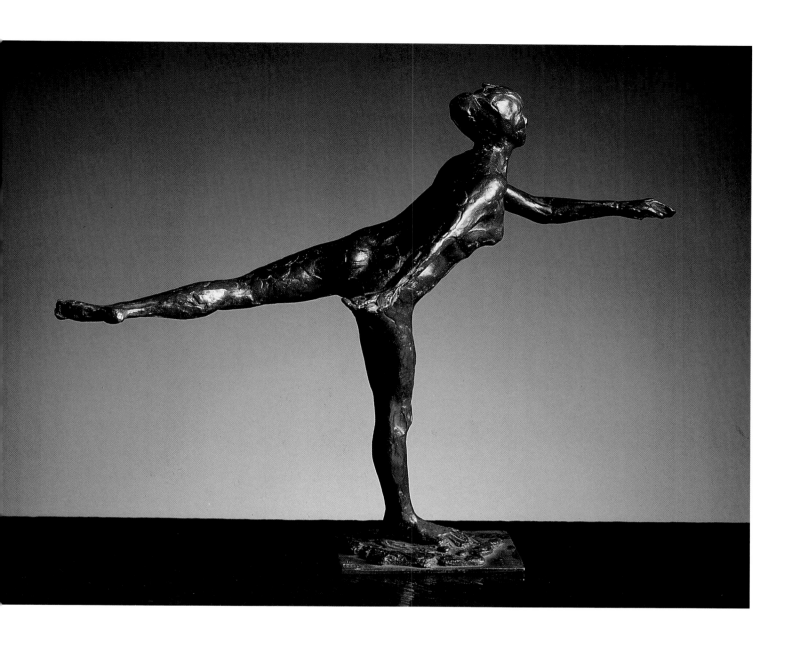

62

Arabesque over the Right Leg, Left Arm in Front,

c. 1882–85

Bronze, 11⅞ in. high

(Rewald 38; BR. S-1)

Museu de Arte de São Paulo Assis Chateaubriand,

São Paulo, Brazil

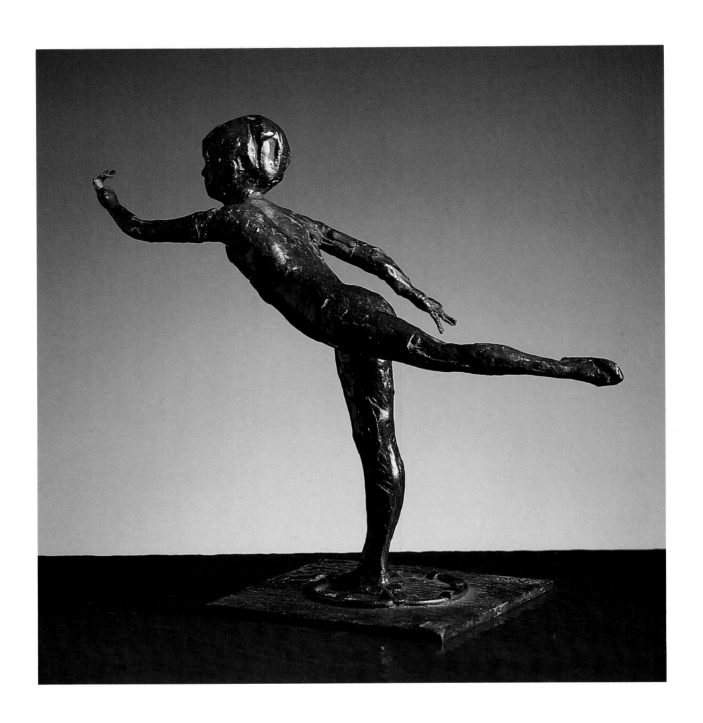

63

**Arabesque over the Right Leg, Left Arm
in Front**, c. 1880–82

Bronze, 8⁹⁄₁₆ in. high

(Rewald 37; BR. S-14)

Museu de Arte de São Paulo Assis Chateaubriand,

São Paulo, Brazil

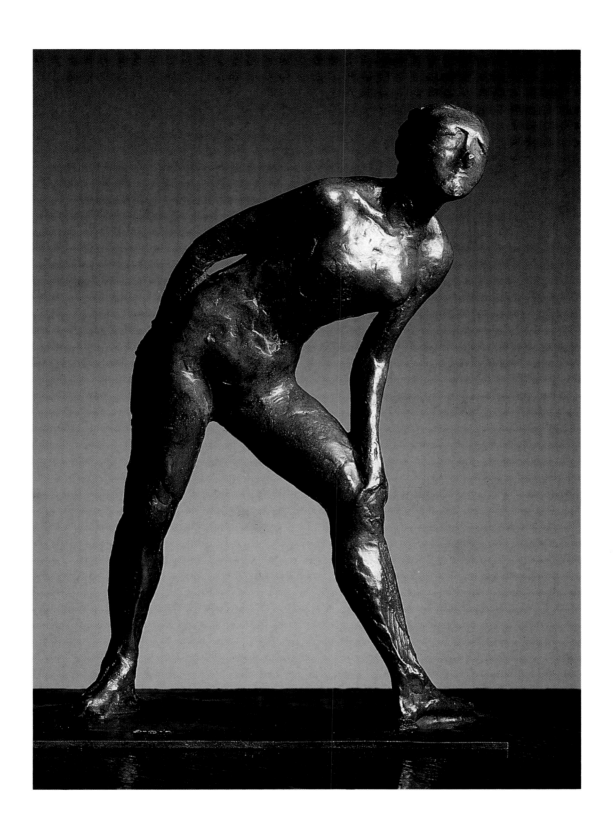

64

**Dancer Rubbing Her Knee or Study for a
Dancer as Harlequin**, c. 1882–85

Bronze, 11¹⁵⁄₁₆ in. high

(Rewald 48; BR. S-39)

Museu de Arte de São Paulo Assis Chateaubriand,

São Paulo, Brazil

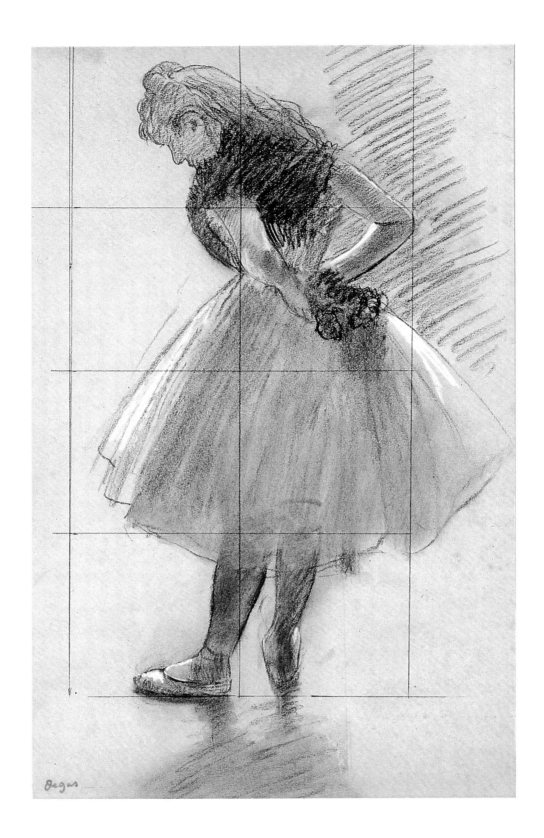

65

Dancer Tying Her Scarf, 1887

Black crayon with white on paper, 18⅜ x 11⅜ in.

The Hyde Collection, Glens Falls, New York,

acc. no. 1971.63

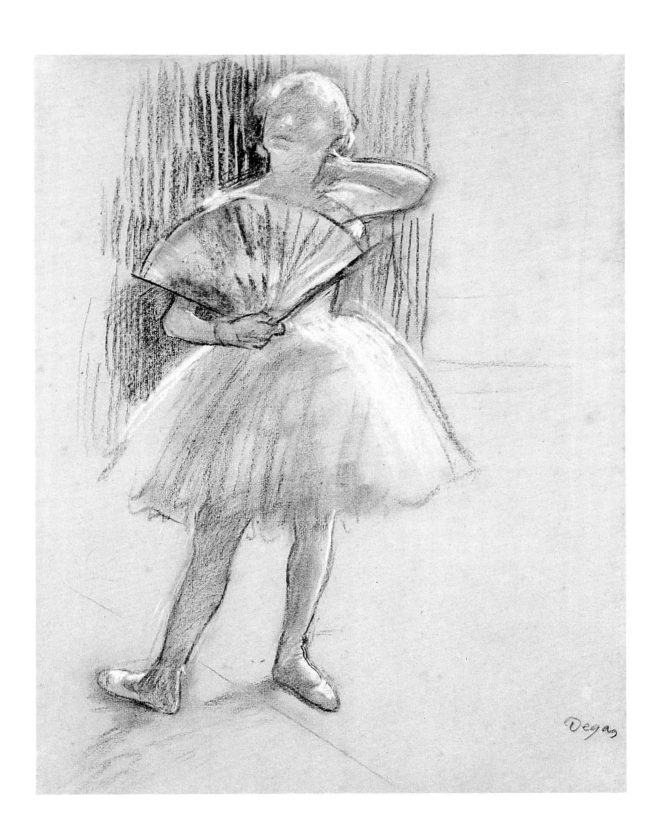

66

Dancer,[b] c. 1884–85

Charcoal heightened with white on paper, 23½ x 18½ in.

Ball State University Museum of Art, Muncie, Indiana

Gift of Mr. and Mrs. William H. Thompson, acc. no. 40.027

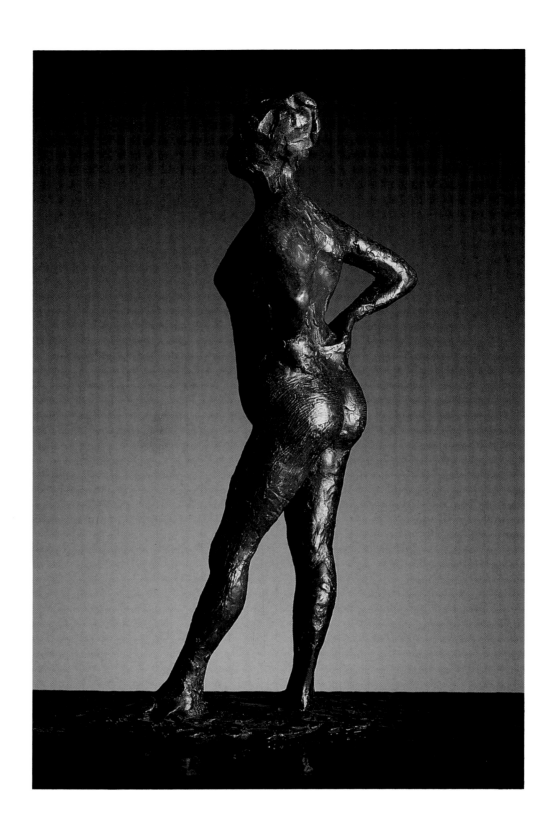

67

Dancer at Rest, Hands on Her Hips,

Left Leg Forward, c. 1895–99

Bronze, 14¹⁵⁄₁₆ in. high

(Rewald 21; BR. S-8)

Museu de Arte de São Paulo Assis Chateaubriand,

São Paulo, Brazil

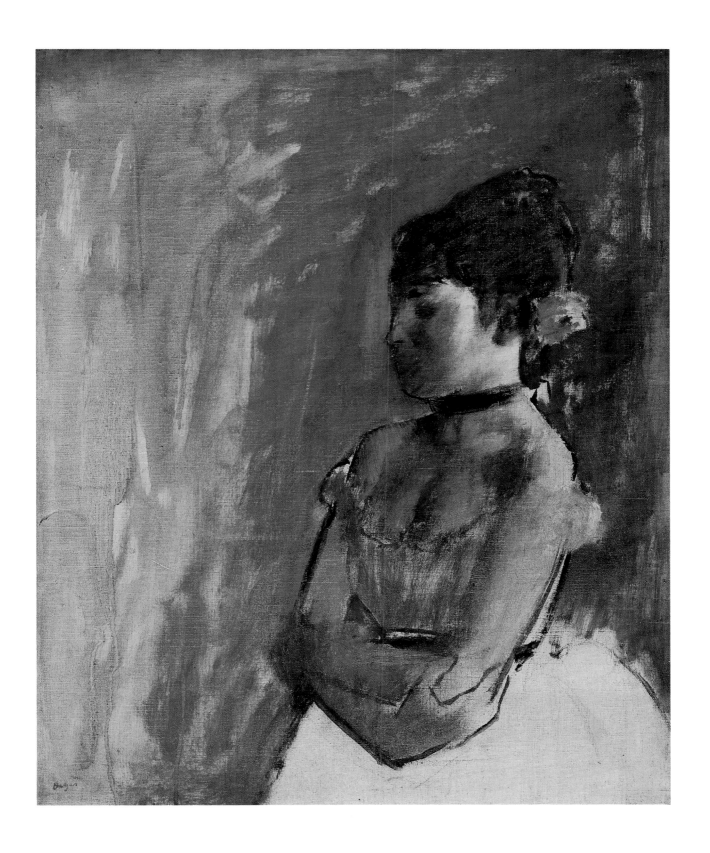

68

Ballet Dancer with Arms Crossed, 1872

Oil on canvas, 24⅗ x 19⅞ in.

Museum of Fine Arts, Boston, Massachusetts

Bequest of John T. Spaulding, acc. no. 48.5341

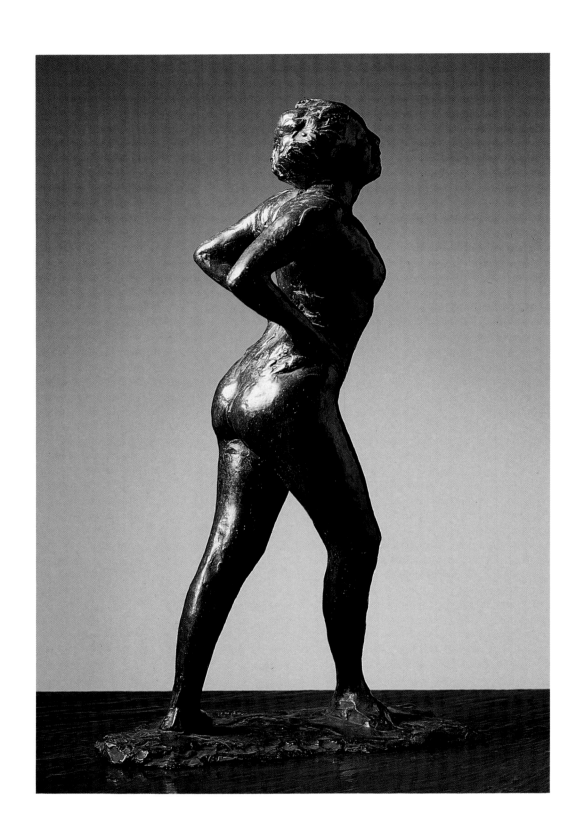

69

Dancer at Rest, Hands Behind Her Back,

Right Leg Forward, c. 1895–99

Bronze, 17⅜ in. high

(Rewald 22; BR. S-63)

Museu de Arte de São Paulo Assis Chateaubriand,

São Paulo, Brazil

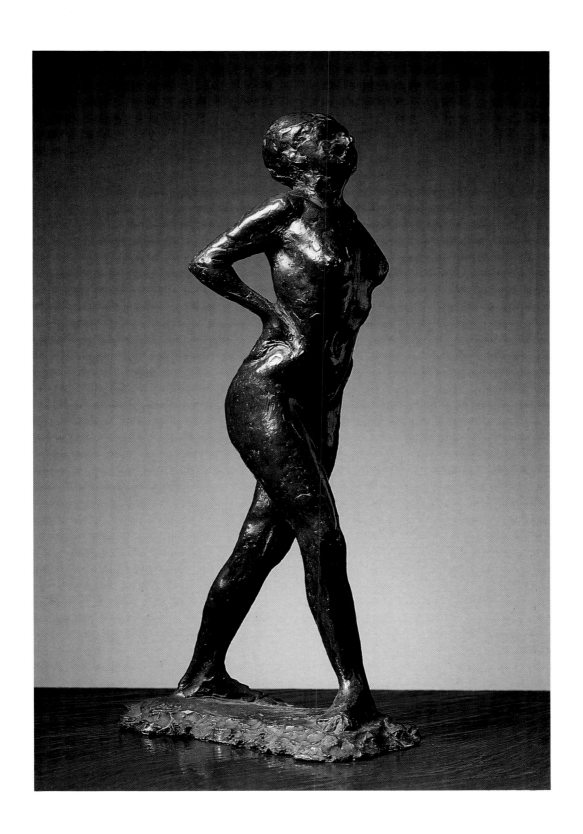

70

Dancer at Rest, Hands Behind Her Back,
Right Leg Forward, c. 1895–99

Bronze, 18⅛ in. high

(Rewald 23; BR. S-41)

Museu de Arte de São Paulo Assis Chateaubriand,

São Paulo, Brazil

71

Dancer on the Stage, c. 1877–80

Oil on canvas, 36 x 46½ in.

The Smith College Museum of Art, Northampton, Massachusetts

Gift of Paul Rosenberg and Company, acc. no. 1955.14

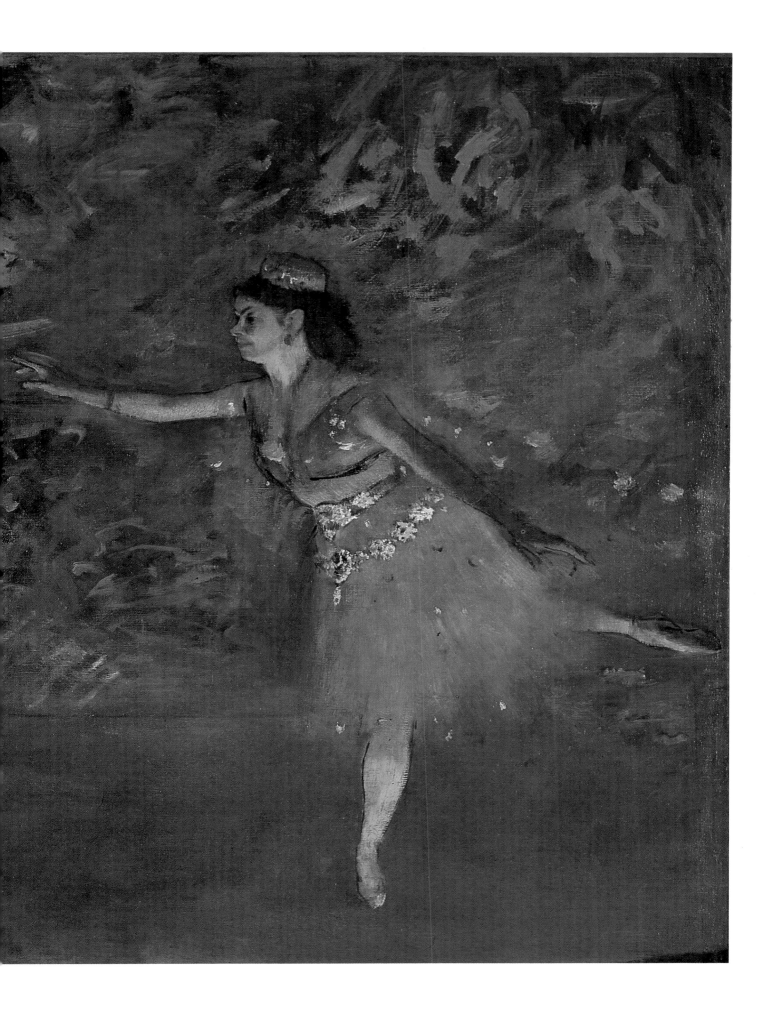

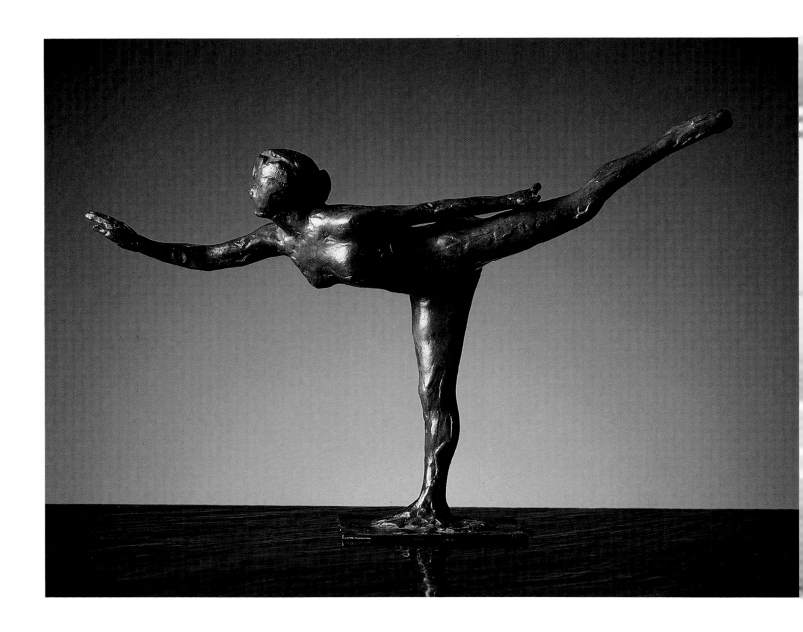

72

Arabesque over the Right Leg, Left Arm in Line,

c. 1882–85

Bronze, 11⅛ in. high

(Rewald 42; BR. S-3)

Museu de Arte de São Paulo Assis Chateaubriand,

São Paulo, Brazil

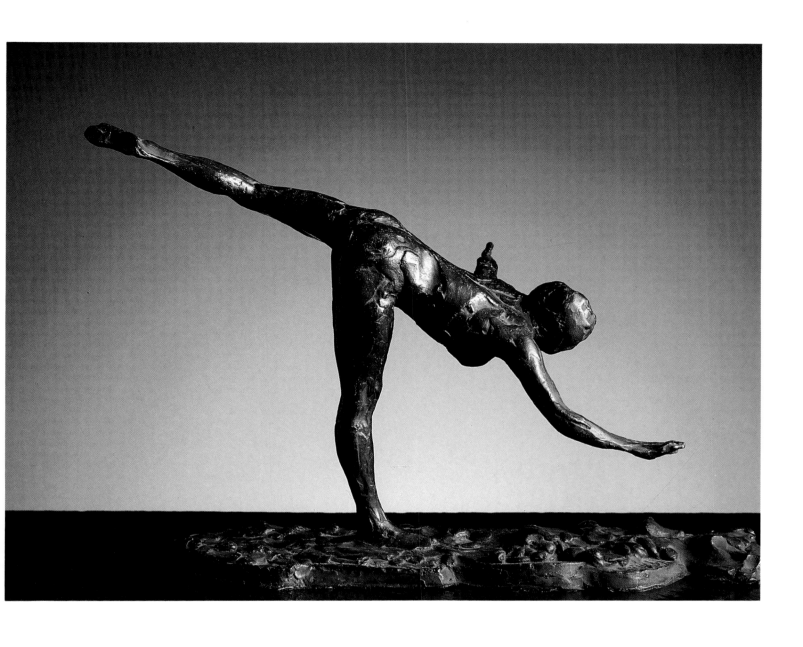

73

Arabesque over the Right Leg, Right Hand near the Ground, Left Arm Outstretched, c. 1882–85

Bronze, 11⅛ in. high

(Rewald 41; BR. S-2)

Museu de Arte de São Paulo Assis Chateaubriand,

São Paulo, Brazil

(detail)

74

Dancer Turning,[e] c. 1878

Charcoal, heightened with white chalk on
gray laid paper, 23¹¹/₁₆ x 17⅝ in.
The Art Institute of Chicago, Illinois
Bequest of John J. Ireland, acc. no. 1968.82

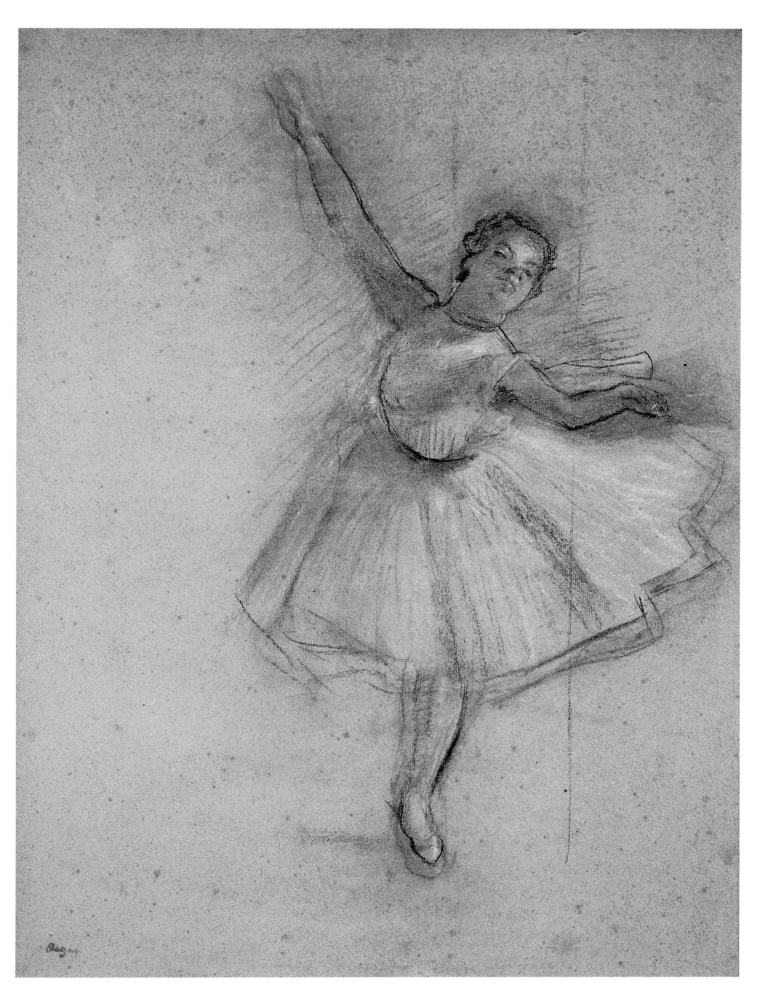

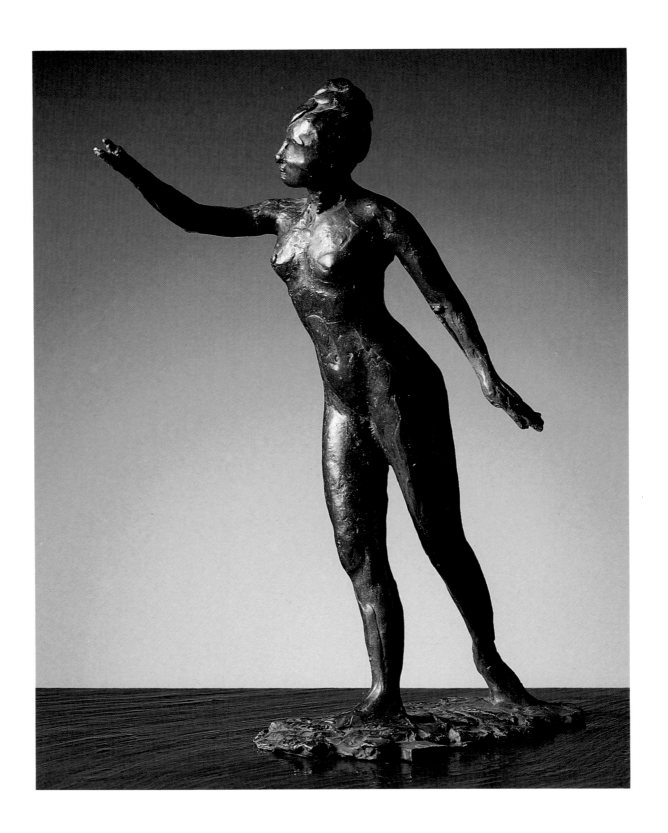

75

Grande Arabesque, First Time, c. 1885–88

Bronze, 19¼ in. high

(Rewald 35; BR. S-18)

Museu de Arte de São Paulo Assis Chateaubriand,

São Paulo, Brazil

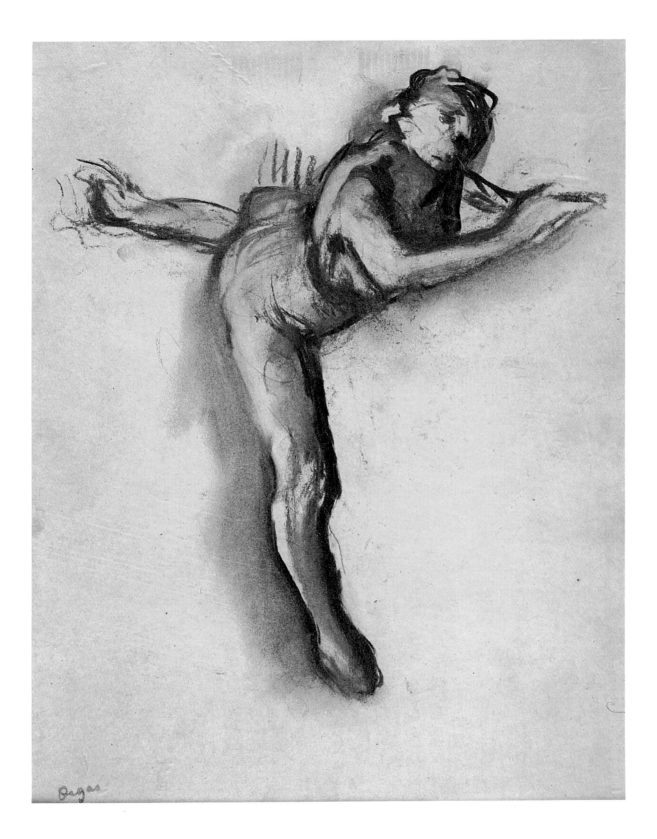

76

Grande Arabesque, Second Time, 1885–90

Charcoal on paper, 18 x 14 in.

Mr. H. Peter Findlay, New York, New York

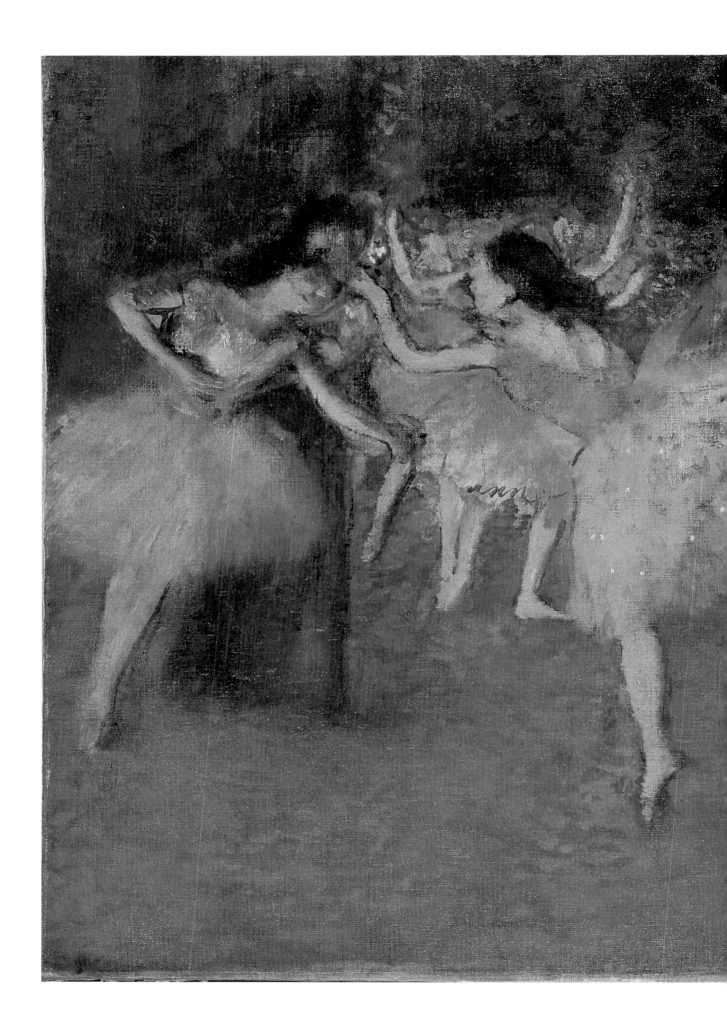

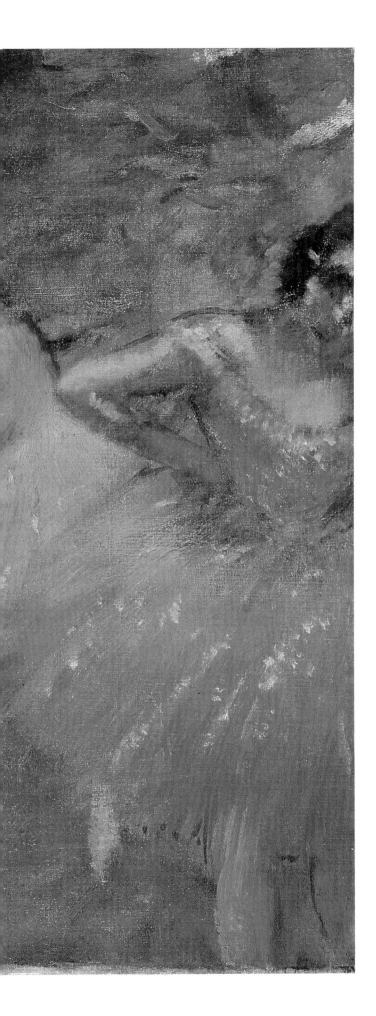

77

Rehearsal Before the Ballet, c. 1877

Oil on canvas, 19¾ x 24¼ in.

Museum of Fine Arts, Springfield, Massachusetts

James Philip Gray Collection, acc. no. 41.01

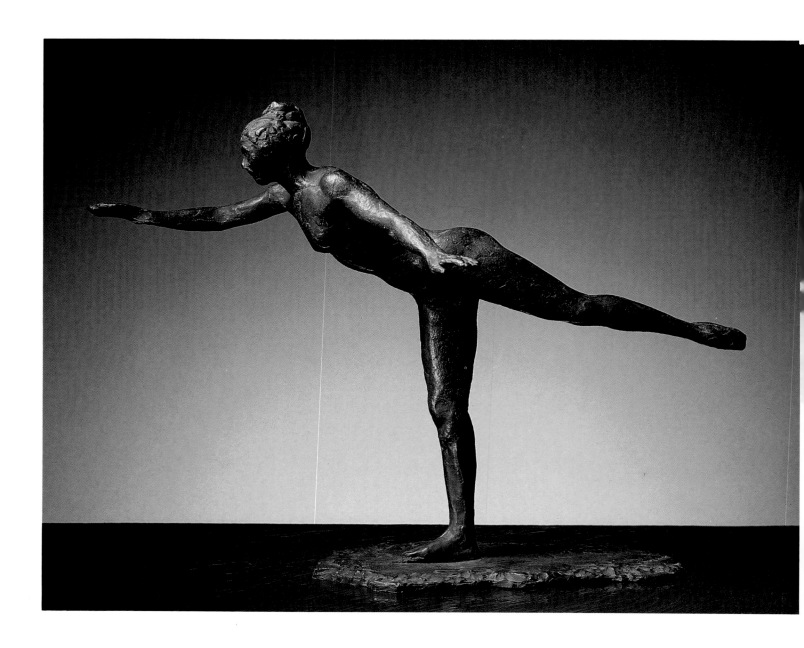

78

Grande Arabesque, Second Time, c. 1882–85

Bronze, 17⅛ in. high

(Rewald 36; BR. L-15)

Museu de Arte de São Paulo Assis Chateaubriand,

São Paulo, Brazil

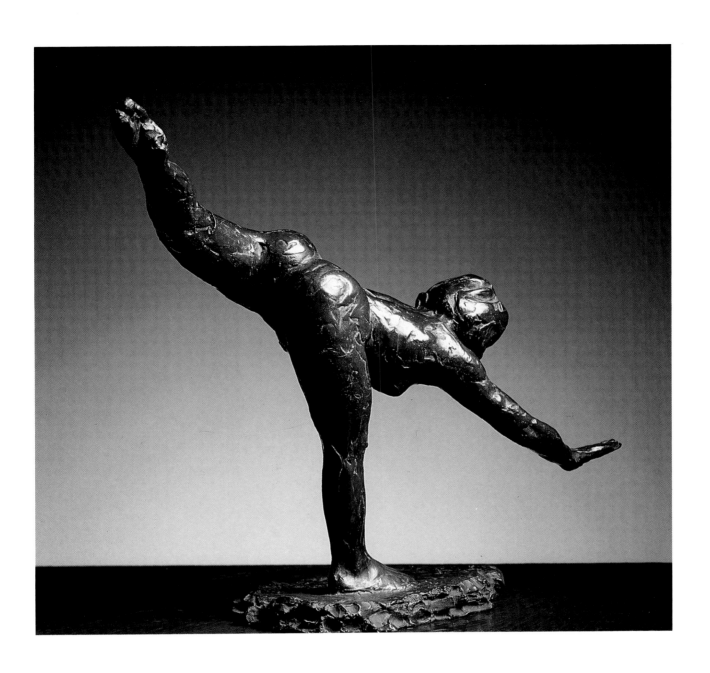

79

First Arabesque Penchée

(or Grande Arabesque, Third Time), c. 1885–90

Bronze, 17¹⁵⁄₁₆ in. high

(Rewald 39; BR. S-60)

Museu de Arte de São Paulo Assis Chateaubriand,

São Paulo, Brazil

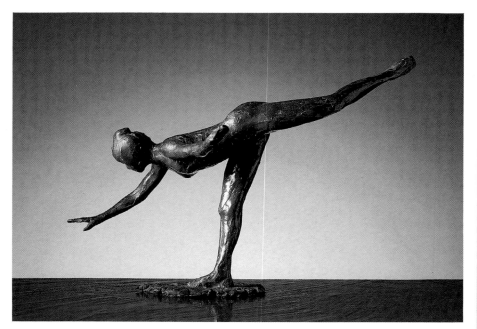

80

First Arabesque Penchée

(or Grande Arabesque, Third Time), c. 1882–85

Bronze, 16 in. high

(Rewald 40; BR. S-16)

Museu de Arte de São Paulo Assis Chateaubriand,

São Paulo, Brazil

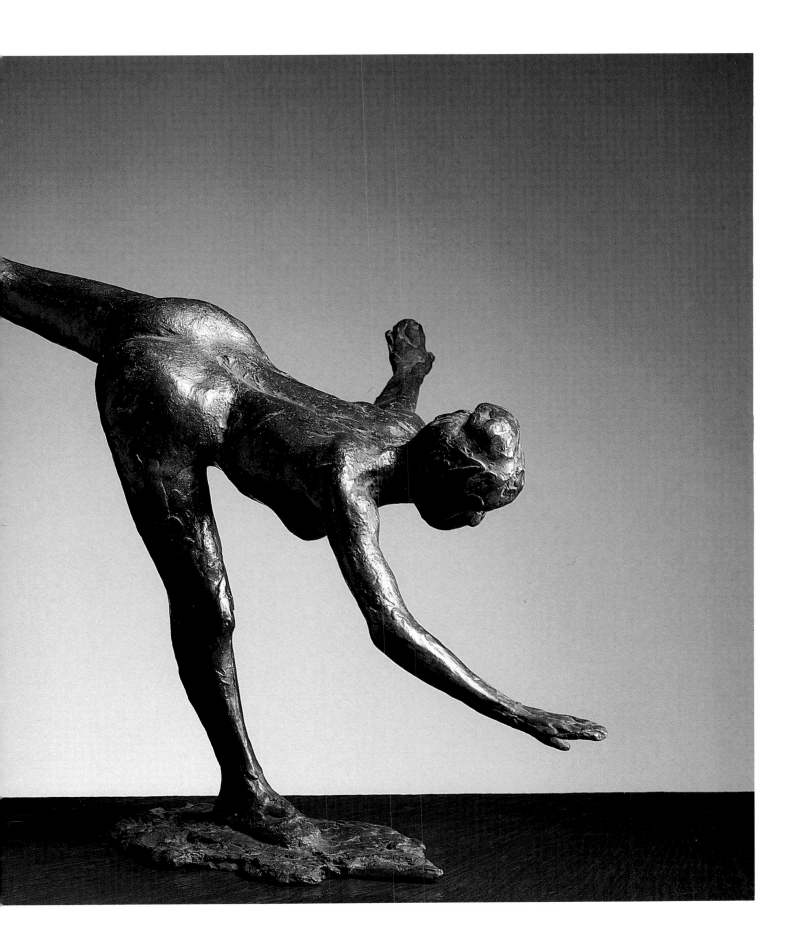

81

Dancer on the Stage (*Scène de ballet*),[f] 1880

Oil on paper on canvas, 20 x 22⅝ in.

The Dixon Gallery and Gardens, Memphis, Tennessee

Gift of The Sara Lee Corporation, acc. no. 1991.3

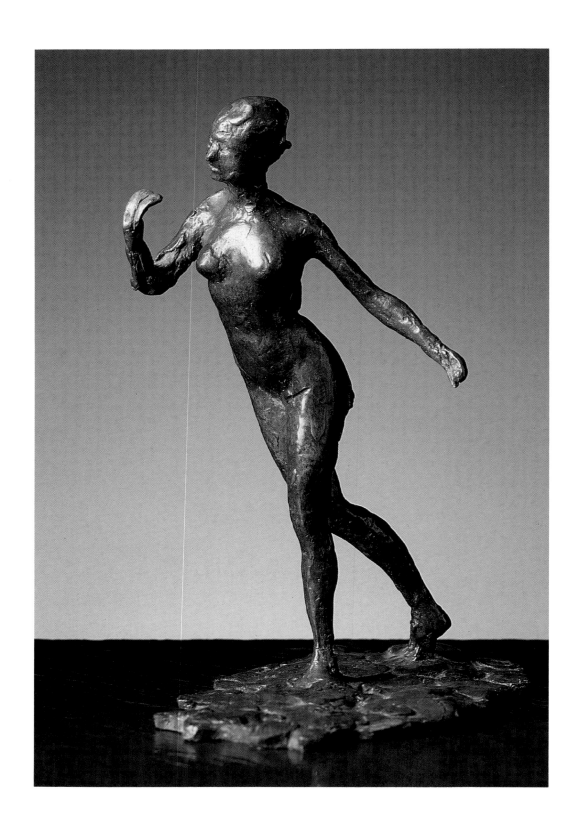

82

Dancer Bowing,

(or The Curtain Call), c. 1885–88

Bronze, 8¾ in. high

(Rewald 32; BR. S-31)

Museu de Arte de São Paulo Assis Chateaubriand,

São Paulo, Brazil

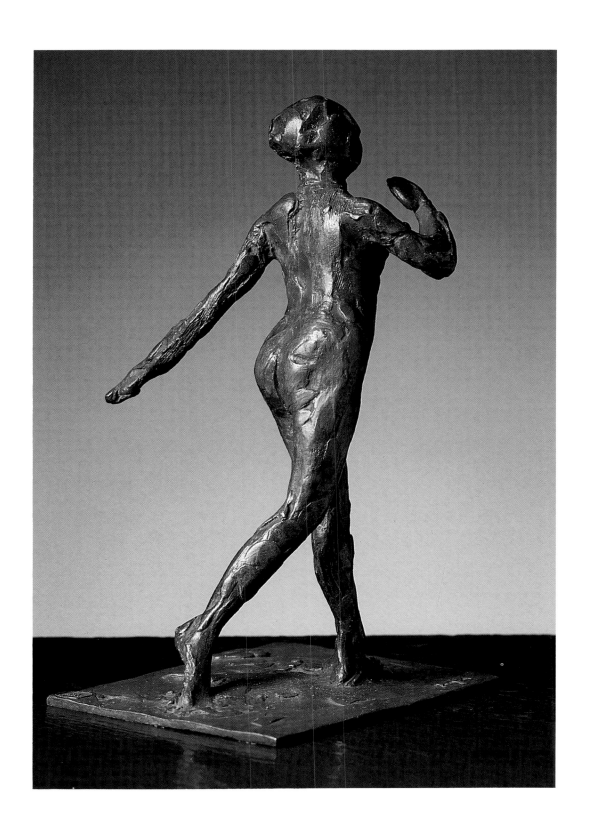

83

**Dancer Bowing
(or The Curtain Call)**, c. 1885–88

Bronze, 8⅞₆ in. high

(Rewald 33; BR. S-9)

Museu de Arte de São Paulo Assis Chateaubriand,

São Paulo, Brazil

84

Program for **Soirée Artistique,** 1884

Transfer lithograph; one state; 10⅜ x 14¹⁵⁄₁₆ in. (image)

(Delteil 58; Adhémar 56; R & S 54)

The Saint Louis Art Museum, Missouri

Gift of Horace M. Swope, acc. no. 249.40

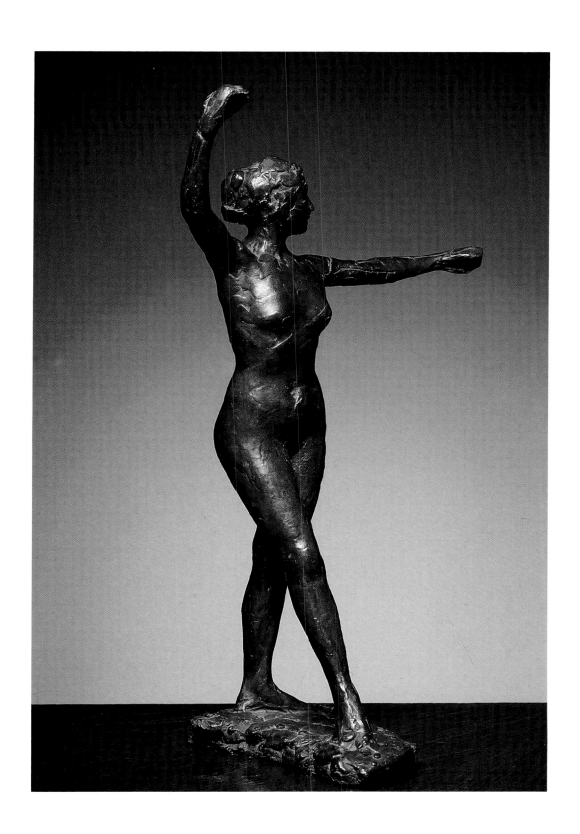

85

Dancer Ready to Dance, the Right Foot Forward,
c. 1885–90
Bronze, 22⅜ in. high
(Rewald 46; BR. S-57)
Museu de Arte de São Paulo Assis Chateaubriand,
São Paulo, Brazil

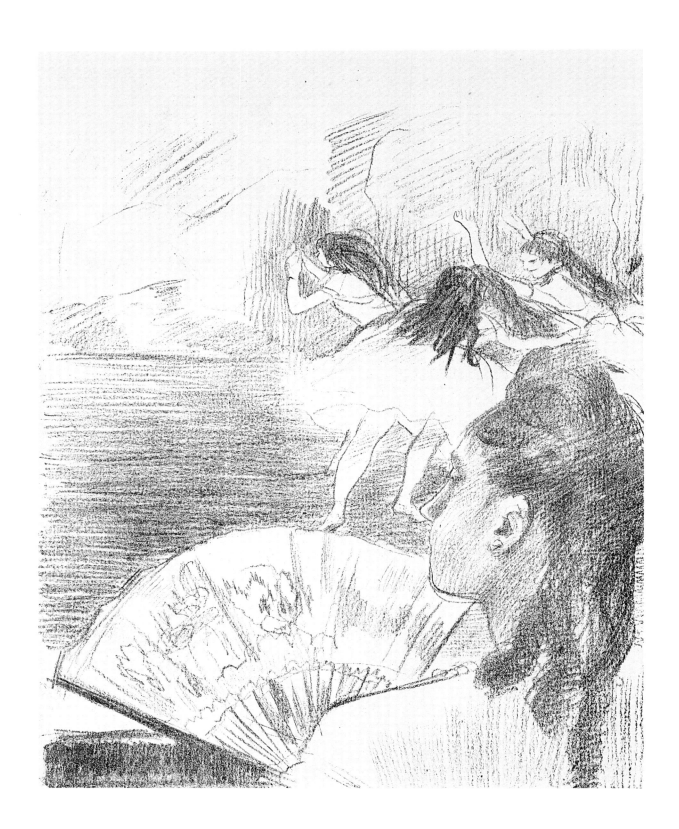

86

At the Theatre: Woman with a Fan, c. 1878–80

Crayon lithograph on paper from a transfer plate; one state;

9⅛ x 7⅞ in. (image)

(Delteil 56; Adhémar 34; R & S 37)

Museum of Fine Arts, Boston, Massachusetts

Bequest of W. G. Russell Allen, acc. no. 60.260

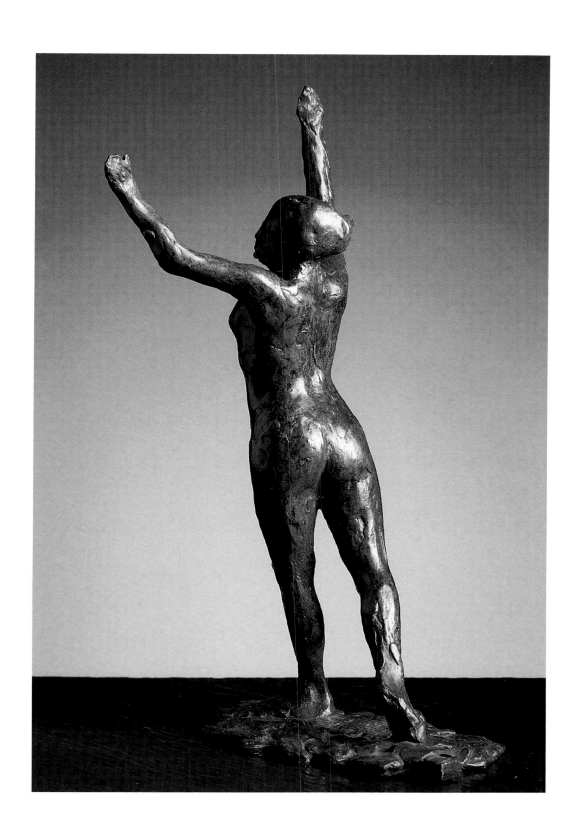

87

Dancer Moving Forward, Arms Raised, c. 1885–90

Bronze, 14 in. high

(Rewald 24; BR. I-19)

Museu de Arte de São Paulo Assis Chateaubriand,

São Paulo, Brazil

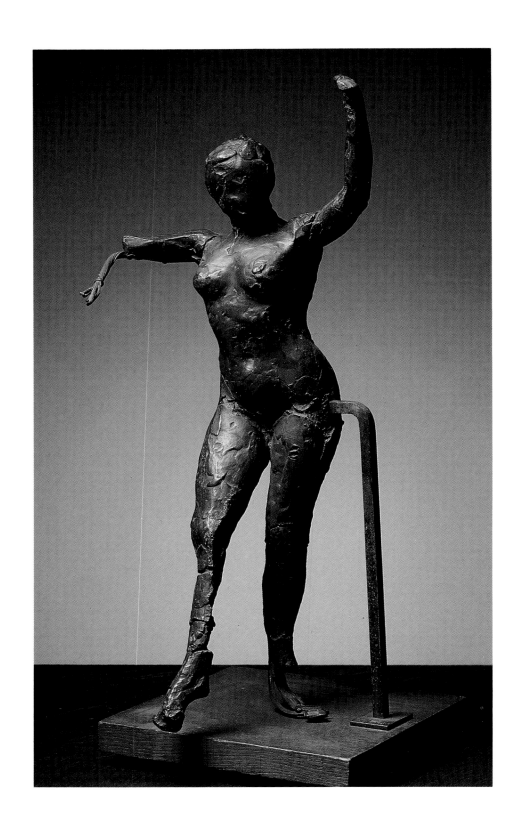

88

Dancer Moving Forward, Arms Raised,

Right Leg Forward, c. 1890

Bronze, 26⅛ in. high

(Rewald 26; BR. S-72)

Museu de Arte de São Paulo Assis Chateaubriand,

São Paulo, Brazil

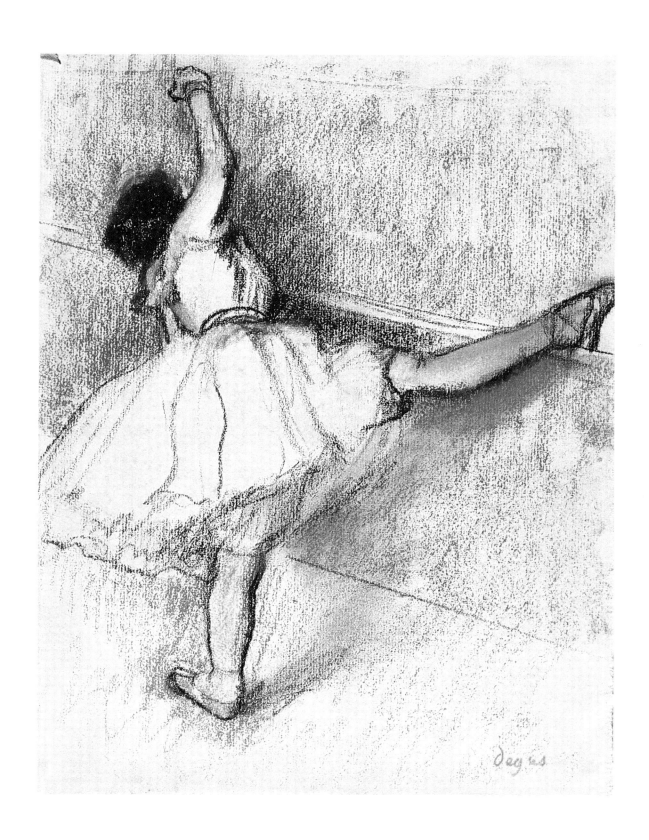

89

Dancer Stretching at the Bar,[b] c. 1877–80

Charcoal and pastel with estompe on cream
laid paper, 12³⁄₁₆ x 9¼ in.

The Art Institute of Chicago, Illinois

Mr. and Mrs. Martin A. Ryerson Collection, acc. no.

1933.1229

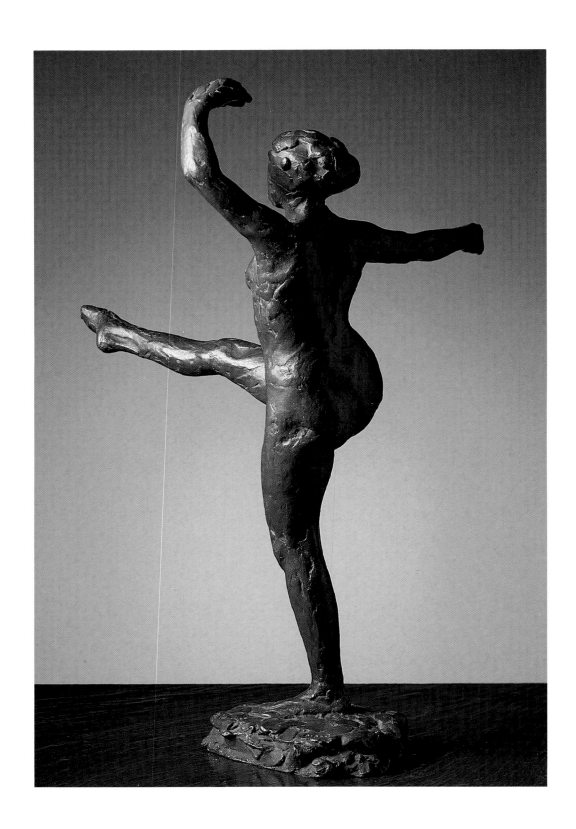

90

Dancer, Fourth Position Front, on the Left Leg

c. 1885–90

Bronze, 22⅜ in. high

(Rewald 44; BR. S-5)

Museu de Arte de São Paulo Assis Chateaubriand,

São Paulo, Brazil

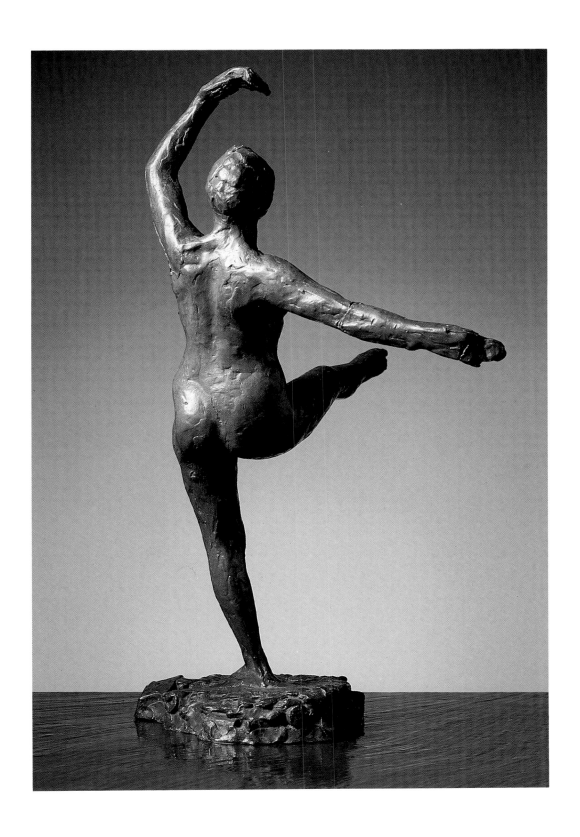

91

Dancer, Fourth Position Front, on the Left Leg,

c. 1885–90

Bronze, 23⅜ in. high

(Rewald 43; BR. S-58)

Museu de Arte de São Paulo Assis Chateaubriand,

São Paulo, Brazil

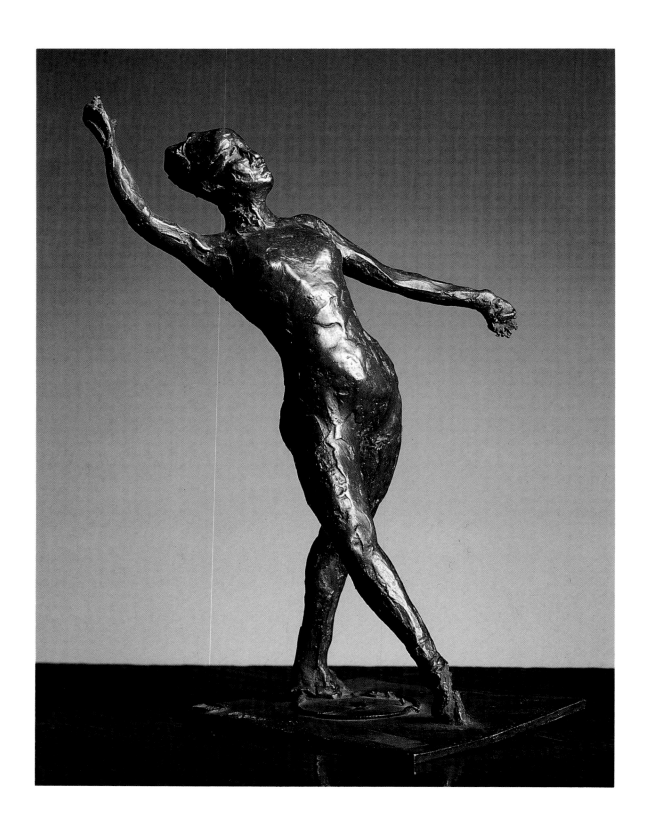

92

Dancer with Tambourine, c. 1885–90

Bronze, 10¹⁵⁄₁₆ in. high

(Rewald 34; BR. S-12)

Museu de Arte de São Paulo Assis Chateaubriand,

São Paulo, Brazil

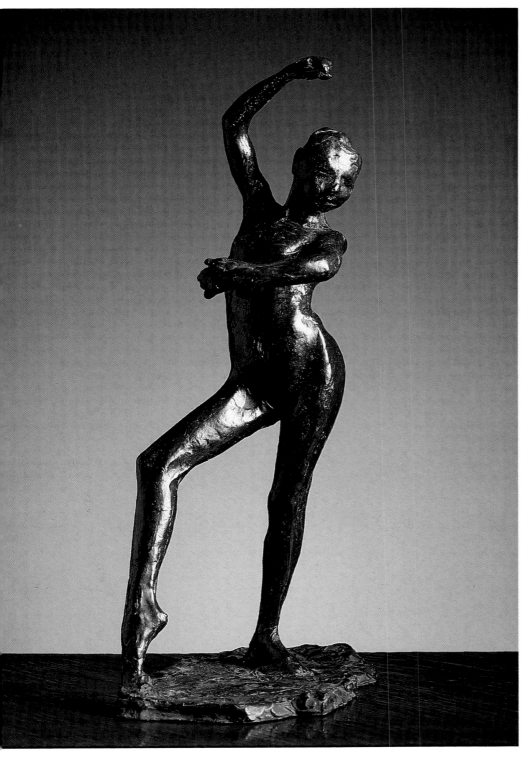

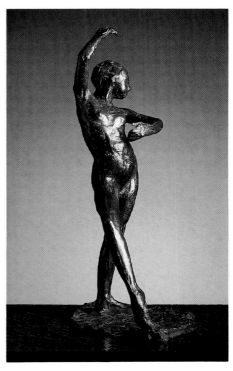

93

Spanish Dance, c. 1885–90

Bronze, 17⅛ in. high

(Rewald 47; BR. S-45)

Museu de Arte de São Paulo Assis Chateaubriand,

São Paulo, Brazil

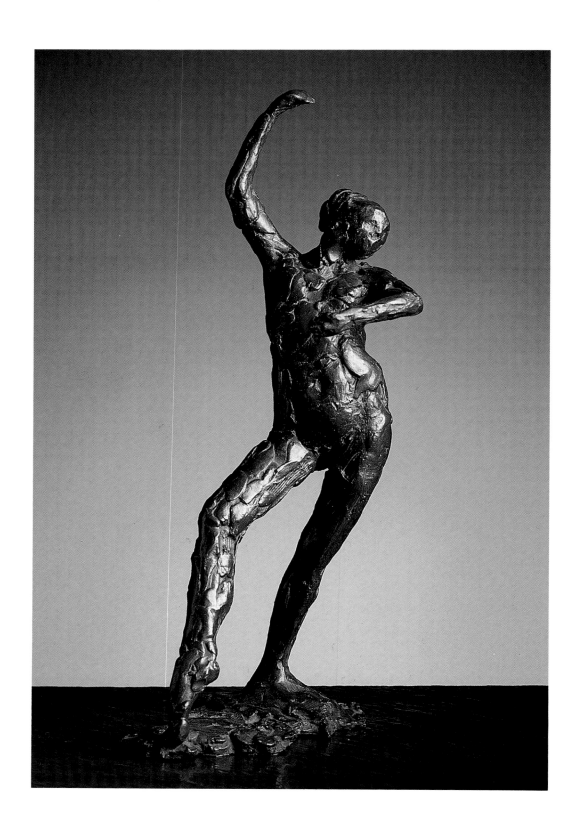

94

Spanish Dance, c. 1885–90

Bronze, 16¼ in. high

(Rewald 66; BR. S-20)

Museu de Arte de São Paulo Assis Chateaubriand,

São Paulo, Brazil

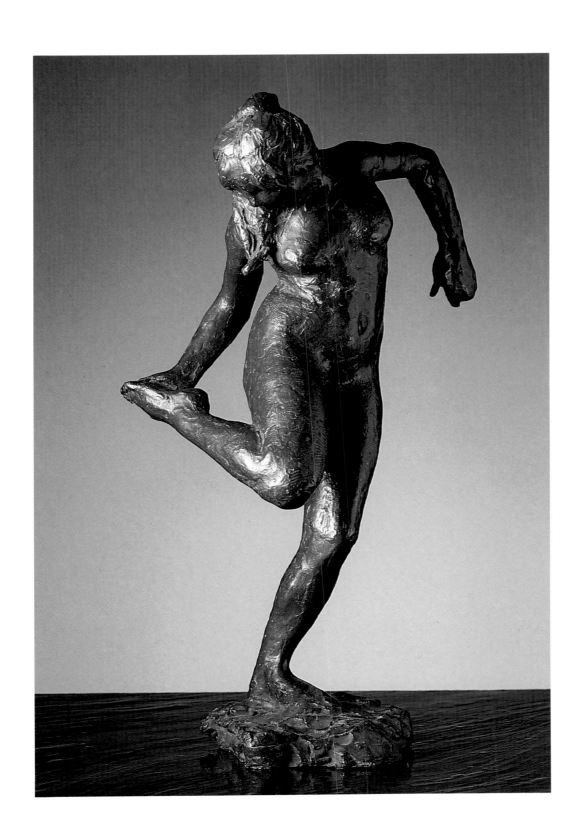

95

Dancer Looking at the Sole of Her Right Foot,

c. 1895–1900

Bronze, 18⅜ in. high

(Rewald 45; BR. S-40)

Museu de Arte de São Paulo Assis Chateaubriand,

São Paulo, Brazil

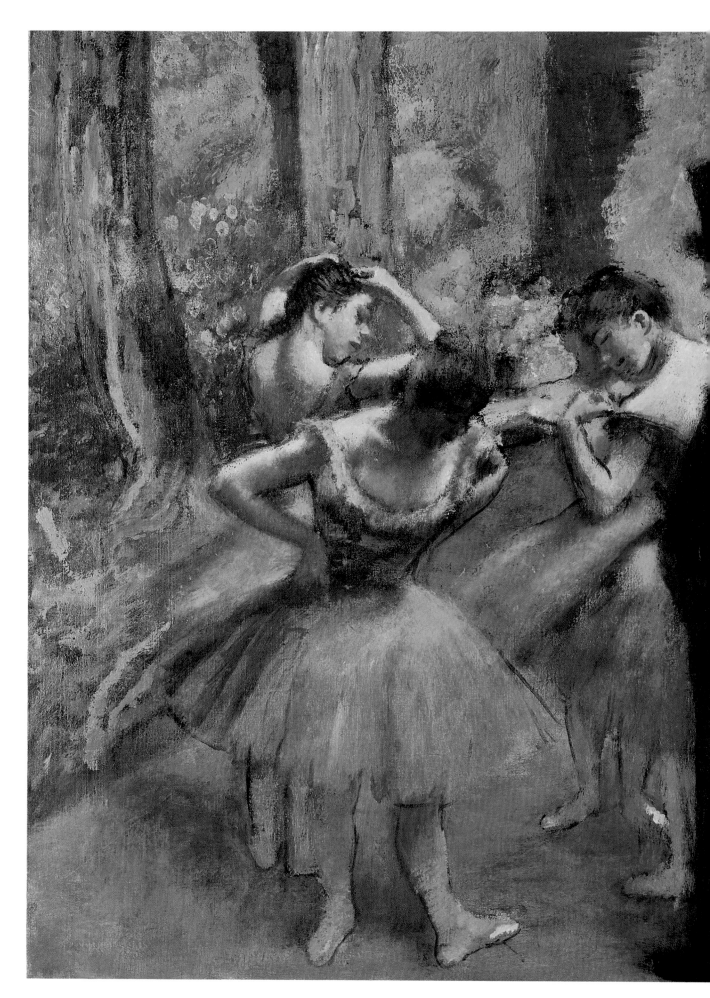

96

Dancers, Pink and Green,[b] c. 1890

Oil on canvas, 32⅜ x 29¾ in.

The Metropolitan Museum of Art, New York, New York

Bequest of Mrs. H. O. Havemeyer, 1929, the H. O.

Havemeyer Collection, acc. no. 29.100.42

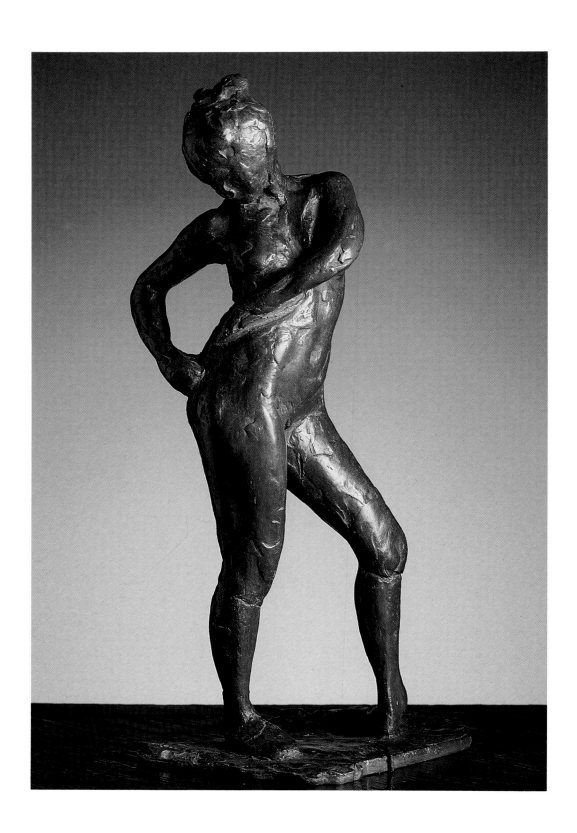

97

Dancer Fastening the String of Her Tights,

c. 1895–99

Bronze, 16¹⁵⁄₁₆ in. high

(Rewald 28; BR. S-33)

Museu de Arte de São Paulo Assis Chateaubriand,

São Paulo, Brazil

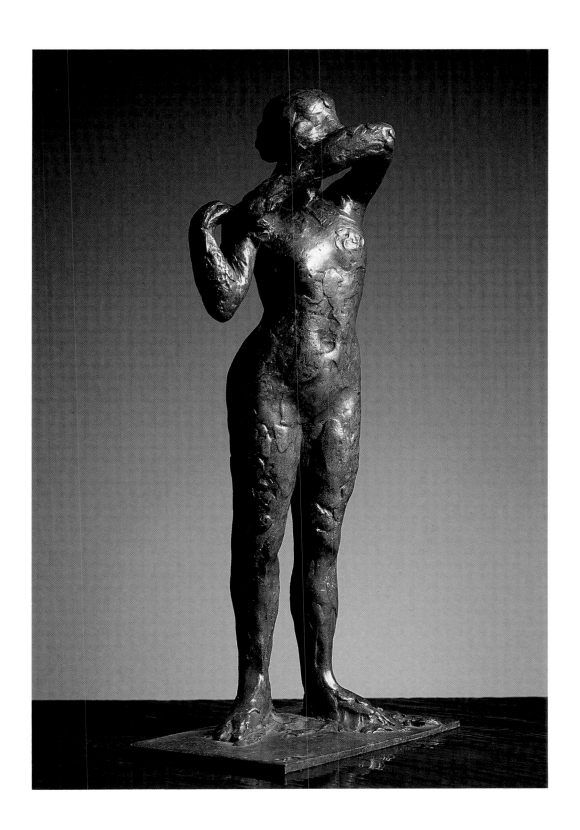

98

**Dancer Adjusting the Shoulder Strap of
Her Bodice**, c. 1896–99

Bronze, 13⅞ in. high

(Rewald 25; BR. S-64)

Museu de Arte de São Paulo Assis Chateaubriand,

São Paulo, Brazil

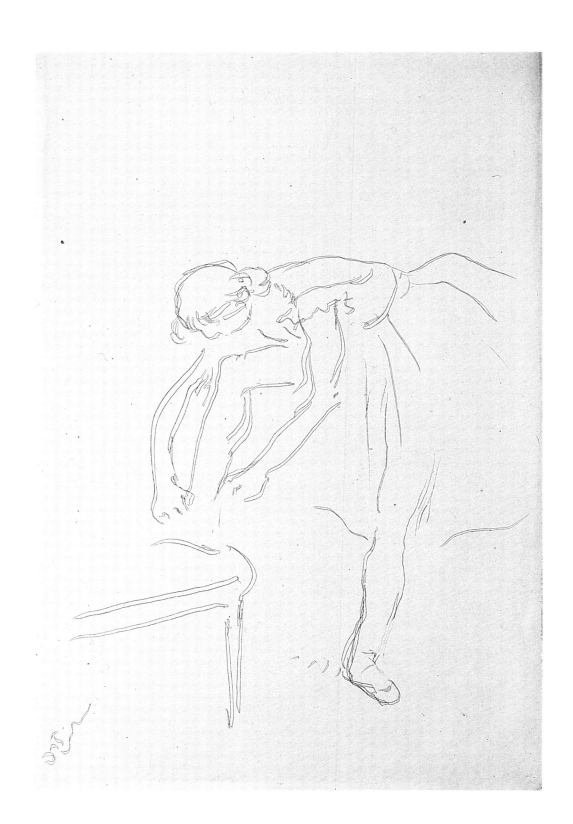

99

Dancer Putting on Her Shoe, c. 1888

Etching on white wove paper, state i/ii, 7 x 4⅝ in. (plate)

(Delteil 36; Adhémar 60; R & S 55)

The Art Institute of Chicago, Illinois

Joseph Brooks Fair Collection, acc. no. 1932.1334

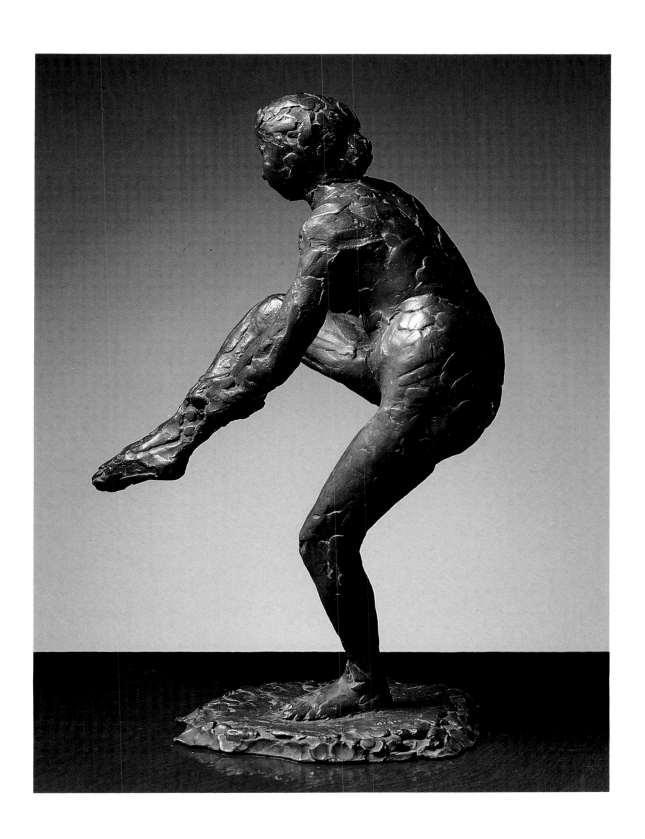

100

Dancer Putting on Her Stocking, c. 1900–05

Bronze, 18½ in. high

(Rewald 56; BR. S-29)

Museu de Arte de São Paulo Assis Chateaubriand,

São Paulo, Brazil

101

Two Dancers in a Rehearsal Room, c. 1877–78

Aquatint, drypoint and burnishing, printed in black ink

on laid paper with partial ARCHES watermark; one state;

6⅞ x 8⅛ in. (plate)

(Delteil 22; Adhémar 37; R & S 33)

Mr. James A. Bergquist, Boston, Massachusetts

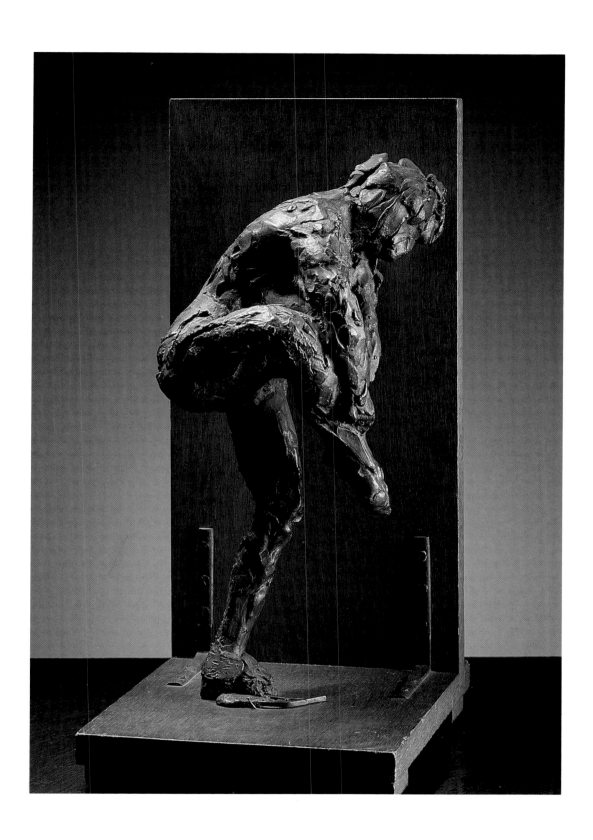

102

Dancer Putting on Her Stocking, c. 1900–05

Bronze, 18¼ in. high

(Rewald 57; BR. S-52)

Museu de Arte de São Paulo Assis Chateaubriand,

São Paulo, Brazil

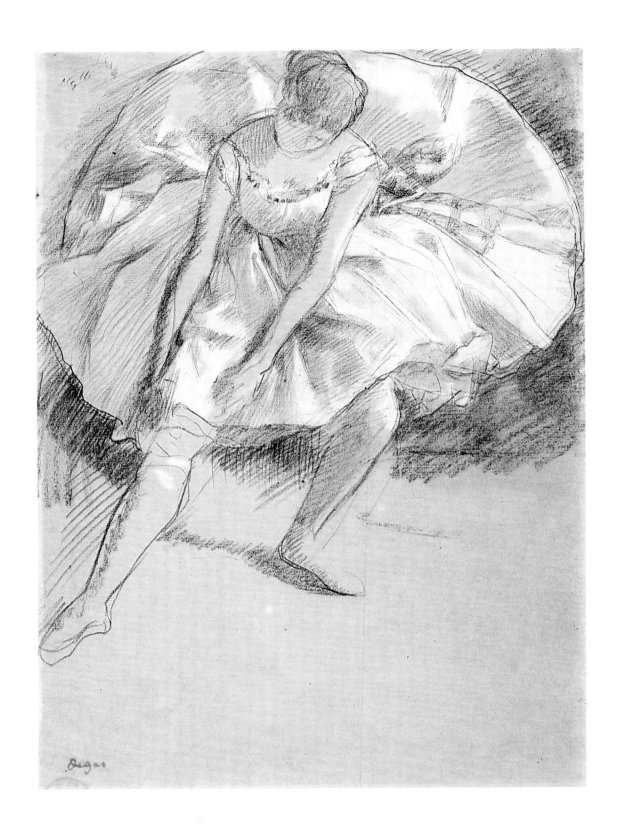

103

Dancer Adjusting Her Stocking,[b] c. 1885

Charcoal and chalk on paper, 15⅝ x 11 in.

The Marion Koogler McNay Art Museum, San Antonio, Texas

Bequest of Marion Koogler McNay, acc. no. 1950-31

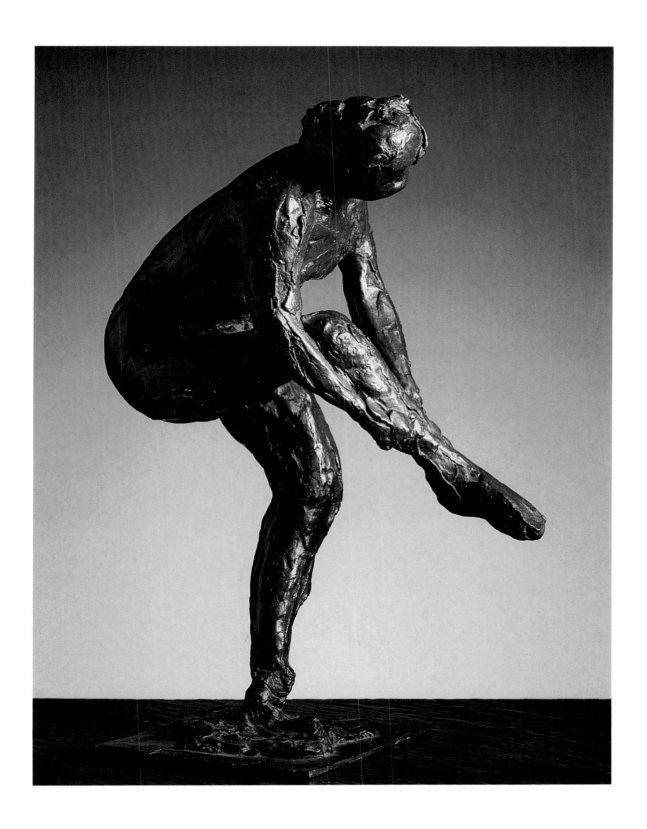

104

Dancer Putting on Her Stocking, c. 1900–05

Bronze, 17 in. high

(Rewald 58; BR. S-70)

Museu de Arte de São Paulo Assis Chateaubriand,

São Paulo, Brazil

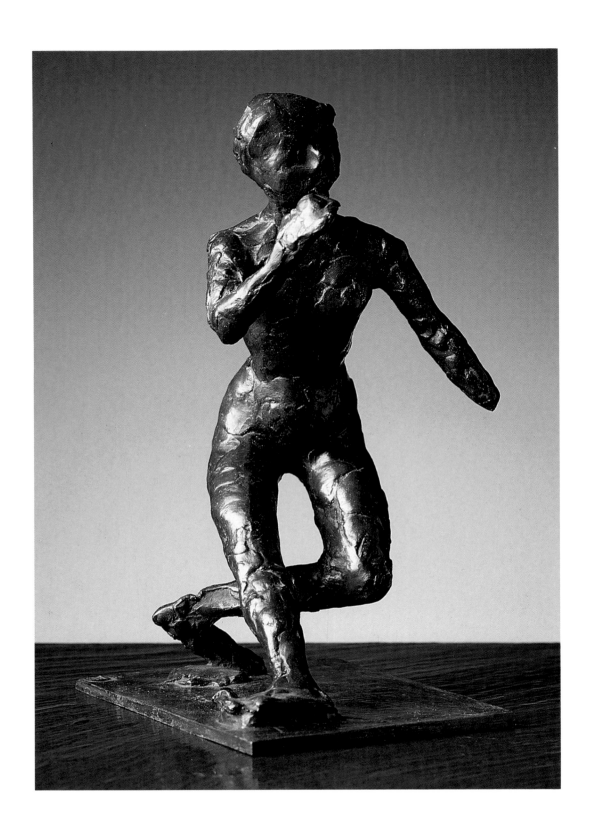

105

The Bow, c. 1895–99

Bronze, 13⅜ in. high

(Rewald 53; BR. S-34)

Museu de Arte de São Paulo Assis Chateaubriand,

São Paulo, Brazil

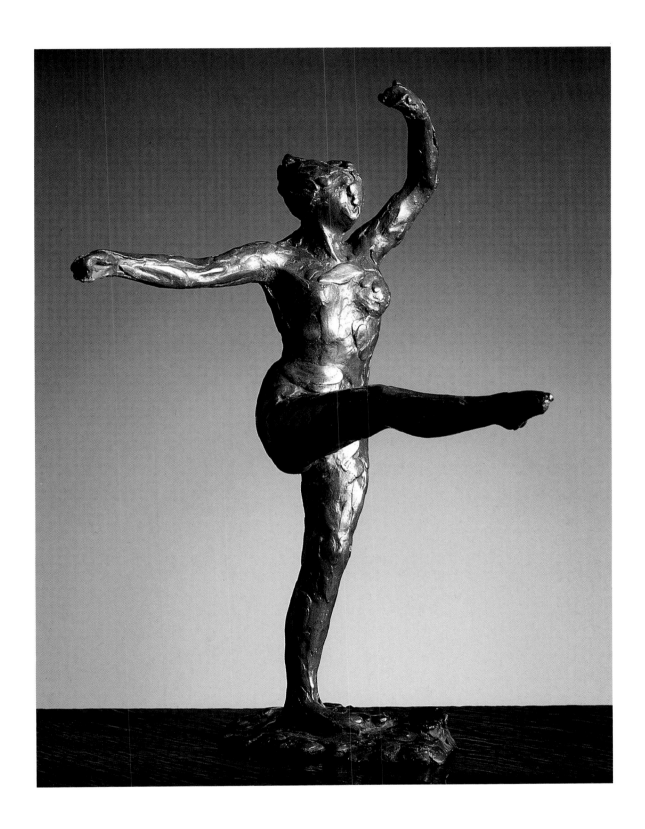

106

Dancer, Fourth Position Front, on the Left Leg,

c. 1885–90

Bronze, 16⅛ in. high

(Rewald 55; BR. S-6)

Museu de Arte de São Paulo Assis Chateaubriand,

São Paulo, Brazil

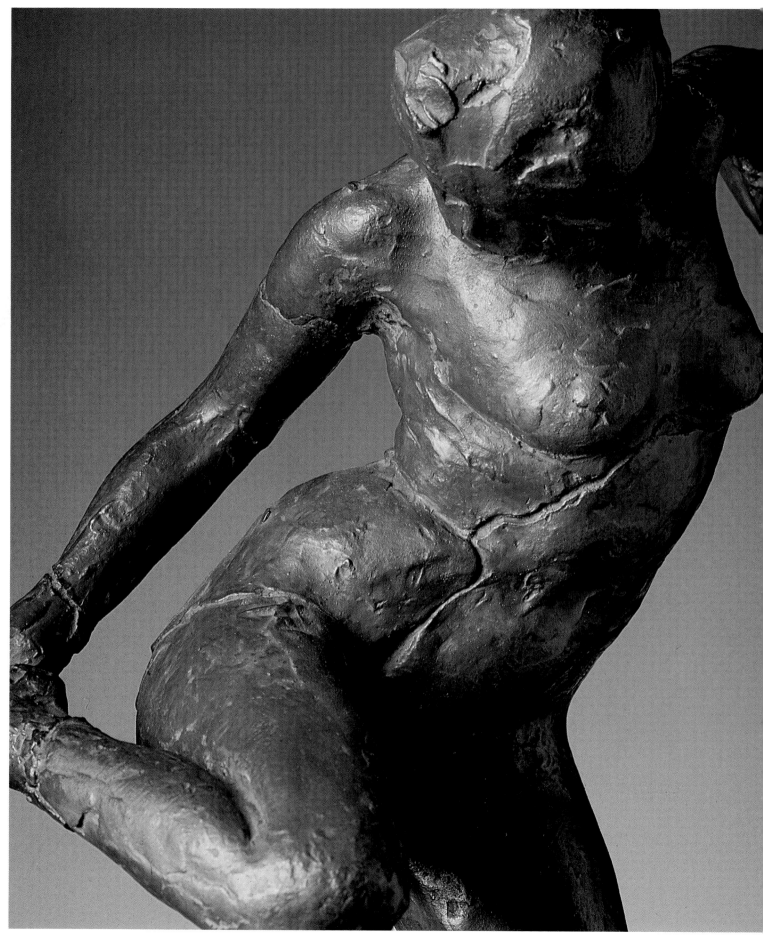

(detail)

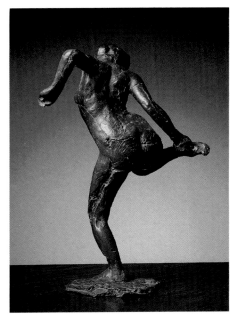

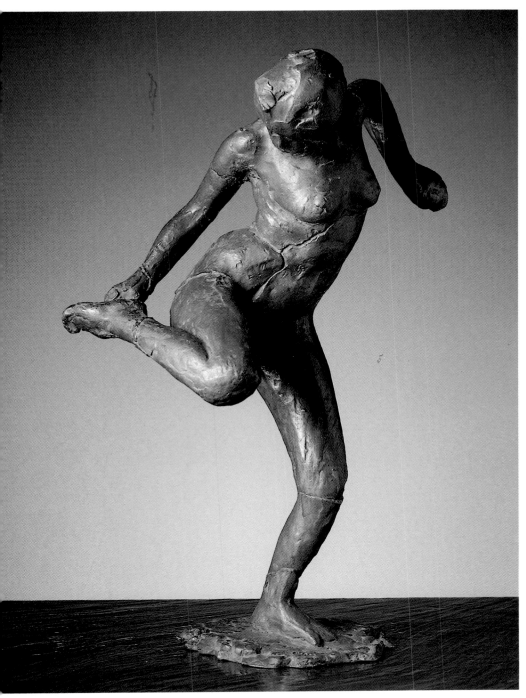

107

Dancer Looking at the Sole of Her Right Foot,

c. 1895–1910

Bronze, 19¼ in. high

(Rewald 49; BR. S-69)

Museu de Arte de São Paulo Assis Chateaubriand,

São Paulo, Brazil

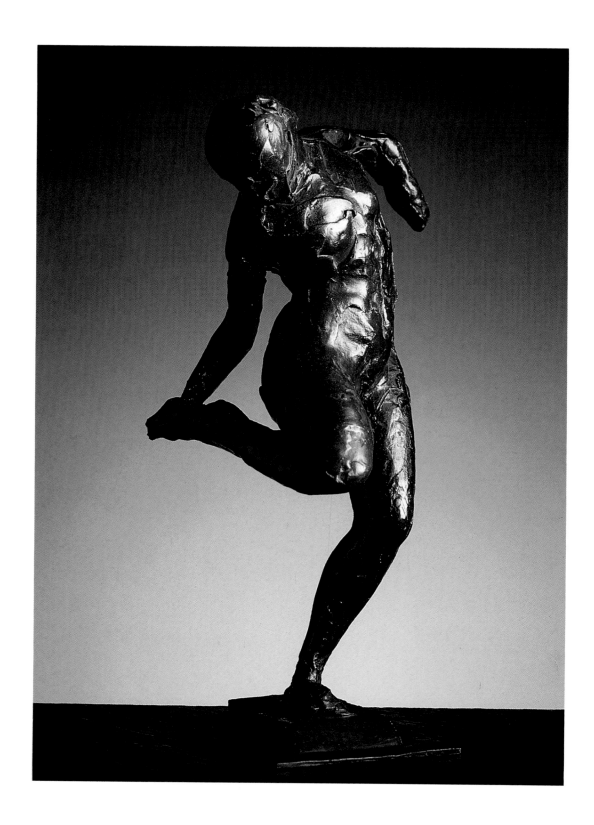

108

Dancer Looking at the Sole of Her Right Foot,

c. 1895–1910

Bronze, 18 in. high

(Rewald 60; BR. S-67)

Museu de Arte de São Paulo Assis Chateaubriand,

São Paulo, Brazil

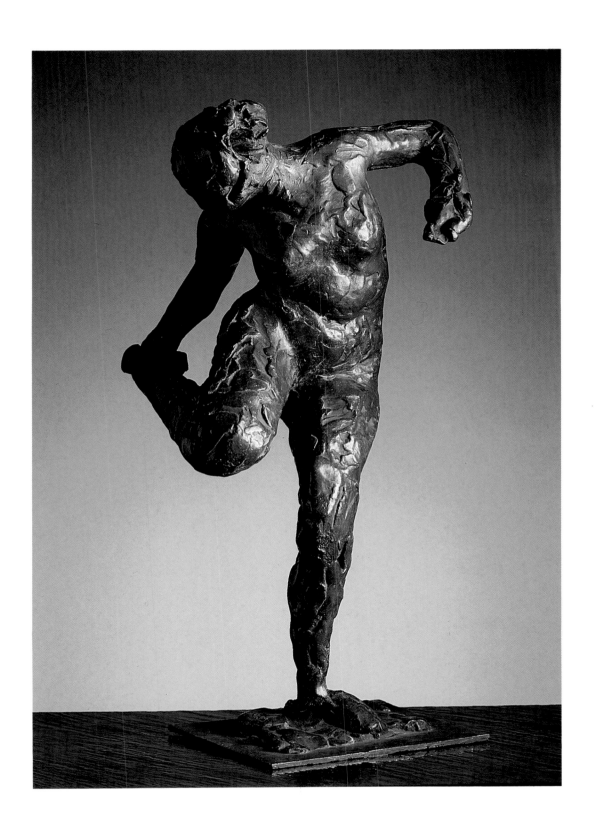

109

Dancer Looking at the Sole of Her Right Foot,

c. 1895–1910

Bronze, 19 in. high

(Rewald 61; BR. S-59)

Museu de Arte de São Paulo Assis Chateaubriand,

São Paulo, Brazil

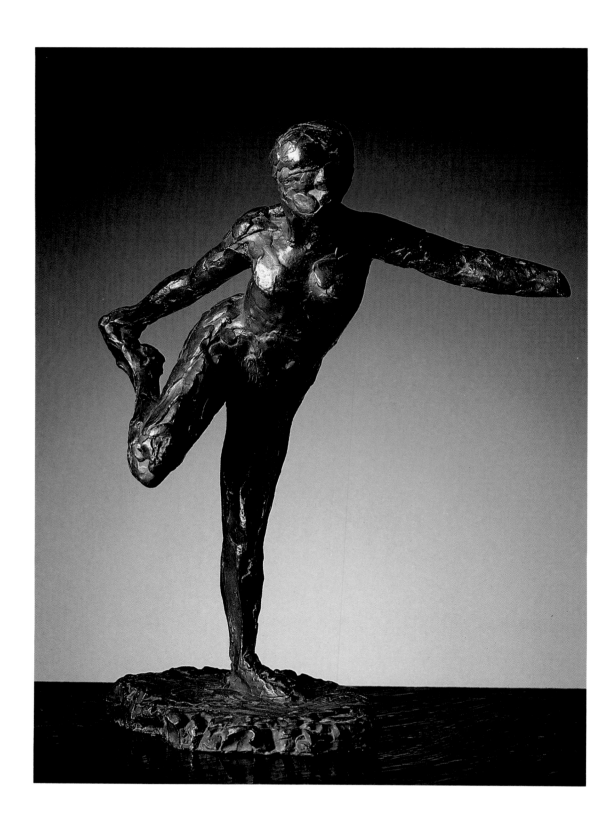

110

Dancer Holding Her Right Foot in Her

Right Hand, c. 1895–1910

Bronze, 19⅞ in. high

(Rewald 62; BR. S-68)

Museu de Arte de São Paulo Assis Chateaubriand,

São Paulo, Brazil

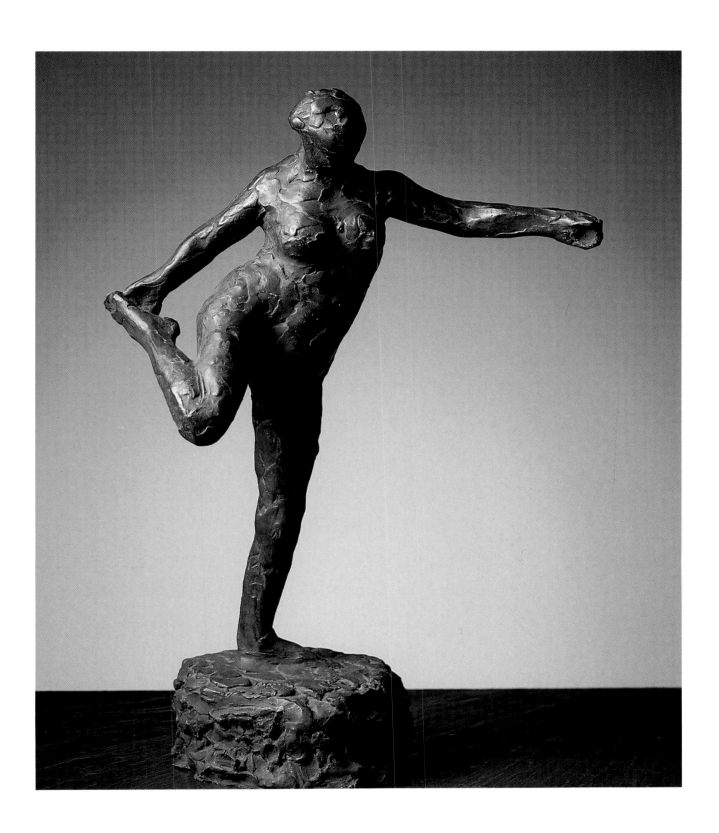

111

**Dancer Holding Her Right Foot in Her
Right Hand**, c. 1895–1910

Bronze, 21⅛ in. high

(Rewald 65; BR. S-23)

Museu de Arte de São Paulo Assis Chateaubriand,

São Paulo, Brazil

Photography Credits

Fondation Pierre Gianadda

Bibliothèque Nationale, Paris

The Art Institute of Chicago

Ball State University

BBS Images, Dayton, Ohio

Museum of Fine Arts, Boston

Sterling and Francine Clark Art Institute

Cleveland Museum of Art

The Dayton Art Institute

The Detroit Institute of Arts

The Dixon Gallery and Gardens

H. Peter Findlay

The J. Paul Getty Museum

Harvard University Art Museums, Photographic Services

Henrich Photographs, Buffalo, NY

Joseph Levy, Saratoga Springs, NY

Los Angeles County Museum of Art

McNay Art Museum

The Metropolitan Museum of Art

Museum of Fine Arts, Springfield

The Nelson-Atkins Museum of Art

The Fine Arts Museums of San Francisco

The Sara Lee Corporation

Smith College Museum of Art

Stephen Petegorsky Photography, Northampton, MA

The Saint Louis Art Museum

Bruce M. White Photography, New York, NY

Yale University Art Gallery

Edgar Degas
Dancer of the Corps de Ballet,
c. 1896
Modern print from the
original collodian plates.
Courtesy Bibliothèque
Nationale, Paris

Exhibition Checklist

1

Self-Portrait, 1857
Etching, state iv/iv, 9⅛₆ x 5¹¹⁄₁₆ in. (plate)
(Delteil 1; Adhémar 13; R & S 8)
Los Angeles County Museum of Art, California
Purchased with funds provided by the Garrett Corporation,
1981, acc. no. M.81.54

Bathers and Varia

2

The Tub, c. 1886–88
Bronze 18 x 17¼ in.
(Rewald 27; BR.ᵃ S-26)
Museu de Arte de São Paulo Assis Chateaubriand,
São Paulo, Brazil

3

After the Bath, 1891–92
Lithograph, transfer, and crayon, on paper; state iv/vi;
10¹³⁄₁₆ x 12⅜₆ in. (image)
(Delteil 64; Adhémar 68; R & S 66)
Museum of Fine Arts, Boston, Massachusetts
Katherine E. Bullard Fund in memory of Francis Bullard and
proceeds from sale of duplicate prints,
acc. no. 1983.312

4

**Woman Rubbing Her Back with a Sponge,
Torso**, c. 1888
Bronze, 19⅛ in. high
(Rewald 51; BR. C-28)
Museu de Arte de São Paulo Assis Chateaubriand,
São Paulo, Brazil

5

After the Bath (La Sortie du bain),ᵇ 1891–92
Lithograph, state i/ii, 9⅞ x 9⅛₆ in. (image)
(Delteil 63; Adhémar 67; R & S 65)
The Marion Koogler McNay Art Museum,
San Antonio, Texas
Gift of the Friends of the McNay, acc. no. 1961.11

6

Nude Woman Standing, Drying Herself,
1891–92
Lithograph, state iv/vi, 13 x 9¾ in.
(Delteil 65; Adhémar 63; R & S 61)
The Sterling and Francine Clark Art Institute,
Williamstown, Massachusetts, acc. no. 62.032,
acc. no. 1962.38

7

Woman Arranging Her Hair, c. 1900–05
Bronze, 18½ in. high
(Rewald 50; BR. S-50)
Museu de Arte de São Paulo Assis Chateaubriand,
São Paulo, Brazil

8

After the Bath, c. 1895–98
Pastel on paper, 37 x 33 in.
The Sara Lee Corporation, Chicago, Illinois

9

Leaving the Bath (La Sortie du bain), c. 1879–80
Drypoint and aquatint, printed in black ink on tan wove
paper; state xviii/xxii; 5 x 5 in. (plate)
(Delteil 39; Adhémar 49; R & S 42)
Mr. James A. Bergquist, Boston, Massachusetts

10

Woman Getting out of the Bath (Fragment),
c. 1895–1900
Bronze, 16⁹⁄₁₆ in. high
(Rewald 59; BR. S-71)
Museu de Arte de São Paulo Assis Chateaubriand,
São Paulo, Brazil

11

Woman Washing Her Left Leg, c. 1900–03
Bronze, 7⅞ in. high
(Rewald 68; BR. S-61)
Museu de Arte de São Paulo Assis Chateaubriand,
São Paulo, Brazil

12

Woman Washing Her Left Leg, c. 1900–03
Bronze, 5¹⁵⁄₁₆ in. high
(Rewald 67; BR. S-17)
Museu de Arte de São Paulo Assis Chateaubriand,
São Paulo, Brazil

13

Seated Woman Wiping Her Left Side,
c. 1900–03
Bronze, 13⅜₆ in. high
(Rewald 69; BR. S-46)
Museu de Arte de São Paulo Assis Chateaubriand,
São Paulo, Brazil

14

After the Bath, Seated Woman Drying Herself,ᵇ
c. 1885
Charcoal and pastel on paper, 13⅜ x 9¾ in.
The Nelson-Atkins Museum of Art, Kansas City, Missouri
Gift of Mrs. David M. Lighton, acc. no. 35-39/1

15

**Woman Seated in an Arm-Chair Wiping
Her Neck**, c. 1900–03
Bronze, 12¹³⁄₁₆ in. high
(Rewald 70; BR. S-44)
Museu de Arte de São Paulo Assis Chateaubriand,
São Paulo, Brazil

16

After the Bath, c. 1886
Charcoal and pastel on cream laid paper
with PL BAS watermark, 18 x 23¼ in.
The Dayton Art Institute, Ohio
Gift of Mr. and Mrs. Anthony Haswell, acc. no. 52.33

17

Seated Woman Wiping Her Left Hip, c. 1900–03
Bronze, 17⅞ in. high
(Rewald 71; BR. S-54)
Museu de Arte de São Paulo Assis Chateaubriand,
São Paulo, Brazil

18

**Woman Seated in an Arm-Chair Wiping Her
Left Armpit**, c. 1900–05
Bronze, 12⅜ in. high
(Rewald 72; BR. S-43)
Museu de Arte de São Paulo Assis Chateaubriand,
São Paulo, Brazil

19
Standing Female Nude (Bather), c. 1896
Charcoal and pastel on light blue paper, 18½ x 12⅜ in.
The Art Museum, Princeton University,
Princeton, New Jersey
Gift of Frank Jewett Mather, Jr., acc. no. 43-136

20
Woman Taken Unawares, c. 1896-1899
Bronze, 16⅛ in. high
(Rewald 54; BR. S-42)
Museu de Arte de São Paulo Assis Chateaubriand,
São Paulo, Brazil

21
The Masseuse, c. 1900–03
Bronze, 16¹⁵⁄₁₆ in. high
(Rewald 73; BR. S-55)
Museu de Arte de São Paulo Assis Chateaubriand,
São Paulo, Brazil

22
Bathers (Les Baigneuses), c. 1875–80
Monotype in black ink on tan laid paper with
partial DAMBRICOURT FRERES watermark, 4¾ x 6¼ in.
(Adhémar 169; Janis 262)
Mr. James A. Bergquist, Boston, Massachusetts

23
Woman Stretching, c. 1895–1900
Bronze, 14⅜ in. high
(Rewald 64; BR. S-53)
Museu de Arte de São Paulo Assis Chateaubriand,
São Paulo, Brazil

24
Pregnant Woman, c. 1895–1900
Bronze, 17⅜ in. high
(Rewald 63; BR. S-24)
Museu de Arte de São Paulo Assis Chateaubriand,
São Paulo, Brazil

25
Picking Apples, before 1870
Bronze, 19⅛ x 18 in.
(Rewald 1; BR. S-37)
Museu de Arte de São Paulo Assis Chateaubriand,
São Paulo, Brazil

26
Woman Arranging Her Hair,[b] c. 1885
Charcoal and pastel on paper, 23 x 16¹⁵⁄₁₆ in.
The Fine Arts Museums of San Francisco, California
Achenbach Foundation for Graphic Arts
Memorial Gift from Dr. T. Edward and Tullah Hanley,
Bradford, Pennsylvania, acc. no. 69.30.42

27
Head Resting on One Hand, Bust, c. 1879–81
Bronze, 4⅜ in. high
(Rewald 29; BR. S-62)
Museu de Arte de São Paulo Assis Chateaubriand,
São Paulo, Brazil

28
Head, Study for the Portrait of Madame S.,
c. 1892
Bronze, 10⅜ in. high (16⅜ in. high with base)
(Rewald 31; BR. S-27)
Museu de Arte de São Paulo Assis Chateaubriand,
São Paulo, Brazil

29
Head, Study for the Portrait of Madame S.,
c. 1892
Bronze, 6⅜ in. high
(Rewald 30; BR. S-7)
Museu de Arte de São Paulo Assis Chateaubriand,
São Paulo, Brazil

30
The Actress Ellen Andrée, 1879
Drypoint, state iii/iii, 4⁷⁄₁₀ x 3⅛ in. (plate)
(Delteil 20; Adhémar 52; R & S 40)
Museum of Fine Arts, Boston, Massachusetts
Katherine E. Bullard Fund in memory of Francis Bullard and
proceeds from sale of duplicate prints,
acc. no. 1983.317

31
The Schoolgirl, c. 1880–81
Bronze, 10¾ in. high
(Rewald 74)
Lent by The Detroit Institute of Arts, Michigan
Gift of Dr. and Mrs. George Kamperman,
acc. no. 56.173

The Racetrack — Horses

32
Study of a Saddled Horse, c. 1873
Pencil on paper, 9 x 11¾ in.
Private Collector, Buffalo, New York

33
Horse Standing, c. 1866–68
Bronze, 11⅜ in. high
(Rewald 3; BR. S-38)
Museu de Arte de São Paulo Assis Chateaubriand,
São Paulo, Brazil

34
Horse at Trough, c. 1866–68
Bronze, 6½ in. high
(Rewald 2; BR. S-13)
Museu de Arte de São Paulo Assis Chateaubriand,
São Paulo, Brazil

35
Horses in the Meadow, c. 1891–92
Softground etching, aquatint, and drypoint; intermediate
unrecorded state between ii and iii/iii; as published in
Georges Lecomte, *L'Art impressioniste d'après la collection
privée de Monsieur Durand-Ruel* (Paris, 1892); 5⅛ x 5¹³⁄₁₆ in.
(plate)
(Delteil 66; Adhémar 57; R & S 56)
Mr. James A. Bergquist, Boston, Massachusetts

36
Study of a Mustang, c. 1882–85
Bronze, 8⅜ in. high
(Rewald 8; BR. S-21)
Museu de Arte de São Paulo Assis Chateaubriand,
São Paulo, Brazil

37
The Jockey, 1881–85
Charcoal on paper, 13¾ x 8½ in.
Private Collector, Buffalo, New York

38
The Jockey,[b] c. 1881–85
Charcoal on paper, 19⅛ x 12⅜ in.
The Cleveland Museum of Art, Ohio
Gift of the Print Club of the Cleveland Museum of Art,
acc. no. 27.301

39
Thoroughbred Horse Walking, c. 1882–85
Bronze, 5¼ in. high
(Rewald 5; BR. S-66)
Museu de Arte de São Paulo Assis Chateaubriand,
São Paulo, Brazil

40
At the Races, 1862
Pencil on paper, 13¾ x 19 in.
The Sterling and Francine Clark Art Institute,
Williamstown, Massachusetts, acc. no. 1401

41
Horse Walking, c. 1882–85
Bronze, 9⅒ in. high
(Rewald 4; BR. S-11)
Museu de Arte de São Paulo Assis Chateaubriand,
São Paulo, Brazil

42
Jockeys on Horses, c. 1885
Charcoal on tan paper, 24⅝ x 12⅝ in.
The Art Museum, Princeton University, Princeton,
New Jersey
Gift of Albert E. McVitty, acc. no. 43-218

43
Horse and Rider,^C c. 1887–90
Charcoal on buff tracing paper, 10 x 11⅞ in.
The Art Institute of Chicago, Illinois
Bequest of Joseph Winterbotham, acc. no. 1954.329

44
Horse Walking, c. 1882–85
Bronze, 8⅜ in. high
(Rewald 10; BR. S-10)
Museu de Arte de São Paulo Assis Chateaubriand,
São Paulo, Brazil

45
Draft Horse, c. 1882
Bronze, 3¹⅒ in. high
(Rewald 7; BR. S-30)
Museu de Arte de São Paulo Assis Chateaubriand,
São Paulo, Brazil

46
Horse with Head Lowered, c. 1882–85
Bronze, 7⅜ in. high
(Rewald 12; BR. S-22)
Museu de Arte de São Paulo Assis Chateaubriand,
São Paulo, Brazil

47
Horse Galloping on the Right Hoof, c. 1888–90
Bronze, 12½ in. high
(Rewald 6; BR. S-47)
Museu de Arte de São Paulo Assis Chateaubriand,
São Paulo, Brazil

48
Horse Clearing an Obstacle (or Horse Standing),
c. 1888–90
Bronze, 11 in. high
(Rewald 9; BR. S-48)
Museu de Arte de São Paulo Assis Chateaubriand,
São Paulo, Brazil

49
Rearing Horse, c. 1888–90
Bronze, 12¼ in. high
(Rewald 13; BR. E-4)
Museu de Arte de São Paulo Assis Chateaubriand,
São Paulo, Brazil

50
Eadweard Muybridge (1830-1904)
Horse Cantering
Photogravure; plate 620 from *Animal Locomotion*, 1887;
7½ x 16⅛ in. (image); 19½ x 24¼ in. (sheet)
The Smith College Museum of Art,
Northampton, Massachusetts
Gift of the Philadelphia Commercial Museum, 1950,
acc. no. 1950:53-620

51
Prancing Horse, c. 1888–90
Bronze, 10⅝ in. high
(Rewald 16; BR. S-65)
Museu de Arte de São Paulo Assis Chateaubriand,
São Paulo, Brazil

52
**Horse Trotting, the Feet Not Touching the
Ground**, c. 1888–90
Bronze, 9¼ in. high
(Rewald 11; BR. S-49)
Museu de Arte de São Paulo Assis Chateaubriand,
São Paulo, Brazil

53
Eadweard Muybridge (1830-1904)
Horse Jumping a Hurdle
Photogravure; plate 637 from *Animal Locomotion*, 1887,
10⅛ x 12⅜ in. (image); 19¼ x 24⅜ in. (sheet)
The Smith College Museum of Art,
Northampton, Massachusetts
Gift of the Philadelphia Commercial Museum, 1950,
acc. no. 1950:53-637

54
Study for "Steeplechase: The Bolting Horse,"
c. 1866
Charcoal on paper, 9⅛ x 14⅛ in.
The Sterling and Francine Clark Art Institute,
Williamstown, Massachusetts, acc. no. 1397

55
**Horse and Jockey: Horse Galloping on Right Hoof,
the Back Left Only Touching the Ground**, c. 1888–90
Bronze, 11 in. high
(Rewald 14 and 15; BR. S-25 and S-35)
Museu de Arte de São Paulo Assis Chateaubriand,
São Paulo, Brazil

58
**Horse and Jockey: Horse Galloping, Turning the
Head to the Right, the Hooves Not Touching the
Ground**, c. 1888–90
Bronze, 11⅜ in. high
(Rewald 17 and 18; BR. S-32 and S-36)
Museu de Arte de São Paulo Assis Chateaubriand,
São Paulo, Brazil

The Ballet – Dancers

57
Dancers,[b] c. 1878
Oil over graphite on paper, 6⅞ x 4½ in.
Yale University Art Gallery, New Haven, Connecticut
The Collection of Frances and Ward Cheney, B.A. 1922,
acc. no. 1970.113.2

58
**Ballet Dancer, Dressed
(or Little Dancer of Fourteen Years)**, 1878–81
Bronze, tinted in part, skirt of cotton, with satin ribbon and
wooden base; 39 in. high
(Rewald 20; BR. S-73)
Museu de Arte de São Paulo Assis Chateaubriand,
São Paulo, Brazil

59
Study in the Nude for the Dressed Ballet Dancer,
c. 1878–79
Bronze, 28¹⁵⁄₁₆ in. high
(Rewald 19; BR. S-56)
Museu de Arte de São Paulo Assis Chateaubriand,
São Paulo, Brazil

60
Dancer Taking a Bow,[d] c. 1878
Graphite on paper, 14¹³⁄₁₆ x 9⅜ in.
The Art Institute of Chicago, Illinois
Bequest of Mrs. Gordon Palmer, acc. no. 1985.470

61
**Dressed Dancer at Rest, Hands Behind Her
Back,
Right Leg Forward**, c. 1895–99
Bronze, 17⅛ in. high
(Rewald 52; BR. S-51)
Museu de Arte de São Paulo Assis Chateaubriand,
São Paulo, Brazil

62
Arabesque over the Right Leg, Left Arm in Front,
c. 1882–85
Bronze, 11⅞ in. high
(Rewald 38; BR. S-1)
Museu de Arte de São Paulo Assis Chateaubriand,
São Paulo, Brazil

63
**Arabesque over the Right Leg, Left Arm
in Front**, c. 1880–82
Bronze, 8⅞ in. high
(Rewald 37; BR. S-14)
Museu de Arte de São Paulo Assis Chateaubriand,
São Paulo, Brazil

64
**Dancer Rubbing Her Knee or Study for a
Dancer as Harlequin**, c. 1882–85
Bronze, 11¹³⁄₁₆ in. high
(Rewald 48; BR. S-39)
Museu de Arte de São Paulo Assis Chateaubriand,
São Paulo, Brazil

65
Dancer Tying Her Scarf, 1887
Black crayon with white on paper, 18⅜ x 11⅜ in.
The Hyde Collection, Glens Falls, New York,
acc. no. 1971.63

66
Dancer,[b] c. 1884–85
Charcoal heightened with white on paper,
23½ x 18½ in.
Ball State University Museum of Art, Muncie, Indiana
Gift of Mr. and Mrs. William H. Thompson,
acc. no. 40.027

67
**Dancer at Rest, Hands on Her Hips,
Left Leg Forward**, c. 1895–99
Bronze, 14¹⁵⁄₁₆ in. high
(Rewald 21; BR. S-8)
Museu de Arte de São Paulo Assis Chateaubriand,
São Paulo, Brazil

68
Ballet Dancer with Arms Crossed, 1872
Oil on canvas, 24⅜ x 19⅜ in.
Museum of Fine Arts, Boston, Massachusetts
Bequest of John T. Spaulding, acc. no. 48.5341

69
**Dancer at Rest, Hands Behind Her Back,
Right Leg Forward**, c. 1895–99
Bronze, 17⅜ in. high
(Rewald 22; BR. S-63)
Museu de Arte de São Paulo Assis Chateaubriand,
São Paulo, Brazil

70
**Dancer at Rest, Hands Behind Her Back,
Right Leg Forward**, c. 1895–99
Bronze, 18⅛ in. high
(Rewald 23; BR. S-41)
Museu de Arte de São Paulo Assis Chateaubriand,
São Paulo, Brazil

71
Dancer on the Stage, c. 1877–80
Oil on canvas, 36 x 46½ in.
The Smith College Museum of Art,
Northampton, Massachusetts
Gift of Paul Rosenberg and Company, acc. no. 1955.14

72
Arabesque over the Right Leg, Left Arm in Line,
c. 1882–85
Bronze, 11⅛ in. high
(Rewald 42; BR. S-3)
Museu de Arte de São Paulo Assis Chateaubriand,
São Paulo, Brazil

73
**Arabesque over the Right Leg, Right Hand near
the Ground, Left Arm Outstretched**,
c. 1882–85
Bronze, 11⅛ in. high
(Rewald 41; BR. S-2)
Museu de Arte de São Paulo Assis Chateaubriand,
São Paulo, Brazil

74
Dancer Turning,[e] c. 1878
Charcoal, heightened with white chalk on
gray laid paper, 23¹¹⁄₁₆ x 17⅜ in.
The Art Institute of Chicago, Illinois
Bequest of John J. Ireland, acc. no. 1968.82

75
Grande Arabesque, First Time, c. 1885–88
Bronze, 19¼ in. high
(Rewald 35; BR. S-18)
Museu de Arte de São Paulo Assis Chateaubriand,
São Paulo, Brazil

76
Grande Arabesque, Second Time, 1885–90
Charcoal on paper, 18 x 14 in.
Mr. H. Peter Findlay, New York, New York

77
Rehearsal Before the Ballet, c. 1877
Oil on canvas, 19¾ x 24¼ in.
Museum of Fine Arts, Springfield, Massachusetts
James Philip Gray Collection, acc. no. 41.01

78
Grande Arabesque, Second Time, c. 1882–85
Bronze, 17⅛ in. high
(Rewald 36; BR. L-15)
Museu de Arte de São Paulo Assis Chateaubriand,
São Paulo, Brazil

79
**First Arabesque Penchée (or Grande Arabesque,
Third Time)**, c. 1885–90
Bronze, 17¹⁵⁄₁₆ in. high
(Rewald 39; BR. S-60)
Museu de Arte de São Paulo Assis Chateaubriand,
São Paulo, Brazil

80
**First Arabesque Penchée (or Grande Arabesque,
Third Time)**, c. 1882–85
Bronze, 16 in. high
(Rewald 40; BR. S-16)
Museu de Arte de São Paulo Assis Chateaubriand,
São Paulo, Brazil

81
Dancer on the Stage (*Scène de ballet*),[f] 1880
Oil on paper on canvas, 20 x 22⅝ in.
The Dixon Gallery and Gardens, Memphis, Tennessee
Gift of The Sara Lee Corporation, acc. no. 1991.3

82
**Dancer Bowing,
(or The Curtain Call)**, c. 1885–88
Bronze, 8¾ in. high
(Rewald 32; BR. S-31)
Museu de Arte de São Paulo Assis Chateaubriand,
São Paulo, Brazil

83
**Dancer Bowing
(or The Curtain Call)**, c. 1885–88
Bronze, 8⅞ in. high
(Rewald 33; BR. S-9)
Museu de Arte de São Paulo Assis Chateaubriand,
São Paulo, Brazil

84
Program for *Soirée Artistique*, 1884
Transfer lithograph; one state; 10⅜ x 14¹⁵⁄₁₆ in. (image)
(Delteil 58; Adhémar 56; R & S 54)
The Saint Louis Art Museum, Missouri
Gift of Horace M. Swope, acc. no. 249.40

85
Dancer Ready to Dance, the Right Foot Forward,
c. 1885–90
Bronze, 22⅜ in. high
(Rewald 46; BR. S-57)
Museu de Arte de São Paulo Assis Chateaubriand,
São Paulo, Brazil

86
At the Theatre: Woman with a Fan, c. 1878–80
Crayon lithograph on paper from a transfer plate; one state;
9⅛ x 7⅞ in. (image)
(Delteil 56; Adhémar 34; R & S 37)
Museum of Fine Arts, Boston, Massachusetts
Bequest of W. G. Russell Allen, acc. no. 60.260

87
Dancer Moving Forward, Arms Raised,
c. 1885–90
Bronze, 14 in. high
(Rewald 24; BR. I-19)
Museu de Arte de São Paulo Assis Chateaubriand,
São Paulo, Brazil

88
**Dancer Moving Forward, Arms Raised,
Right Leg Forward**, c. 1890
Bronze, 26⅛ in. high
(Rewald 26; BR. S-72)
Museu de Arte de São Paulo Assis Chateaubriand,
São Paulo, Brazil

89
Dancer Stretching at the Bar,[b] c. 1877–80
Charcoal and pastel with estompe on cream
laid paper, 12⅜ x 9¼ in.
The Art Institute of Chicago, Illinois
Mr. and Mrs. Martin A. Ryerson Collection,
acc. no. 1933.1229

90
Dancer, Fourth Position Front, on the Left Leg,
c. 1885–90
Bronze, 22⅜ in. high
(Rewald 44; BR. S-5)
Museu de Arte de São Paulo Assis Chateaubriand,
São Paulo, Brazil

91
Dancer, Fourth Position Front, on the Left Leg,
c. 1885–90
Bronze, 23³⁄₁₆ in. high
(Rewald 43; BR. S-58)
Museu de Arte de São Paulo Assis Chateaubriand,
São Paulo, Brazil

92
Dancer with Tambourine, c. 1885–90
Bronze, 10¹³⁄₁₆ in. high
(Rewald 34; BR. S-12)
Museu de Arte de São Paulo Assis Chateaubriand,
São Paulo, Brazil

93
Spanish Dance, c. 1885–90
Bronze, 17⅛ in. high
(Rewald 47; BR. S-45)
Museu de Arte de São Paulo Assis Chateaubriand,
São Paulo, Brazil

94

Spanish Dance, c. 1885–90
Bronze, 16¼ in. high
(Rewald 66; BR. S-20)
Museu de Arte de São Paulo Assis Chateaubriand,
São Paulo, Brazil

95

Dancer Looking at the Sole of Her Right Foot,
c. 1895–1900
Bronze, 18⁹⁄₁₆ in. high
(Rewald 45; BR. S-40)
Museu de Arte de São Paulo Assis Chateaubriand,
São Paulo, Brazil

96

Dancers, Pink and Green,b c. 1890
Oil on canvas, 32⅜ x 29¾ in.
The Metropolitan Museum of Art, New York, New York
Bequest of Mrs. H. O. Havemeyer, 1929, the H. O.
Havemeyer Collection, acc. no. 29.100.42

97

Dancer Fastening the String of Her Tights,
c. 1895–99
Bronze, 16¹⁵⁄₁₆ in. high
(Rewald 28; BR. S-33)
Museu de Arte de São Paulo Assis Chateaubriand,
São Paulo, Brazil

98

**Dancer Adjusting the Shoulder Strap of
Her Bodice**, c. 1896–99
Bronze, 13⅞ in. high
(Rewald 25; BR. S-64)
Museu de Arte de São Paulo Assis Chateaubriand,
São Paulo, Brazil

99

Dancer Putting on Her Shoe, c. 1888
Etching on white wove paper, state i/ii, 7 x 4⅜ in. (plate)
(Delteil 36; Adhémar 60; R & S 55)
The Art Institute of Chicago, Illinois
Joseph Brooks Fair Collection, acc. no. 1932.1334

100

Dancer Putting on Her Stocking, c. 1900–05
Bronze, 18½ in. high
(Rewald 56; BR. S-29)
Museu de Arte de São Paulo Assis Chateaubriand,
São Paulo, Brazil

101

Two Dancers in a Rehearsal Room, c. 1877–78
Aquatint, drypoint and burnishing, printed in black ink
on laid paper with partial ARCHES watermark; one state;
9⁄₁₆ x 8¹⁄₁₆ in. (plate)
(Delteil 22; Adhémar 37; R & S 33)
Mr. James A. Bergquist, Boston, Massachusetts

102

Dancer Putting on Her Stocking, c. 1900–05
Bronze, 18¼ in. high
(Rewald 57; BR. S-52)
Museu de Arte de São Paulo Assis Chateaubriand,
São Paulo, Brazil

103

Dancer Adjusting Her Stocking,b c. 1885
Charcoal and chalk on paper, 15⅜ x 11 in.
The Marion Koogler McNay Art Museum,
San Antonio, Texas
Bequest of Marion Koogler McNay, acc. no. 1950-31

104

Dancer Putting on Her Stocking, c. 1900–05
Bronze, 17 in. high
(Rewald 58; BR. S-70)
Museu de Arte de São Paulo Assis Chateaubriand,
São Paulo, Brazil

105

The Bow, c. 1895–99
Bronze, 13⅜ in. high
(Rewald 53; BR. S-34)
Museu de Arte de São Paulo Assis Chateaubriand,
São Paulo, Brazil

106

Dancer, Fourth Position Front, on the Left Leg,
c. 1885–90
Bronze, 16⅛ in. high
(Rewald 55; BR. S-6)
Museu de Arte de São Paulo Assis Chateaubriand,
São Paulo, Brazil

107

Dancer Looking at the Sole of Her Right Foot,
c. 1895–1910
Bronze, 19¼ in. high
(Rewald 49; BR. S-69)
Museu de Arte de São Paulo Assis Chateaubriand,
São Paulo, Brazil

108

Dancer Looking at the Sole of Her Right Foot,
c. 1895–1910
Bronze, 18 in. high
(Rewald 60; BR. S-67)
Museu de Arte de São Paulo Assis Chateaubriand,
São Paulo, Brazil

109

Dancer Looking at the Sole of Her Right Foot,
c. 1895–1910
Bronze, 19 in. high
(Rewald 61; BR. S-59)
Museu de Arte de São Paulo Assis Chateaubriand,
São Paulo, Brazil

110

**Dancer Holding Her Right Foot in Her
Right Hand**, c. 1895–1910
Bronze, 19⅞ in. high
(Rewald 62; BR. S-68)
Museu de Arte de São Paulo Assis Chateaubriand,
São Paulo, Brazil

111

**Dancer Holding Her Right Foot in Her
Right Hand**, c. 1895–1910
Bronze, 21⅛ in. high
(Rewald 65; BR. S-23)
Museu de Arte de São Paulo Assis Chateaubriand,
São Paulo, Brazil